EMBRACING EARTH

NEW VIEWS OF OUR CHANGING PLANET

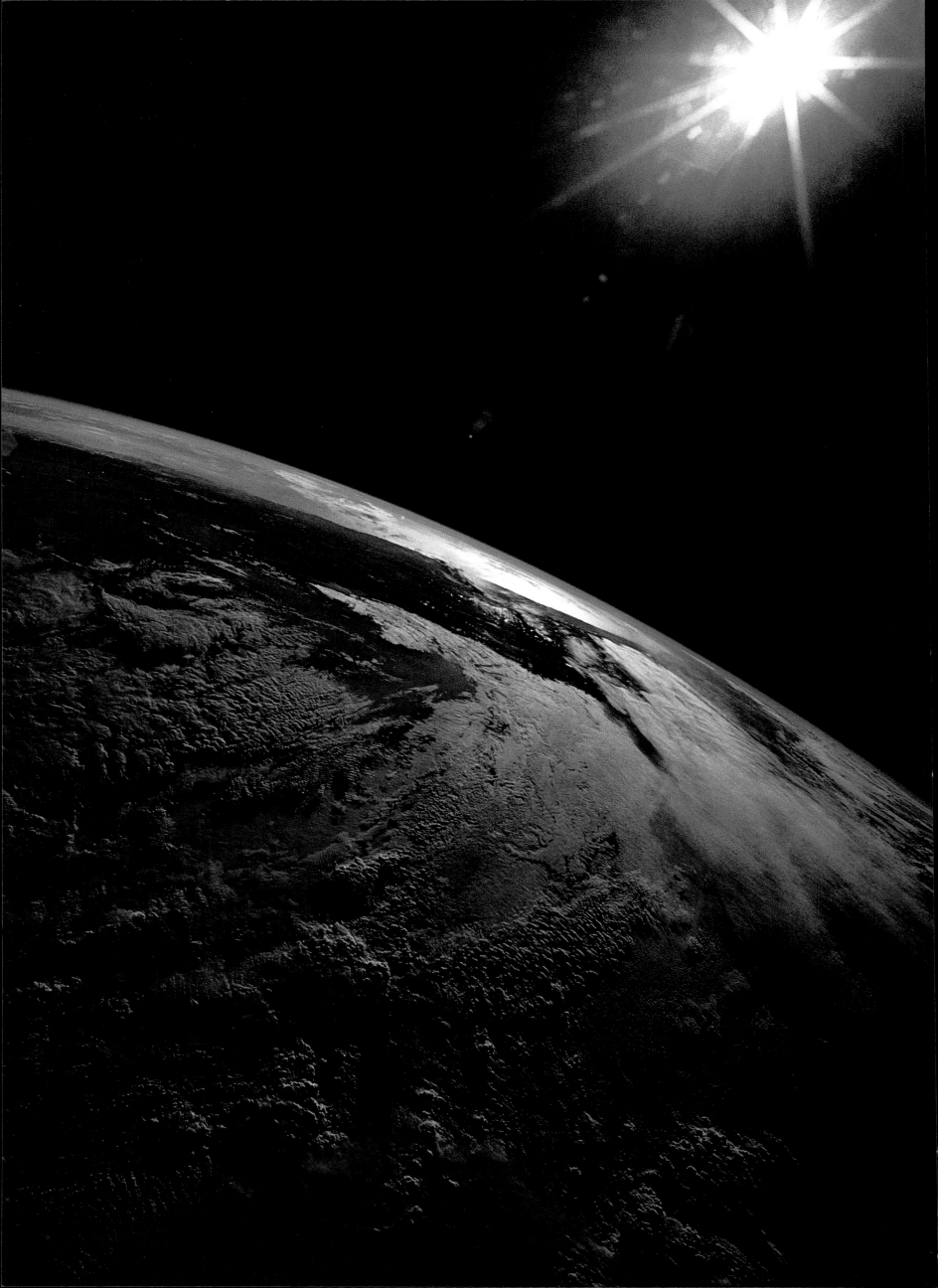

EMBRACING EARTH

NEW VIEWS OF OUR CHANGING PLANET

PAYSON R. STEVENS AND KEVIN W. KELLEY

FOREWORD BY JAMES BURKE

ESSAY BY W. STANLEY WILSON, NASA

THAMES AND HUDSON

May our one Earth become one world

First published in Great Britain in 1992
by Thames and Hudson Ltd, London

Printed and bound in Hong Kong

CONTENTS

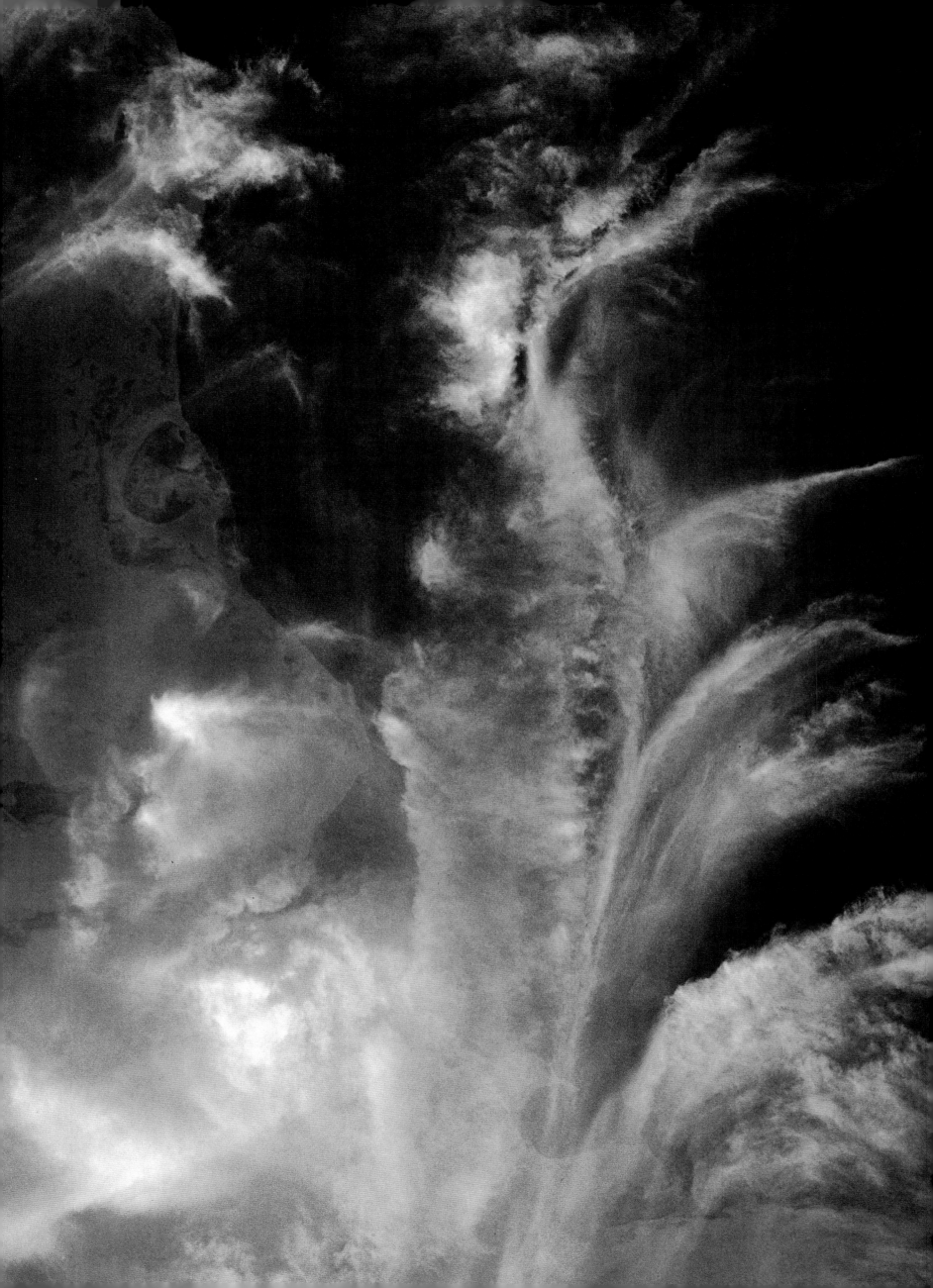

FOREWORD
by James Burke

More than a hundred thousand years ago, a small group of the first modern humans came north out of Africa to colonize the Earth. Somewhere, perhaps in the Sinai, they split, bade goodbye to each other, and went their separate ways to separate destinies. Their descendents would not meet again for twelve hundred centuries.

For the next eighty thousand years the inquisitive wanderers hunted their way across the world. From time to time individual groups would break off the great journey to settle permanently: in the forest glades, on the savannah, along lakes and seas.

Over the course of centuries these tiny communities would take on the characteristics of their new homes. Body shape and coloring would adapt to fit local climatic conditions. Tools and lifestyles would emerge to suit the physical constraints of the immediate environment. Language would develop to reflect surrounding reality.

Personal identity would become one with place.

Thus it is that humans are the children of the planet, selected for survival by the ecosystems with which they have coexisted for millennia.

Unlike all other life-forms, however, we descendents of those first ax-maker Africans have gone forth and multiplied because of the tools bequeathed us by our ancient predecessors.

In an extraordinarily brief span of time we have used those tools to change the world. With the help of plough and sword, printing press and electron, we have freed ourselves from total dependence on nature.

As part of that process we have also succeeded in enhancing the Earth's carrying capacity beyond anything our distant ancestors could have dreamt of. But we have succeeded too well. Today we are within sight of what appears to be the final planetary limit on population growth. In all probability we will reach that limit by 2050.

And as our global presence has grown, so too has our effect on the environment. Particularly since the Industrial Revolution, we have made ourselves felt, chemically, throughout the biosphere.

We are exterminating plant and animal species at an unknown rate. Desertification and deforestation radically perturb the balance of natural ecocycles.

However, the technology that has brought us to the brink of disaster could also save us. The convergence of data processing and telecommunications, which makes possible the enthralling images in this book, offers the hope of a new understanding of the planet.

As we move closer to the completion of a global information network, we have become aware that these advances have not made it a shrinking world, but one which, fortunately for our survival, still retains much of its original physical and cultural richness and variety.

In spite of our best efforts, we have not entirely succeeded in destroying the heterogeneity of the human species. Most important, many of the thousands of different cultures still alive around the planet have retained much of their archaic intimacy with their environment. If we can find ways to make use of that ancient knowledge in the next century, it may help us to retrieve some of our diminished sense of belonging.

Earth is our home, vividly and majestically displayed in this magnificent volume. Each picture shows a different face of our common mother. The evocative power of these wonderful images should stir genetic memories of our origins, reminding us of how far we have come and warning us of what our end might be.

Above all, this book serves as a timely reminder that, if we are to survive as a global community in the next century, it will be here, where we began, on Earth.

There is nowhere else to go.

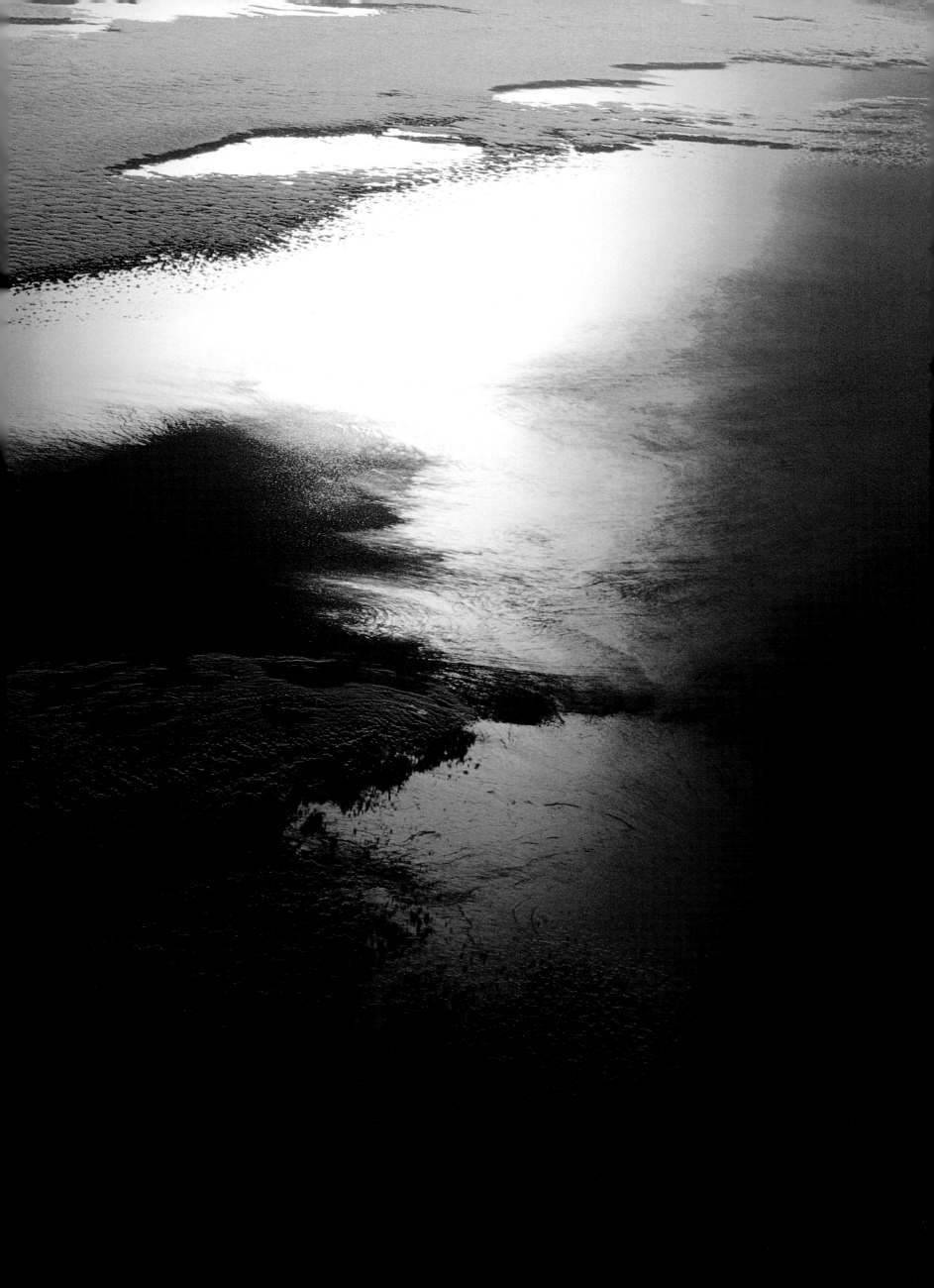

PREFACE
by Payson R. Stevens and Kevin W. Kelley

Payson R. Stevens. In writing and designing this book, two images have stood out for me as quintessential visions of the twentieth century. One looms with horrifying darkness, disgorging waves of incinerating heat and clouds of mushrooming radiation. It was the time when one small Japanese watch was charred still and silent forever at the beginning of the nuclear countdown. It was a snapshot ushering in the age of the bomb—whose destructive power first burst on Hiroshima and Nagasaki, and continues to be a sword of Damocles.

The other image is of the Earth from space as first seen by the NASA Apollo missions over twenty years ago. In it, our exquisitely beautiful planet floats amid the darkness of space, a jewel of blue awash with water, surrounded by a pale reddish blue atmosphere as thin as a hair glowing against the blackness of eternity, with fleecy white clouds and continents as familiar as those on a childhood school map. Our home seen as a whole is a powerful symbol of the only life in our solar system—a place to cherish, protect, and value.

Two images: powerful, awesome, and encompassing alternative realities—one destructive and pessimistic, the other constructive and expansive. Both rely on the power of the human intellect and the disciplines of science and technology to be realized. They also offer widely divergent options for our species.

Viewed from space, our planet, our home, has a sense of oneness that must become an emblem for a higher order of existence. Everything around us, however, seems to indicate that the human species has reached a very precarious time in its evolution. Life is out of balance. Aggressive behavior has become the simplest, most direct form of diplomacy. War between nations and with the environment emerges as the backdrop for the daily news. The consequences that are unleashed cut into the fabric of our existence and into the ecosphere.

Warnings of great danger are everywhere: a global population that will double in fifty years, causing severe stresses on resources and resulting in increased human misery; a thinning of the ozone layer in the atmosphere over Antarctica and the rest of the planet; the hottest year on record in 1990; the largest oil spill in human history as the consequence of the 1991 war in the Persian Gulf. These and many other indicators, including the destruction of species and bioregions, are all linked to the same metaphor: we are fragmenting because we are afraid to trust wholeness. In spite of these dangers, holistic views are entering mass consciousness. Our need to understand the Earth as a system, with its interdependent, interconnected components, is why the different views from space are so exciting for contemporary science: they provide us with a potentially liberating perspective. *Embracing Earth: New Views of Our Changing Planet* contains striking images of our planet seen from space, offered as reflections on both its beauty and its vulnerability to human impact.

The science of remote sensing—observing and analyzing the Earth from a distance—has given us eyes in space that observe with superhuman powers once only the privilege of mythic gods. Sophisticated sensors can "see" day or night, through fog and clouds. They are sensitive to temperatures, water vapor, the amount of chlorophyll (and therefore plant life) in water and on land, seasonal changes in the concentration of ice, yearly changes in ozone levels, winds blowing over the water and roughening its surface, even ancient aquifers under the desert. Remote sensing images take many visual forms: they can be photographs as well as computer renditions from different sensors, which are enhanced with digital colors that emphasize patterns. These images are forming an enormous portrait, a massive mosaic that shows the state of our planet's health and

the interaction of all its components. With this perspective has come a new discipline: earth system science. It is an all-encompassing view that requires an understanding that is more than geology or oceanography alone, more than climatology or meteorology. It is a meta-science that draws on all the natural sciences to help create a new approach for understanding how our planet works and how we affect it.

From the incredible diversity revealed by the imagery of our planet, we must seek inspiration that will help us find balance within a larger whole. The sophisticated technologies we have developed are only the tools of our inventive intellect; the way they are used ultimately reflects our view of ourselves. Technologies may help us understand and deal with some of our environmental problems but they are not the answer to these dilemmas. Solutions will come by developing human values that are global and interconnected, and which recognize that unlimited growth and expansion come at the expense of an ecologically and economically sustainable future.

We must search within ourselves to clear away the negativity and personal pain that is projected out into the larger world and desensitizes us to our destructive behavior toward each other and the Earth. All small acts of conservation, of questioning conformity and authority, of speaking out and demanding responsible behavior from politicians, schools, the media, and ourselves, must be viewed as normal behavior that will be additive, synergistic, and transformational.

All of science and all of art are the tools that allow patterns to be recognized. And within each cultural moment of history, they can be at the service of the status quo—the socioeconomic paradigms that drive us—or they can be elevated through a collective consciousness which rejects fear and requires love, clarity, and balance. Nothing less will do. Nothing else is more needed to welcome the Third Millennium.

Kevin W. Kelley. It is the fundamental beauty of the Earth that draws me to the creation of a book such as *Embracing Earth: New Views of Our Changing Planet*. As seen from space, the awesome majesty of the Earth is particularly exciting and illuminating, and it induces an even more profound reverie. No matter how many times I see these images, no matter how well I understand the important scientific and ecological messages that the images convey, ultimately I am most moved and most satisfied by the exquisite beauty and abundant truths of our planet.

I would encourage the reader to spend time with the images in this book, to really look at them. Allow your intuition and curiosity to lead you to your own discoveries. Your initial response may be an emotional reaction to the abstract beauty of what you see, or it may be the thrill of recognition of a familiar continent or contour from a radically new perspective. Continue to explore the images. You will find your own patterns and connections and significances, often taking you in directions other than the one we, the authors, address in the text.

You might see that the large macro patterns of the Earth resemble, sometimes with remarkable precision, the designs at ground level, or the micro systems of your own body. Rivers and their tributaries ranging over thousands of miles resemble patterns in a leaf or the veins in your hand; the folds of mountain ranges also appear to be ripples in sand dunes. You will notice rhythms in the clouds, in the texture of the land, in the color of the sea.

These rewarding discoveries will lead to new questions that will take you in many directions. Do not let yourself be satisfied with the literal explanations of what you see. You may find, as I sometimes do, that these images of the physical Earth can serve as metaphors for a wide range of mental, cultural, and spiritual processes.

I deeply enjoy the cycle of discovery, reflection, and mystery. Often I go back to my favorite photographs and spend more time with them, roaming the details of terrain and the subtleties of texture to find, once again, another layer of understanding and challenge. Ultimately, for me and perhaps for you, there is more mystery than discovery, more wonder and beauty than cognitive understanding.

This intuitive approach complements and enhances, rather than replaces, a more scientific approach to what the images in the book reveal. One thing that you are certain to discover, no matter how you consider the Earth, is the sobering fact that the planet is in jeopardy. Our resources are being depleted, and the very fabric, balance, and stability of the Earth are being threatened.

How will we create a sustainable future? The information conveyed in the images in this book and the powerful technology that delivered them can be a first step, but they are only the first step. The fabulous images and technology can help us see and understand what is going on in an unprecedented way—the hole in the ozone is now actually visible. We can now see what is beyond our own senses, beyond the limitations of an earthbound perspective.

The best perspective is always from a distance. From the distance and silence of space, from manned and unmanned spacecraft, this book brings us images and messages for survival. But information alone will not save the Earth. Decisions and actions will.

Many people have already been moved to action by the data on our destruction of the planet, and many others will undoubtedly heed the call of the startling information and conclusions in this volume. For some people, including myself, the call to action will come from a different inspiration. When we look closely and fully at the images in this book, we apprehend a wholeness that is more than the sum of its parts, a totality that is more than the sum of numbers. Patterns and textures become rhythms of interdependent systems and metaphors for a chaotic harmony: this vibrant, living Earth, sacred, divine, and immensely beautiful, evokes a love within us, an Epiphany.

For me, that is the power of the beauty of Earth as seen in these images. I hope that this beauty will inspire enough love to move you and me to act.

Note on the images: The images that follow were taken from space by cameras and a variety of remote sensing devices, as explained in the essay that begins on page 164. Satellites equipped with detectors sensitive to visible wavelengths, microwave, and thermal radiation, as well as other bands of the electromagnetic spectrum, send data to computers on Earth that process and display the data, as you will see in this book. In some cases, these images are photographs that capture what was visible to an astronaut's eye; in many other cases, the images reveal what the eye or photographic camera cannot see. These highly informative, visually dramatic, and usually false-colored images highlight vegetation, heat, water and air currents, and other aspects of the Earth and its atmosphere. The captions to the images explain the significance of the color scheme produced by the remote sensors. What may appear to be an imperfection in an image is often a consequence of data transmission. On many pages, there are composite images that show an entire hemisphere or the whole globe at one time, or that superimpose geographic boundaries or data-graphic information over the images. To provide an additional perspective to the view from space, there are occasional Earth-based photographs of places or events. From ground level to the Space Shuttle to a satellite over 1 million miles from Earth, these images present an intimate portrait of our planet as it has never been seen before.

NATURAL RHYTHMS

Patterns and structure. Everywhere we look we see them. What appears random and chaotic also has order. And on Earth much of the order is linked to interrelationships that drive constant change. Cycles and rhythms. Pulses and flows. Changes in magnetic fields. Continental plates moving. Water cycles. Seasons changing. Life and death. Process and connection. Nature flows through webs of structure and shifting time: from ocean to cloud to rain to river to ocean. Natural rhythms.

NATURAL RHYTHMS

The rhythms of the natural world are all around us. They are constantly changing, with countless clocks ticking at different beats, different times. We immediately perceive the moment-to-moment flux of our daily world: the drifting of clouds, the surging of waves, the rustling of wind in trees, the bubbling of water in brooks, the melting of icicles. We know the seasons, from the mantle of summer's green to that of winter's snow. We have faith that the Earth will renew itself each spring. The cycles of human or animal life—from birth to death—are a constant part of our deepest psyche, for they remind us of our own mortality and return to the earth.

Then there is the scale of deep time, spanning millions, even billions of years, with a clock that ticks almost beyond our comprehension. It is the rhythm of continents moving, of mountains uplifting and eroding, of deep canyons slowly being carved by water through countless millennia. It is also the clock of life's evolution: species evolving, and disappearing into the oblivious maw of extinction. Somewhere in between the brief moment and the millions of millennia are time scales that embrace sunspot cycles, poles wandering, and glaciers retreating and expanding.

The natural rhythms of our planet give us a sense of order even when we are faced with catastrophic earthquakes, tornadoes, hurricanes, and avalanches. Everything has its time and place: its origins and evolution, its life and death. We understand that there are processes which drive these events and that we are somehow part of them and part of nature, from volcanoes to ocean currents. These processes are as uplifting as the new spring buds, as comforting as the waves endlessly breaking, and as harrowing as the tornado or tidal wave sweeping the landscape with

death and destruction. They are the matrix that helps give order and sets the rhythms of the physical world.

For plants and animals, the cycles of change operate on many scales. As the Earth rotates around the sun, day shifts to night, sunlight to darkness. Flowers close up at night; animals go to sleep or awaken depending on their feeding habits. The seasonal alternation of shorter and longer days, and colder and warmer temperatures, triggers the internal clocks deeply etched into the genetic material of all life-forms. Hormones flow, behaviors manifest, and mating seasons start, all based on cues from the rhythms of the external world.

For five hundred thousand years, humans have learned to survive and adapt to these rhythms and to carefully observe the cycles that would help ensure our survival and the survival of our offspring, our species.

Our perspective for watching change has always been from the vantage point of level ground, a high hill, or a mountain. Storms brew in the distance, fields of flowers blossom, and forests change color. From our beginnings, we have only been able to perceive our immediate landscape. Only recently has our view expanded beyond the evolutionary limits of our vision. In the twentieth century, airplanes gave us a larger regional perspective that expanded our awareness to hundreds of miles. The last three decades have taken us out into space and given us views of thousands of miles and even the entire planet.

Satellites have become technological sentinels orbiting the Earth, taking countless snapshots with numerous sensors. Images of whole continents and ocean basins allow us to track change at daily, weekly, monthly, and annual rhythms. Satellites allow us to watch fires burning in Yellowstone National Park and storms forming around the world, shown on the daily television weather report. We can see the oceans bloom, the land lose vegetation and turn to desert, and the seasons change. A new global vision is emerging. Seen from space, our planet is not only a beautiful blue marble, but a complex interaction of many components: land, air, water, snow and ice, life. We are in the process of gathering a portrait of our planet that will enable us to understand how these elements interact and interrelate. Without this satellite perspective, we would never advance beyond struggling to tell the forest from the trees.

The cycles of change, part of the dynamics of the Earth system, affect all of its components. Our planet has natural archives that can reveal past episodes of some of these changes. Tree rings can record events over thousands of years. Ice cores sample time going back hundreds of thousands of years. Ocean cores and sedimentary rocks reveal events that occurred millions of years ago. These records tell us about past temperatures, rainfall, vegetation patterns, air composition, sea levels, and solar activity. Our understanding of future global change relies on our ability to read and interpret these past records. They are part of the planetary library that will help us to predict the effect of our activities on the Earth.

What follows is a panorama of these rhythms as seen from the perspective of space. Their inherent beauty and order are apparent. Yet our appreciation of natural rhythms is essential not only to delight in an understanding of the way the world works but to realize our place within these rhythms and our impact on them.

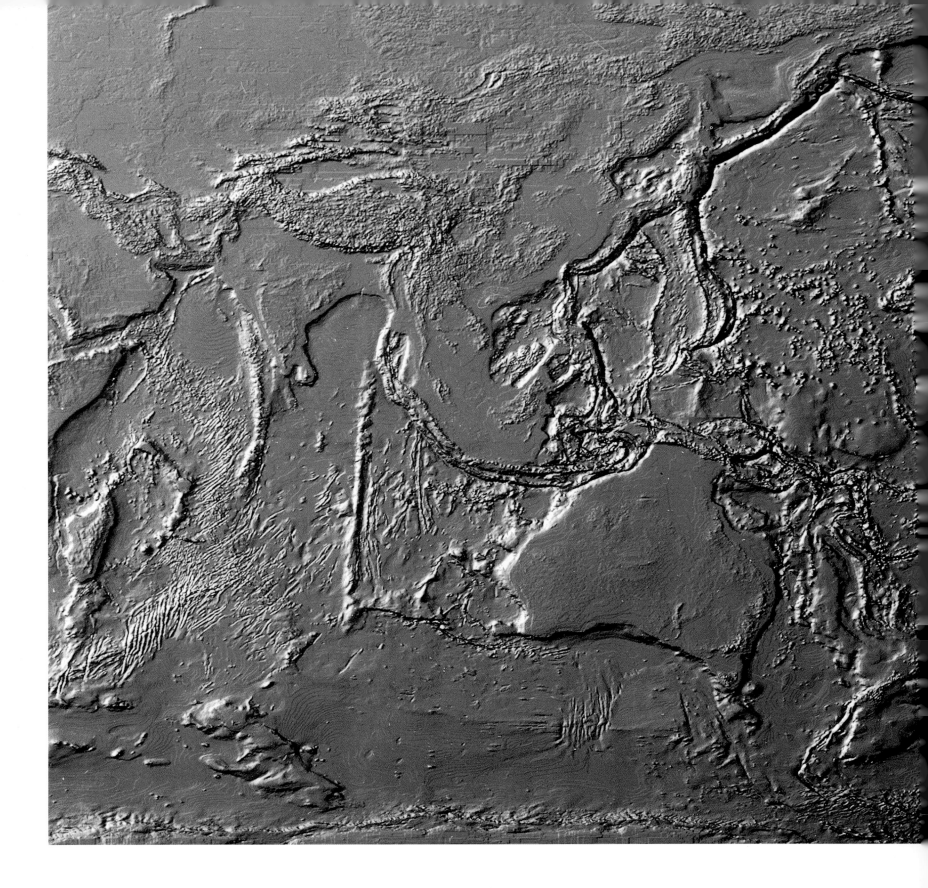

LAND

Global Ocean and Continental Relief. Most of us think of the earth beneath us as solid and immovable. But those who have experienced the force of an earthquake know that even the seemingly solid earth moves and changes. Only in the last few decades has science revealed that the Earth's surface is made up of a series of huge plates that have been moving for hundreds of millions of years. This theory of plate tectonics and seafloor spreading is one of the great discoveries of recent times. Volcanoes, earthquakes, underwater seafloor relief, the movement of continents, and even the evolution of certain organisms can be explained by this elegant theory.

These huge plates move as if on a gigantic conveyor belt. They are driven by a heat engine from deep within the Earth, which generates magma that comes to the surface at ridges beneath the ocean. As the plates move,

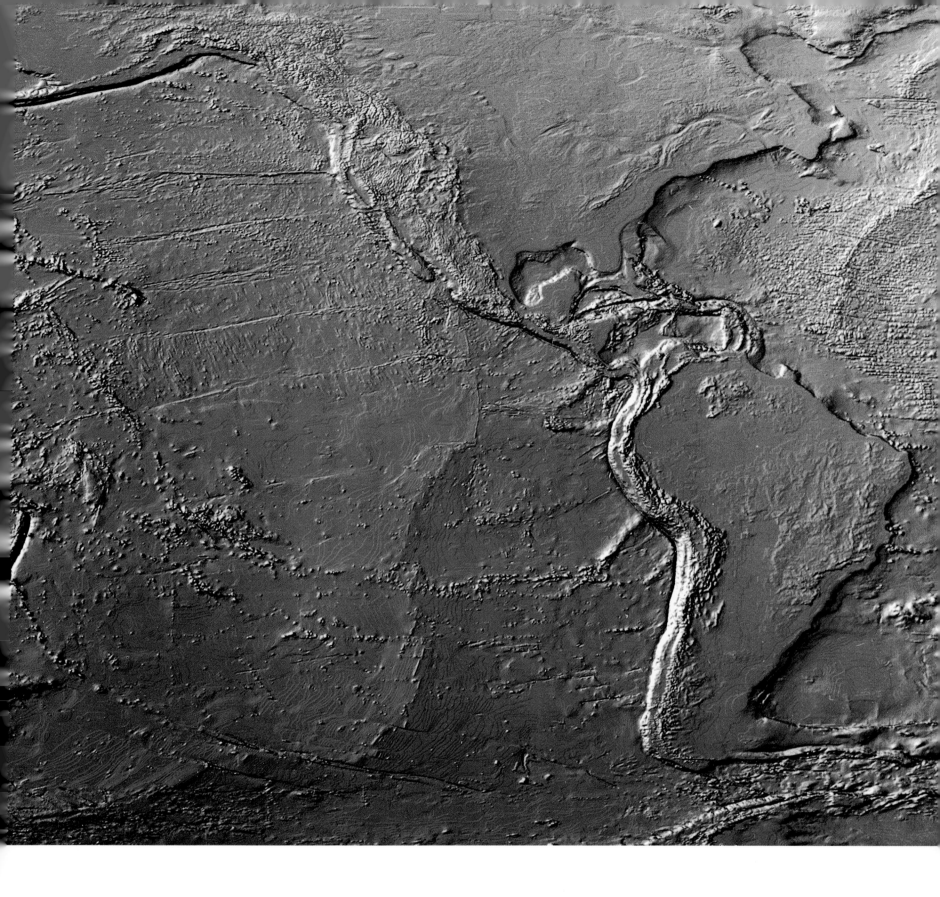

they collide into each other, one plate riding on the top, the other subsiding below it. Mountains are formed, the earth trembles and quakes, and where the magma comes close to the surface, volcanoes spew their fiery, molten rock.

There is a flow to all this movement that can accurately be measured by satellites using lasers. Scientists have found that the Atlantic Ocean is widening at the rate of one inch a year, so that the continents on either side are drifting farther apart from each other. The fit of South America and Africa confirms that the continents were once part of a super landmass, called Pangaea.

Many of the Earth's most spectacular geological features are hidden from view deep beneath the ocean's surface. There are trenches six times deeper than the Grand Canyon and mountains several times taller than Mount Everest. The image shown above is a representation of that waterless view of Earth. It has been made by a combination of ship depth-sounding technology and an altimeter sensor aboard NASA's Seasat satellite. The altimeter sends down a radar beam that can measure differences in the height of the sea surface with a precision of two inches. These measurements can map the relief of the ocean's surface, which actually reflects how gravity affects the ocean water surface. Over a midocean ridge, water piles up, while over a trench, the sea surface may be depressed as much as 190 feet.

This global ocean and continental relief shows that continental borders are extended farther by their shelves and slopes, which are normally hidden from view. Deep trenches can be seen at the margins of South America and North America and along the rim of the eastern Pacific. Midocean ridges are visible at the center of the Atlantic and at varying points in the Pacific and Indian oceans. These and many other features all fit together like a giant puzzle, the pieces being the plates of North and South America, Eurasia, Africa, and the Pacific.

The creation of uplifted mountains from plate motion and volcanic islands is the beginning of an endless cycle for the solid Earth. Then, wind and water begin the process of erosion, which further defines the appearance and evolution of geologic features. At each scale, from the mighty Himalayas to the trickle of water eroding the desert floor, the solid surface of our planet is constantly being altered.

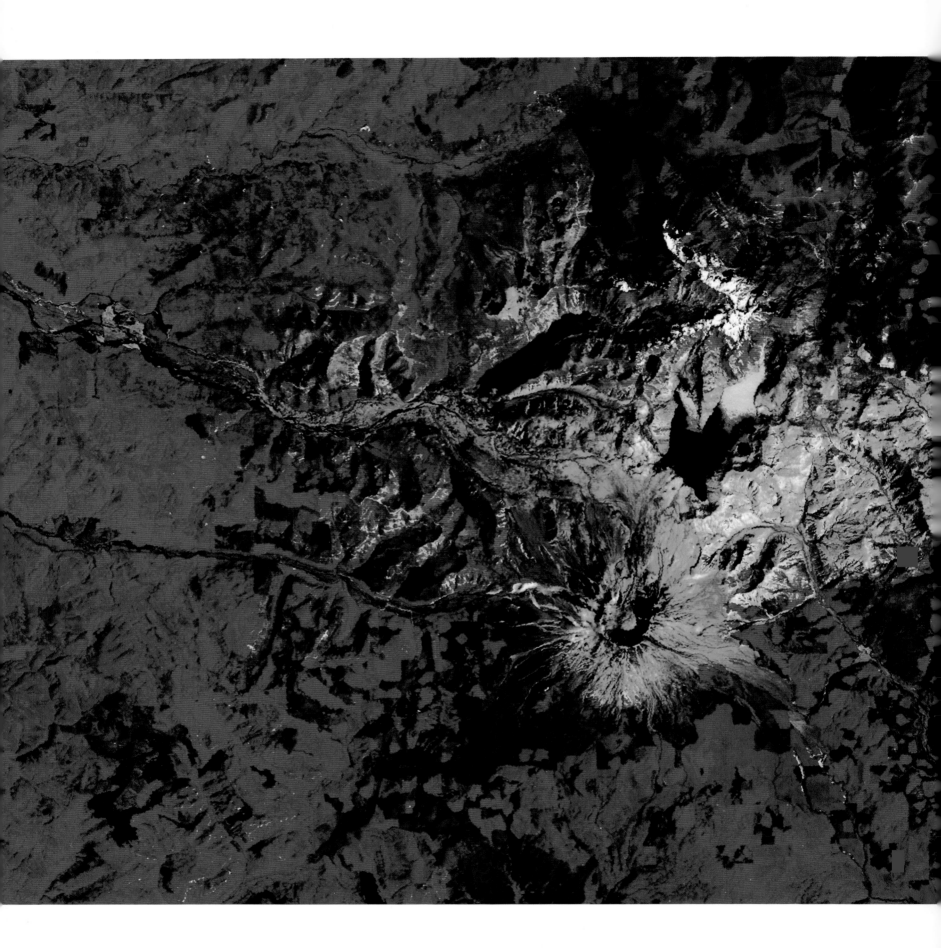

Mount St. Helens, United States. In just a few minutes on May 18, 1980, the eruption of Mount St. Helens in Washington State blew away a cubic mile of the mountain's summit, reduced its elevation by 1,313 feet, and clear-cut 230 square miles of forest. From Vesuvius to Mount St. Helens, volcanoes are part of human history: their explosive eruptions are burnt into our collective memories. Their lava flows have buried cities and their ash has changed our weather. Remote sensing has enabled us to study the impact of volcanoes on the surrounding landscape and atmosphere. Satellite sensors have tracked volcanic clouds for days as they are carried by the global winds.

Volcanoes play an important role in the geological cycle by bringing new material up to the Earth's surface, which is then eroded by the process of weathering. Eroded material, transported by water, wind, and ice, is deposited as sedimentary rock. In the Earth's early history, volcanism was responsible for the creation of part of its surface.

◄ This satellite image shows surface features in the vicinity of Mount St. Helens four years after the eruption. Vegetation is red, and devastation from the blast and mudflows on the volcano's flank appear blue-green.

▼ The photograph shows the volcano during its eruption on May 18, 1980.

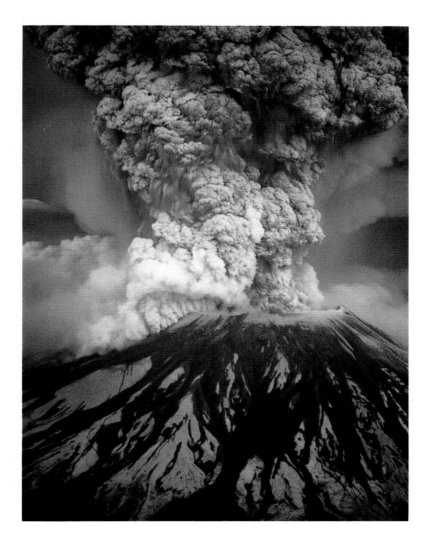

Ring of Fire, Pacific Ocean. Volcanoes and earthquakes are the result of the continual movement of the Earth's plates as they collide. Magma squeezes its way upward, allowing molten rock, or lava, to ascend to the surface. Only in the cooling of the lava can we see the formation of solid rock. Eruptions can be explosive, like that of Mount St. Helens in Washington, or more benign with oozing flows, like that of Kilauea in Hawaii.

Both volcanoes are in one of the main regions of seismic and volcanic activity, known as the Ring of Fire, within the Pacific Ocean basin. Here the vast Pacific Plate collides with other larger and smaller plates. Numerous volcanoes and earthquakes occur annually, and a majority of the world's active volcanoes are found within the Ring of Fire.

▶ **Sakurajima, Japan.** The volcano (elevation 10,049 feet), shown during an eruption in August 1986, is at the top of the image, in Kagoshima Bay, on the island of Kyushu, the southernmost island of Japan. Recent lava flows, in blue, can be seen to the right of the peak. Older flows have red regions indicating the reestablishment of vegetation. The city of Kagoshima is on the left.

▼ **Island of Hawaii, United States.** This island is the youngest of the Hawaiian Island chain. It is volcanically active including the 13,796-foot-high Mauna Kea, the small dark circle seen at the top of the island. Beneath it is Mauna Loa, at 13,677 feet, with extensive dark black-brown lava flows. Kilauea volcano, at 4,077 feet, is in the lower right and has been active throughout this century with flows as recent as 1990. Areas of vegetation are dark green; older, established vegetation is light green.

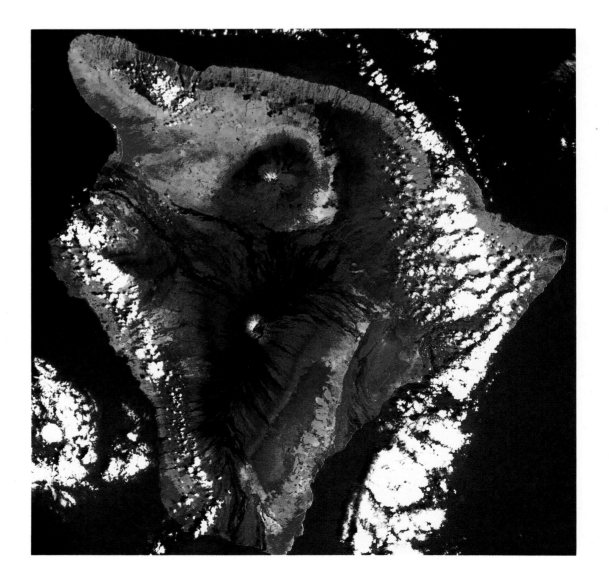

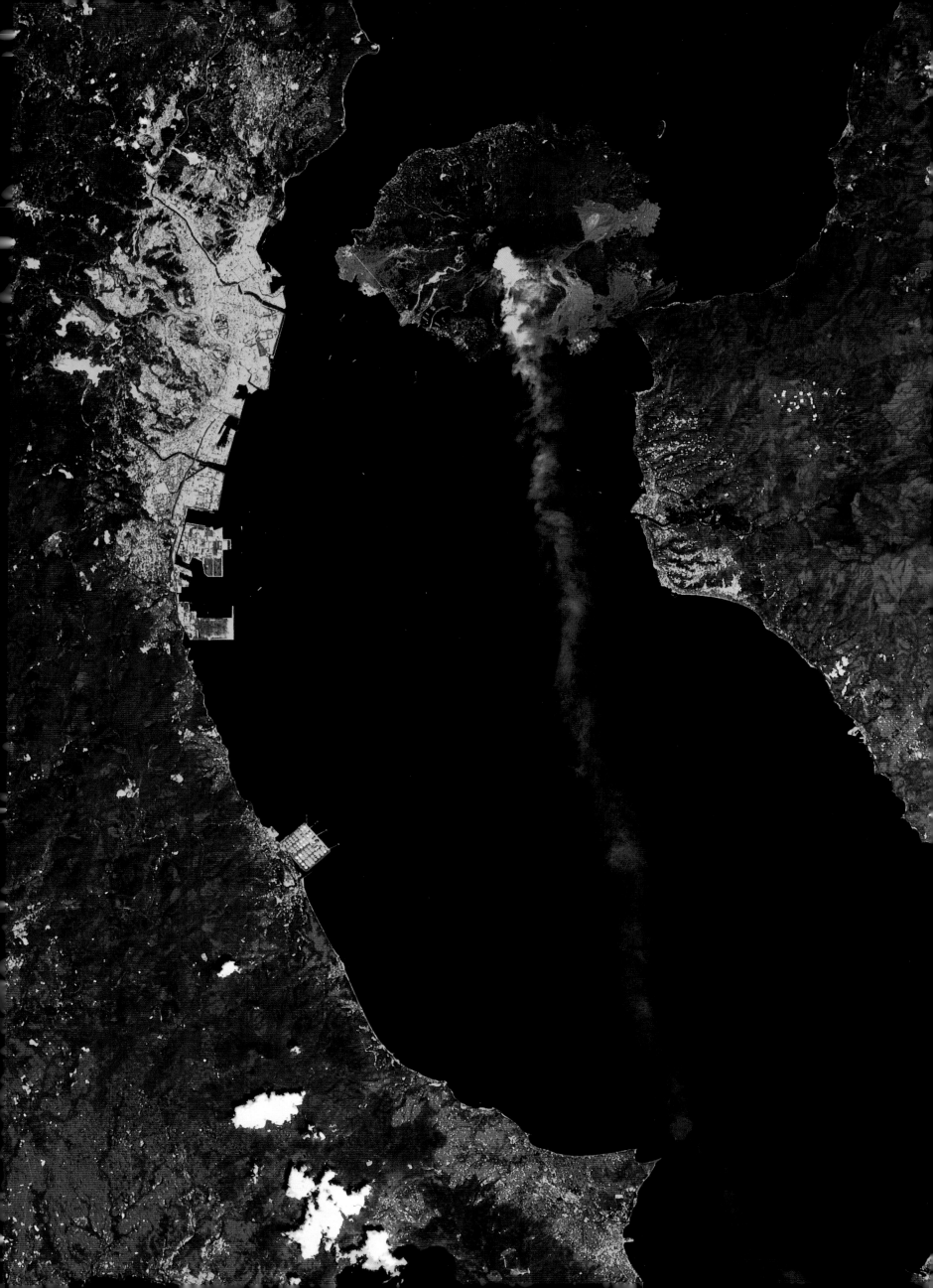

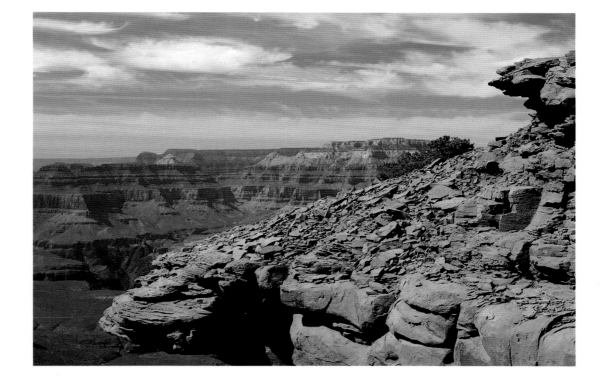

◄ **Grand Canyon, United States.** The Grand Canyon in Arizona is a dramatic example of the power of water to erode the land. The Colorado River took 4 million years to cut a 278-mile-long canyon, whose width varies from less than 1 mile to over 18 miles, and whose depth extends as much as 1 mile. The great variation in the altitude of the canyon, from 1,200 to 9,100 feet, has created desert to subarctic ecosystems.

The appearance of the canyon walls was shaped by geologic events that go back almost 2 billion years. It was a drama with many forces: volcanoes erupting, mountains thrusting upward and twisting, land subsiding, water and wind constantly eroding the land. All of these are phases of the geologic cycle that determine the look and lay of the land.

▲ A view of the Grand Canyon from the South Rim looking toward the North Rim.

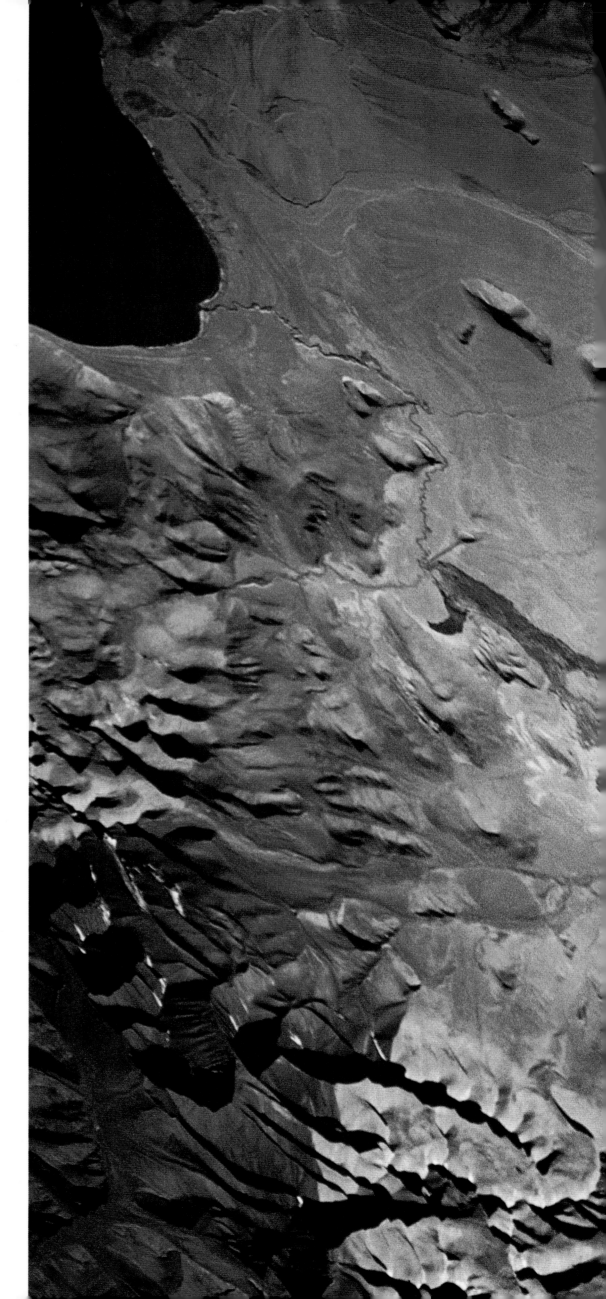

Tibet and Nepal. These two countries are part of the great 1,500-mile-long Himalaya mountain range, created when the Indian Plate collided with the Asian subcontinent 40 to 60 million years ago. Nepal rises to great mountainous heights, while Tibet, to the north, occupies a high plateau averaging 16,000 feet. Tibet dominates this Space Shuttle image of approximately 150 square miles. A glacier in the upper right flows off the north slope of the Gangdise Shan mountains in southern Tibet. A small lake, Konggyu-tso, is in the center, and a portion of another lake, Manasarowar, is in the top left. Nepal is in the lower left.

When we talk about preservation of the environment, it is related to many other things. Ultimately the decision must come from the human heart. The key point is to have a genuine sense of universal responsibility, based on love and compassion, and clear awareness.

The Dalai Lama

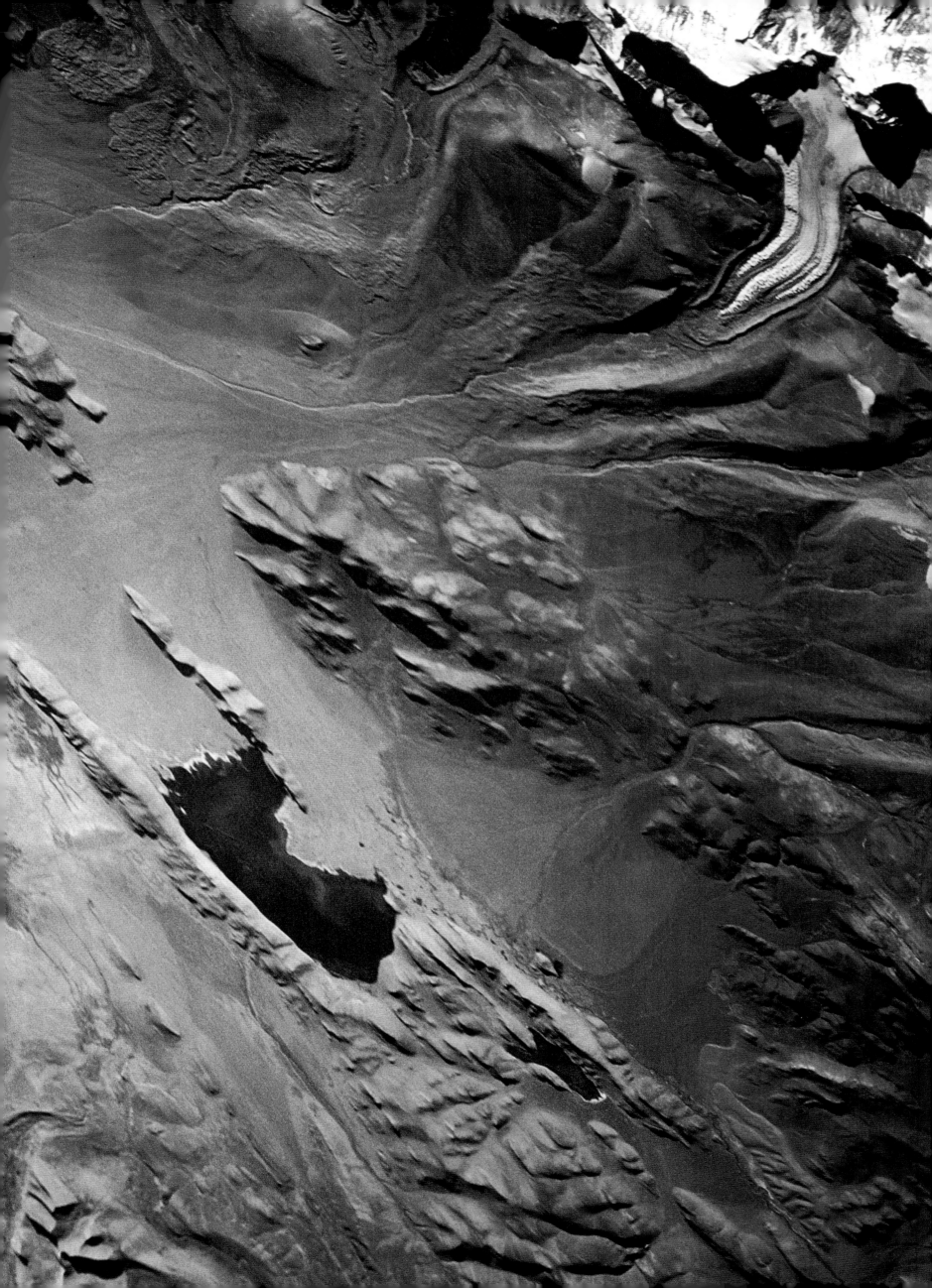

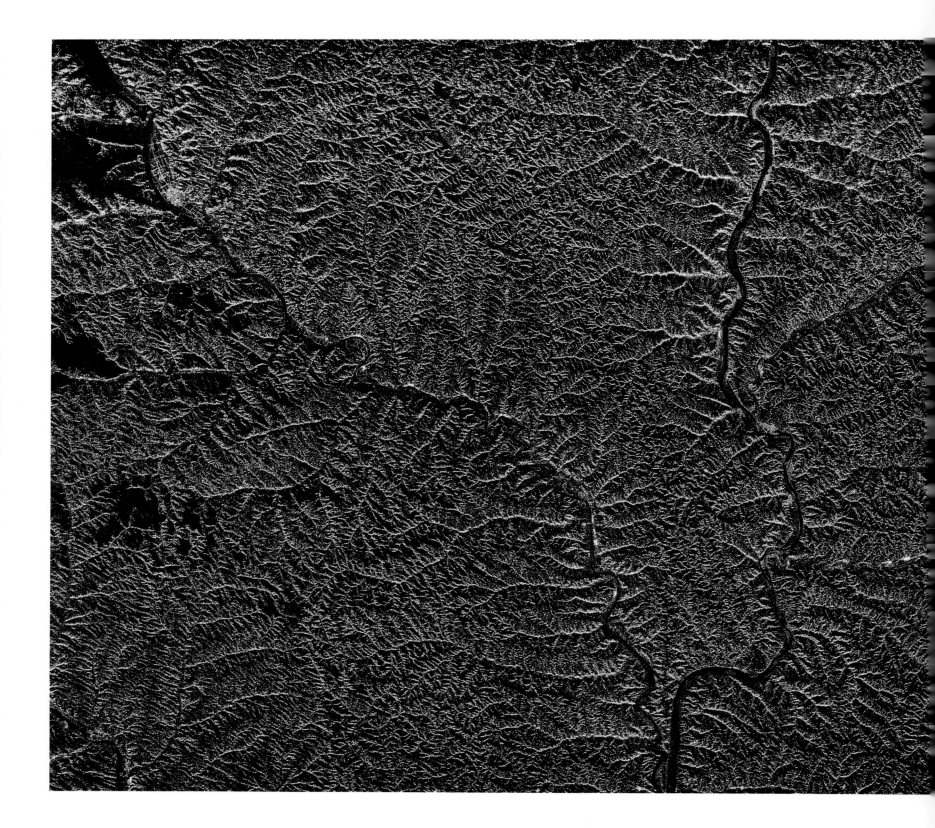

The wind blows pebbles across the fields. Sheep cannot find even dry grass. In every ten years, nine yield no food. If it rains, there's a harvest. If not, all is lost.

Gansu, China, folk saying

Windblown Silt, Loess Plateau, China. Dust storms, a part of nature's rhythms, arise when the turbulent movement of the wind sweeps up the surface soil. Loess is a form of windblown silt or dust that can bury landforms over the course of time. The Loess Plateau of central China is probably the largest accumulation of windblown silt on the planet, having been carried over many centuries from the Gobi Desert of Mongolia nearly 1,000 miles away. The plateau,

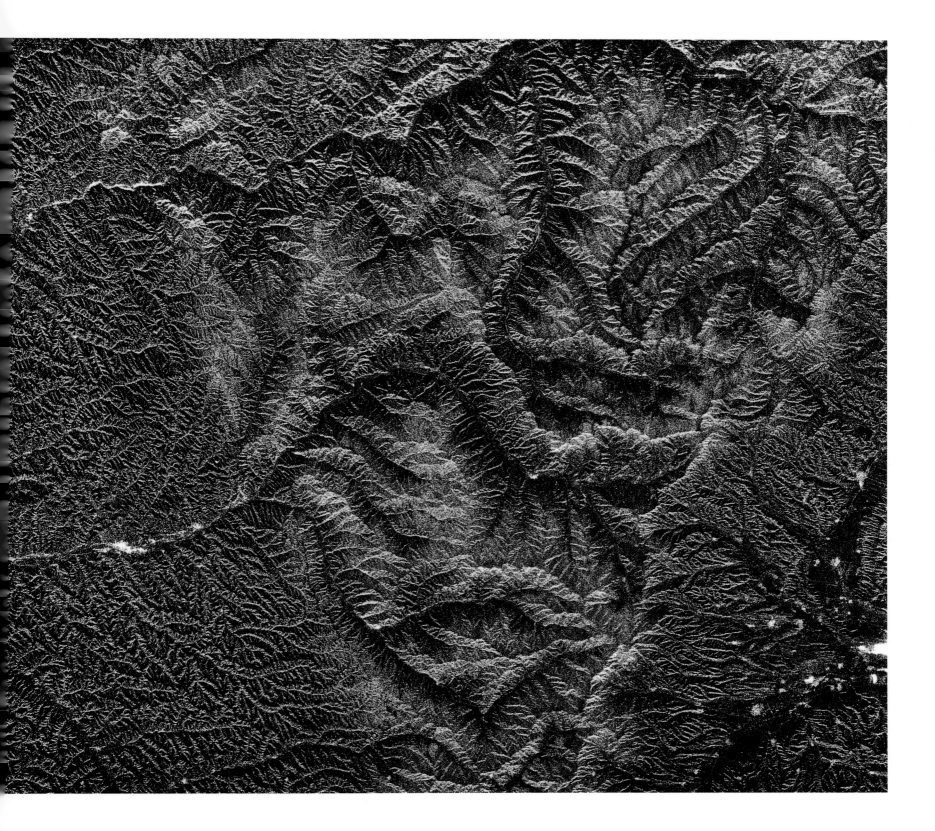

covering an area of almost 200,000 square miles, is a powerful example of the wind's capacity to transport the earth.

This radar image is centered on the Huang He, or Yellow River, in the Shanxi Province of China, as it flows south. The Kuye He joins it at the bottom. The entire scene reveals the effects of intense water erosion. Because the windblown silts are not very compacted and easily wash away, rainstorms and runoff have created an extensive terrain of elongated ridges and gullies. The tremendous erosion contributes to the sediment load of the river. Hence its name: Huang He, or Yellow River. The city of Xing Xian is the bright spot at the center of the image to the east of the river. The villagers living on the Loess Plateau often struggle in this desolate and harsh environment, where a constant and reliable source of water for irrigation is difficult to obtain.

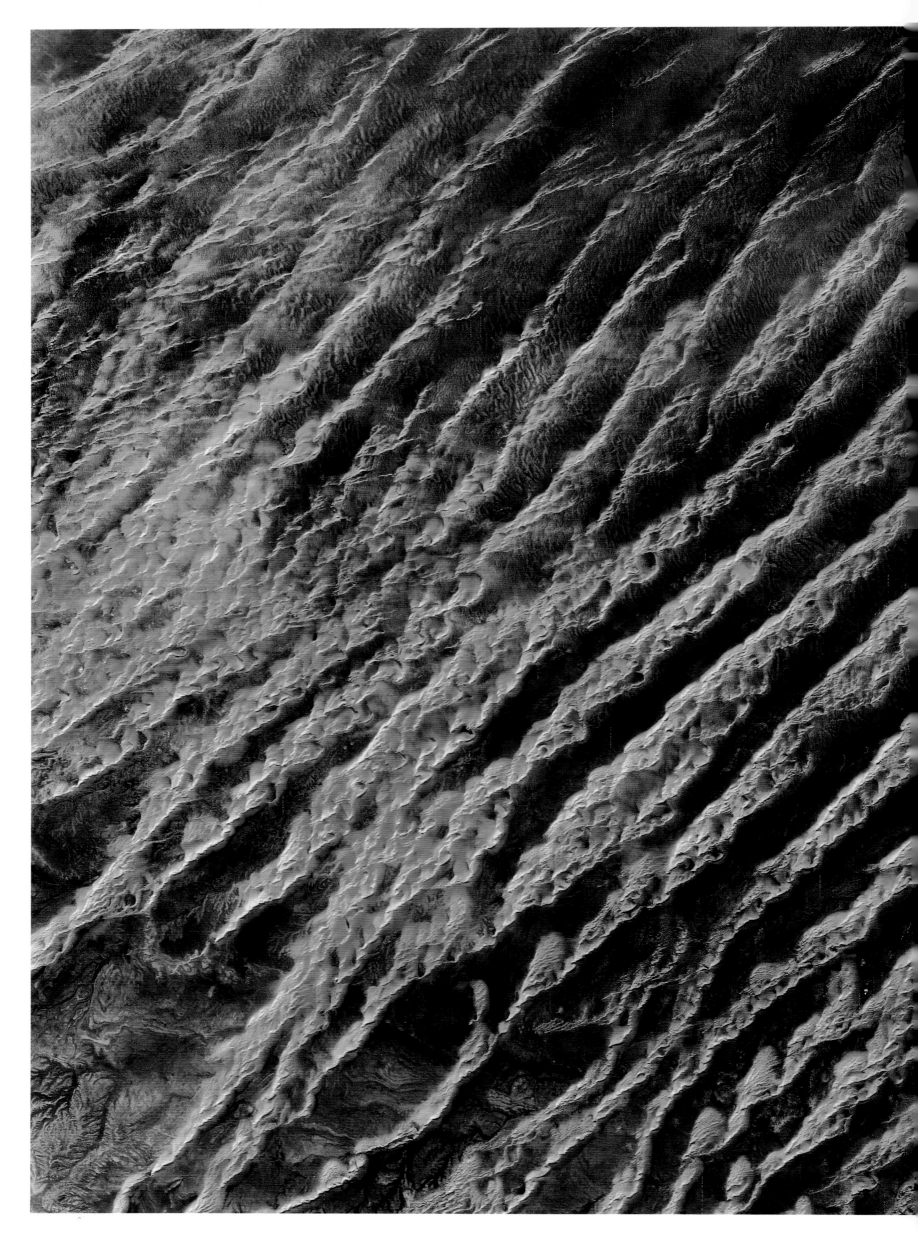

◄ **Empty Quarter, Saudi Arabia.** Winds blowing across the Arabian Peninsula have created vast regions of undulating dunes resembling the ocean surface. The Grand Rub' al Khali Erg is an extensive sand basin in the southwestern quadrant of Saudi Arabia. Known as the Empty Quarter, it is a desolate expanse of crested dunes shaped into long parallel ridges by continuously blowing southwesterly winds. The light blue regions in the image are oases, where water collects. Formations caused by water erosion are in the lower left.

▲ **Baja California, Mexico.** This image of the surface of a dune in Baja was taken from a distance of only a few feet. The pattern in the sand was caused by the same forces that formed the dunes covering 250,000 square miles in the Empty Quarter of Saudi Arabia.

Western Andes Mountains, Peru. The Andes Mountains, like the Himalayas, were formed by the collision of huge tectonic plates moving over the Earth's surface. As the Nazca Plate in the Pacific Ocean moved east, it struck the South American Plate. The Nazca Plate slipped under the South American continent, uplifting the terrain into a 4,500-mile-long mountain range whose highest peak is nearly 23,000 feet.

This false-color image shows the region in the Andean foothills surrounding Nazca, Peru, after which the plate is named. The elevation of the area ranges from 2,000 to 6,000 feet. The mountains, in the upper right, are veined with numerous rivers draining westward toward the lower-lying land (gray-green). Villages and cities surround the major rivers, along which farm plots are clearly visible. Vegetation appears in reddish brown. The image indicates that much of this region is semiarid, with little vegetation, hence the proximity of the farms and villages to the main sources of water for irrigation. The white fan shapes are older river deposits that streamed from the longer valleys of the mountains.

It is lovely indeed, it is lovely
indeed ...
I, I am the spirit within the Earth;
The bodily strength of the Earth is my strength;
The thoughts of the Earth are my thoughts;
All that belongs to the Earth belongs to me;
I, I am the sacred words of the Earth;
It is lovely indeed, it is lovely
indeed.

Navaho Creation Chant of Changing Woman

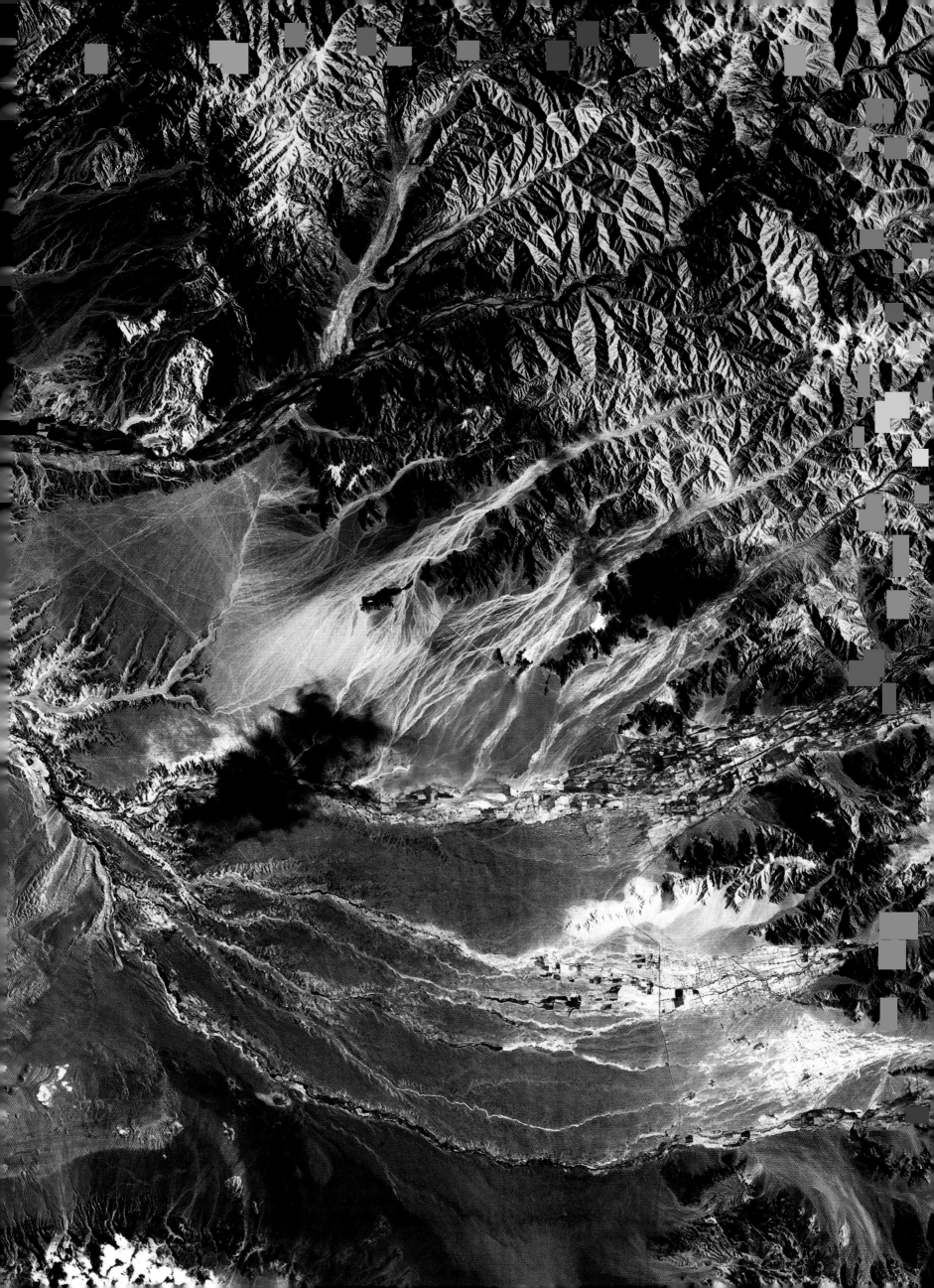

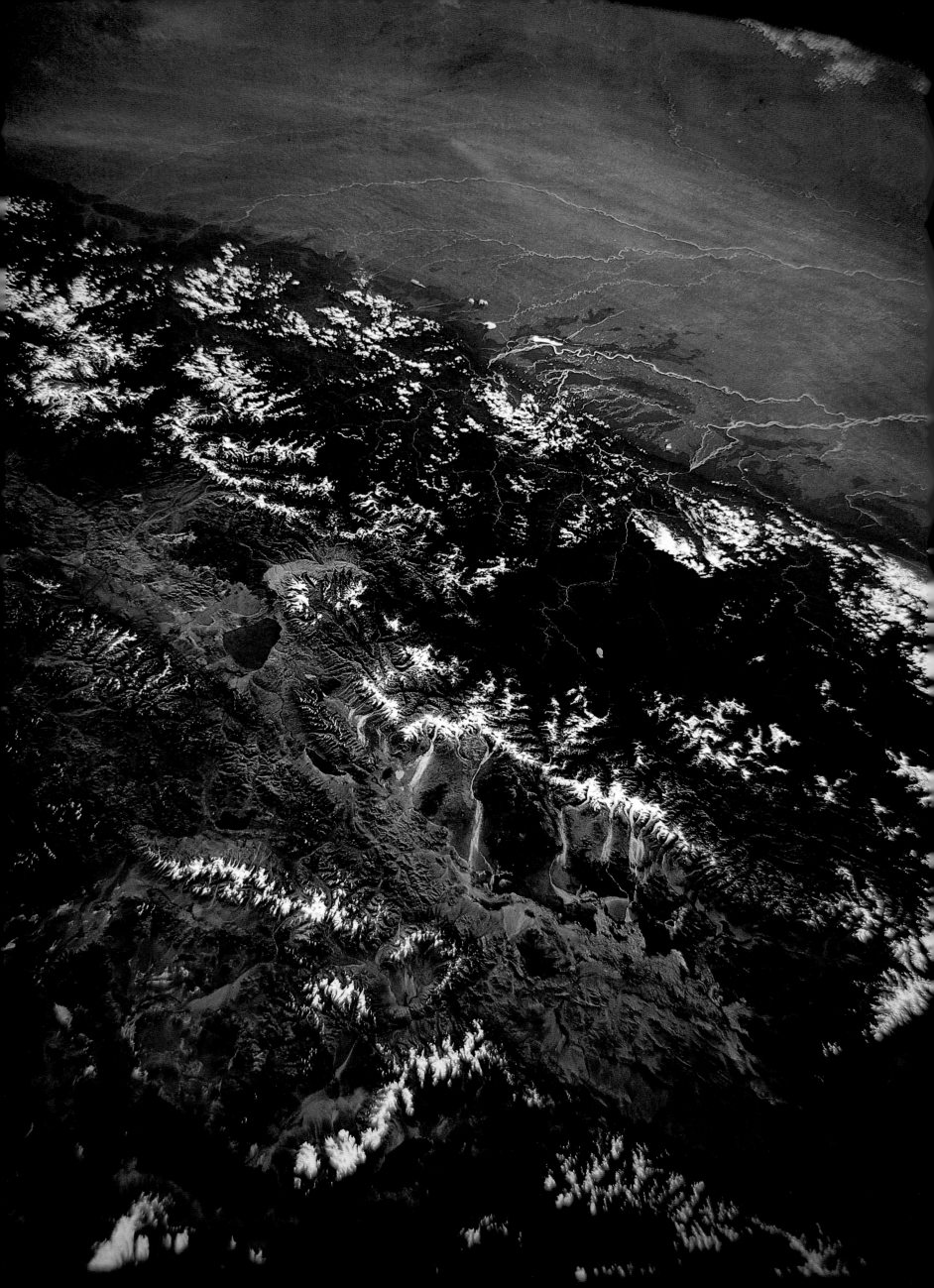

If the doors of perception were cleansed
every thing would appear to man as it is,
infinite.

William Blake, poet

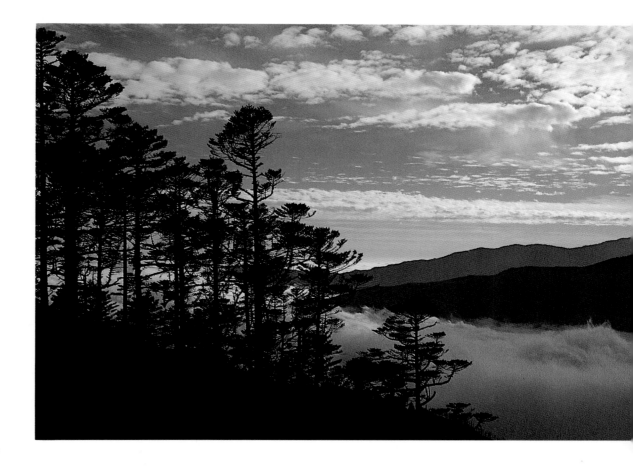

◄ **The Himalayas**. This sweeping view takes in the plateaus of Tibet (bottom), the Himalayas and Nepal, and the great plains of the Ganges River in India (top). The scene is late summer, when minimal snow covers the mountains. The Himalayas, the highest land range on our planet, include Mount Everest, at 29,030 feet. The mountains were created when the area now known as India collided into the landmass of Asia over 40 million years ago. The mountain-building processes caused by plate tectonics and continental drift, which formed the Himalayas and other ranges, such as the Andes, continue to change the Earth today.

▲ The Himalayas, near Dudh Kund, Nepal, at an elevation of 12,000 feet.

Gibson Desert, Australia. Almost two-thirds of Australia is arid or semiarid, with extensive deserts of sand. Wind-driven processes have created this patchwork of color and texture. The predominant features are the linear sand dunes caused by winds. The colors, which are computer enhanced, signify a variety of natural processes. The faint red areas are sparse grasses and shrubs, the main desert vegetation, which stabilizes the dunes. The dark areas are scars from many years of fires that have burnt back the plants. The cycle of fire and plant regrowth is evidenced by the red regions amid the black scars. Areas of bright yellow are exposed shifting sands with little vegetation. The brilliant blue highlights show water collected in shallow depressions.

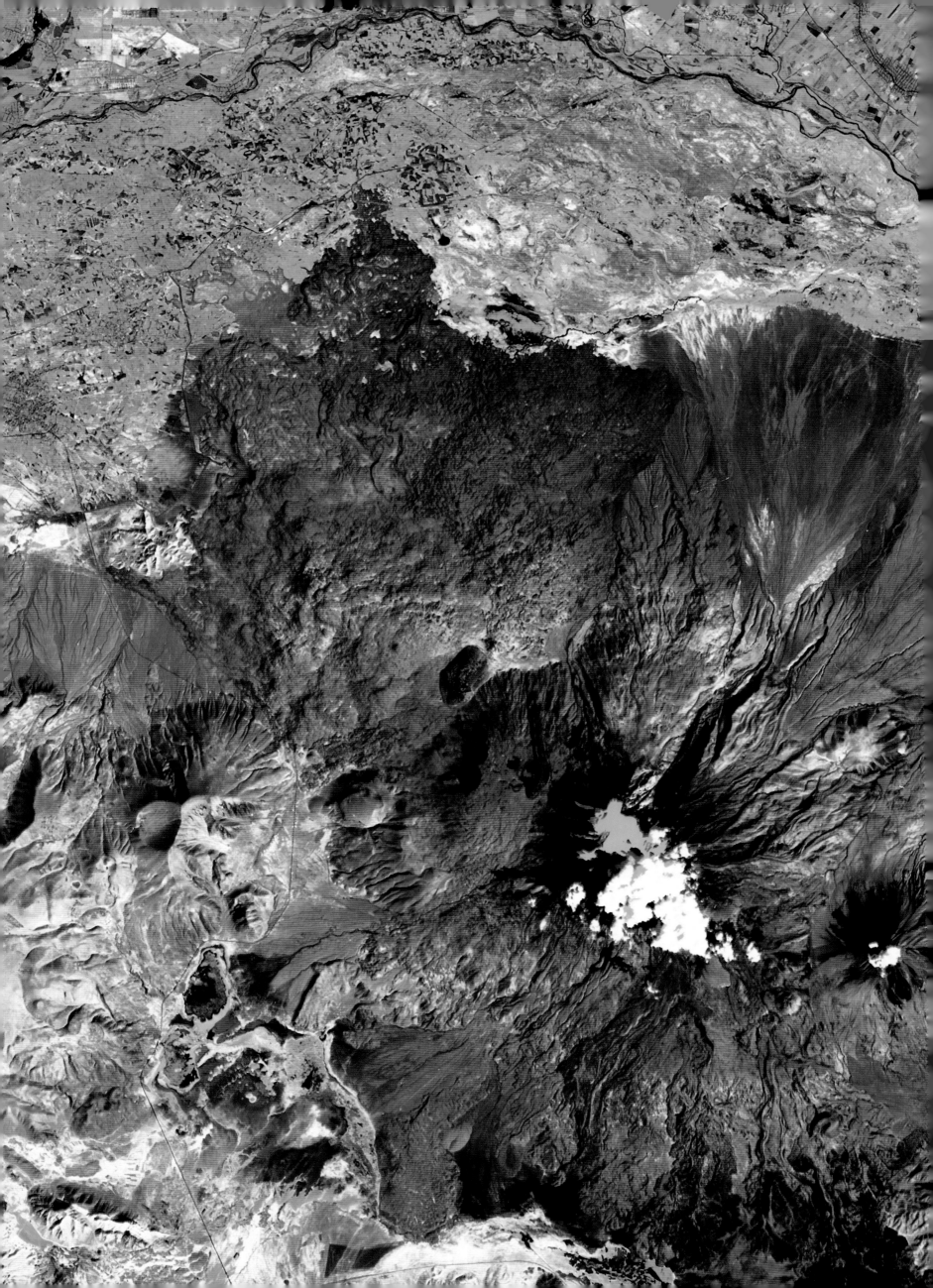

Mount Ararat, Turkey. Most of the active volcanoes in the world today lie along the circumference of the Pacific Ocean. Another area of sporadic activity extends from Armenia through Iran. It is a zone where the Arabian Plate collides with the Eurasian Plate in the ongoing process of continental drift and the continual action of plate tectonics. Earthquakes are common here, often with devastating impact on small villages and poorly built homes, which are not prepared to withstand earth tremors. There is also a history of older volcanic activity going back millions of years.

Mount Ararat is a large, extinct volcanic cone, measuring over 22 miles at its base, located in eastern Turkey near the border with Iran and Soviet Armenia. Shown here are the two major peaks, the larger, cloud-topped Great Ararat (16,945 feet) at the center towering above Little Ararat (12,077 feet) to its right. The sensor used to make these images can distinguish between the white clouds above Great Ararat and the ice cap (in blue) to the left of the peak, even though both are normally seen as white. The lava and ash deposits are warm brown. The bright red regions are fire scars from burnt brush and vegetation. Lava channels and gutters are apparent along the slopes of both volcanoes. The Razdan River and its fertile plain with numerous agricultural plots can be seen at the top of the image.

Mountain ranges, volcanoes appeared in salt-and-flour relief. It was easy to imagine the dynamic upheavals that created jutting mountain ranges and smoking craters.... I became an instant believer in plate tectonics.... The view from overhead makes theory come alive.

Sally Ride, astronaut

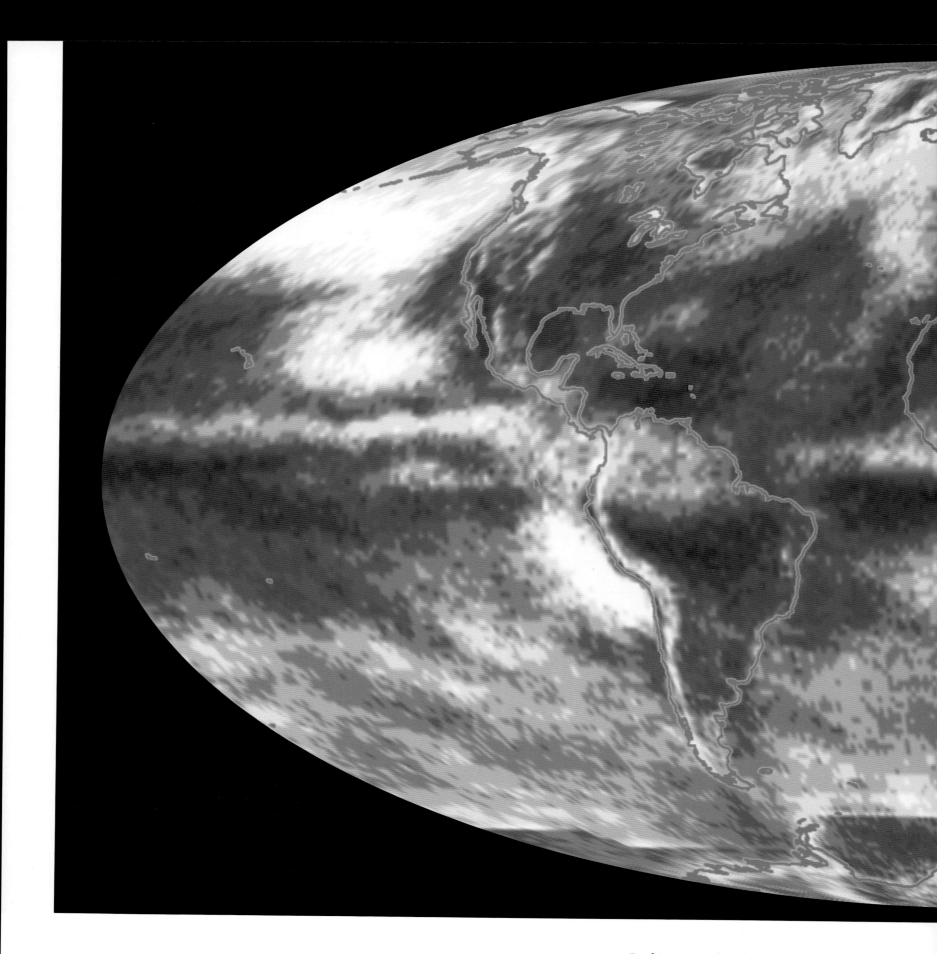

AIR

Looking upward to the sky has always
presented us with an ever-changing spectacle
of beauty and often of immense power.
Clouds move endlessly, storms roll in with
ominous darkness, and sunsets fill the
horizon with vibrant hues. It is a thin veil
through which we look, for our planet is
surrounded by an invisible ocean of air that
forms the boundary between Earth and outer
space. This shell of gases and particles rises
some 300 miles, becoming thinner and lighter
as it ascends. It is more than a boundary,
for it protects and shelters life from damaging
solar rays, heat, and cold. Countless meteors
are rendered harmless each day as they burn
up before they reach the Earth's surface. The
great weather machine—of heat, water, and
wind, of energies transformed—plays out its
daily drama in this constantly moving veil.

The atmosphere, which science has probed
for four hundred years, has been shown to be
divided into a number of regions. The first 10

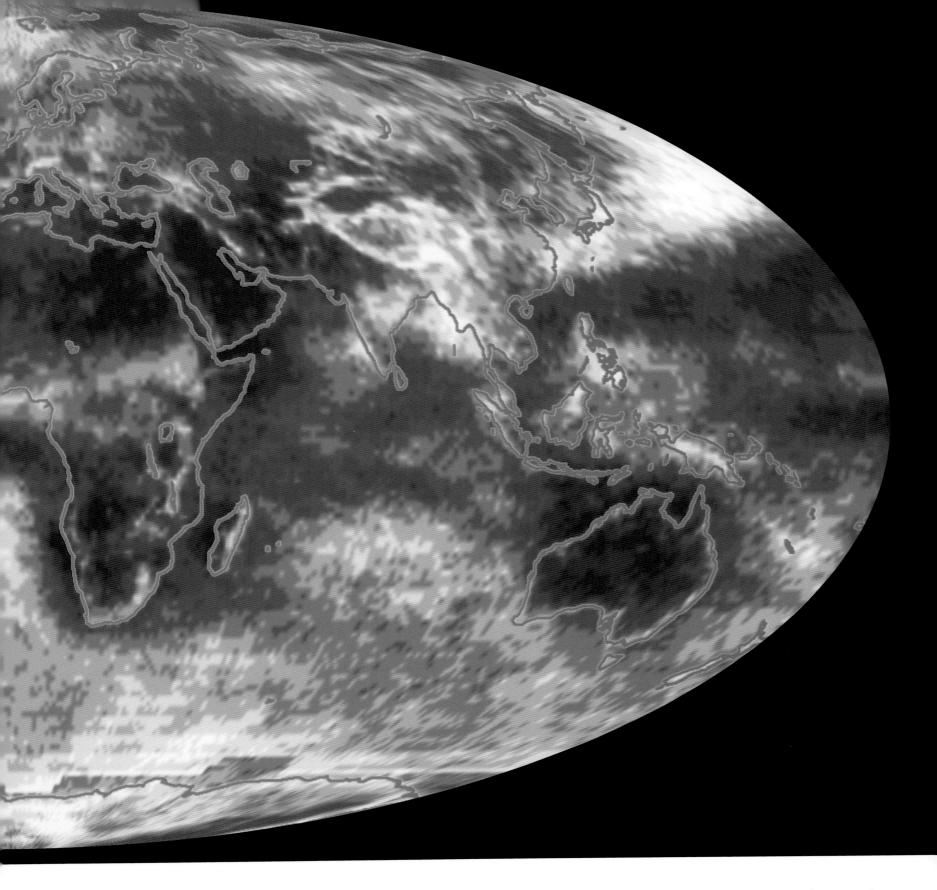

miles is the troposphere, where weather and clouds form. This region is followed by the stratosphere (10–30 miles); the mesosphere (30–50 miles); the ionosphere (50–180 miles), where auroras glow and meteors leave burning trails; the thermosphere (up to 300 miles); and the exosphere (over 300 miles).

The atmosphere is a vast chemical soup of molecules interacting with each other and also is affected by photochemical reactions driven by solar radiation. The gases trapped in the atmosphere make our planet habitable. Oxygen sustains life. Carbon dioxide, a by-product of that same life, regulates the planet's temperature through the greenhouse effect. Ozone helps protect life from damaging ultraviolet radiation.

Satellites continuously supply data and images that expand our knowledge of the atmosphere. Clouds and winds, the harbingers of changing weather, are monitored daily and appear nightly on television. Hurricanes are tracked with concern and interest. Winds are shown to etch vast regions with dunes or to blow dust off Africa that ends up in South America. The ozone hole over Antarctica is monitored annually, and these images have motivated international treaties governing the production of chemicals that destroy ozone. In the fall of 1991, NASA launched the Upper Atmosphere Research Satellite (UARS), the first spacecraft dedicated to conducting a systematic, comprehensive study of the stratosphere. UARS will also provide data on the mesosphere and thermosphere—regions of the upper atmosphere that are especially susceptible to changes caused by human activities.

The satellite image above depicts mean (or average) global cloud cover for June 1988. A combination of different sensors was used to determine the opacity and height of clouds. Cloud cover ranges from the lowest levels, in dark blue, to the higher levels, in pale blue to white. The image also shows the essential features of global cloud dynamics. A white band extends across the tropics from Africa to South America to the Pacific Ocean. Known as the Intertropical Convergence Zone, it is a region of high concentrations of large clouds that is nearly continuous around the equator. The zone of high cloud levels that covers India and the Bay of Bengal is associated with Indian monsoons.

Exploration of space has revealed the atmosphere to appear as a blue-violet glow surrounding the Earth. Only recently have we been conscious of the fragility of this delicate, life-giving membrane. Now that we see its aura from space, and understand the impacts of potential global climate change, air pollution, and ozone depletion, we realize that our atmosphere can no longer be taken for granted.

There is inward beauty only when you feel real love for people and for all the things of the earth; and with that love there comes a tremendous sense of consideration, watchfulness, patience.

Krishnamurti, philosopher

Atmospheric Veil. The atmosphere is a veil of gases and particles that forms the boundary between the Earth and outer space. It shelters us from the intense heat and cold of space, damaging forms of solar radiation, and billions of small meteors that bombard the Earth daily. Comprising a series of layers, the atmosphere is about 300 miles thick, and the life-protecting stratosphere extends to only 30 miles above the surface of the Earth.

In this Space Shuttle image, the sun illuminates the Earth's atmosphere as a red-, violet-, and blue-tinted band. This band is actually made up of many layers. The red-to-orange region is the troposphere; the blue region is the upper atmosphere, which consists of three regions: stratosphere, mesosphere, and thermosphere. Clouds are seen in silhouette.

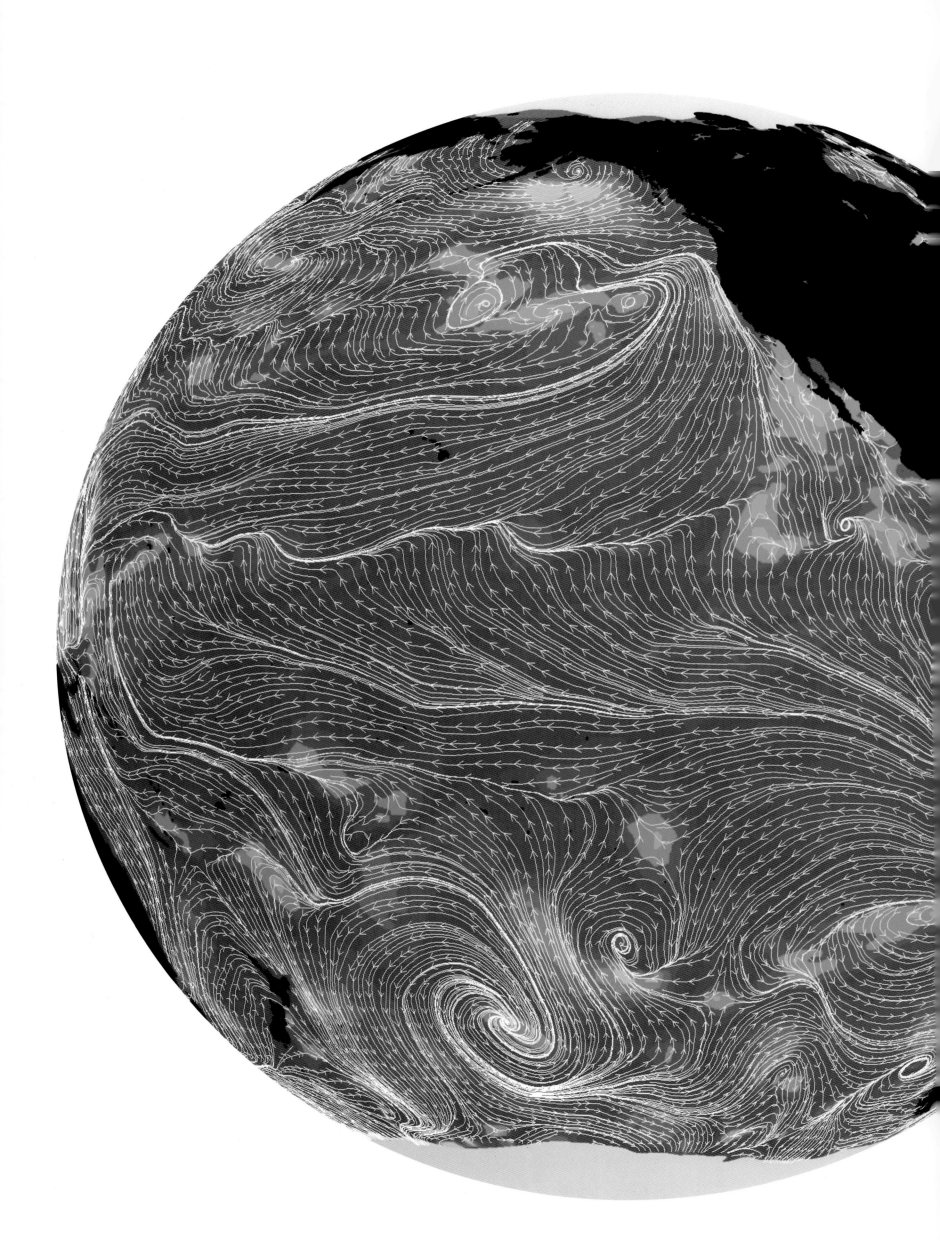

◄ **Winds over the Pacific.** The wind is a principal engine driving ocean waves and currents. It is one of the main forces that move water over our planet's surface and influence the exchange of heat between the atmosphere and the oceans. Wind also helps redistribute solar heat from the tropics into the cooler polar regions. The dynamics of wind is crucial to the Earth's weather and climate.

Satellites can observe global wind patterns on the ocean surface that are impossible to measure at sea by ships and buoys. This image is based on more than 150,000 satellite measurements made during a single day. A radar beam measures the roughness of the sea surface, which is caused by wind action. Computer programs turn this information into wind speed and direction, shown here. The silhouettes of North and South America are added for reference. Wind speed increases from blue-purple to yellow-orange, with the strongest winds being at 20 miles per hour. White lines with arrows show the direction of wind flow.

Winds swirl in a counterclockwise direction in the Northern Hemisphere and clockwise in the Southern Hemisphere. Small storms appear in the Gulf of Alaska, and two giant storms are shown in the bottom center of the image, between New Zealand and Chile.

▼ This black-and-white image shows the same scene in a satellite photo. It is similar to the daily weather pictures we see on the television news. The main storms and cloud patterns are visible but without any indication of their strength or direction.

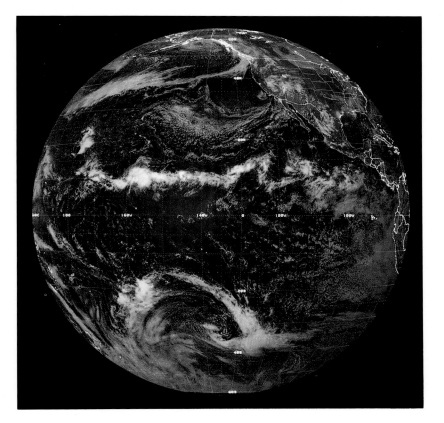

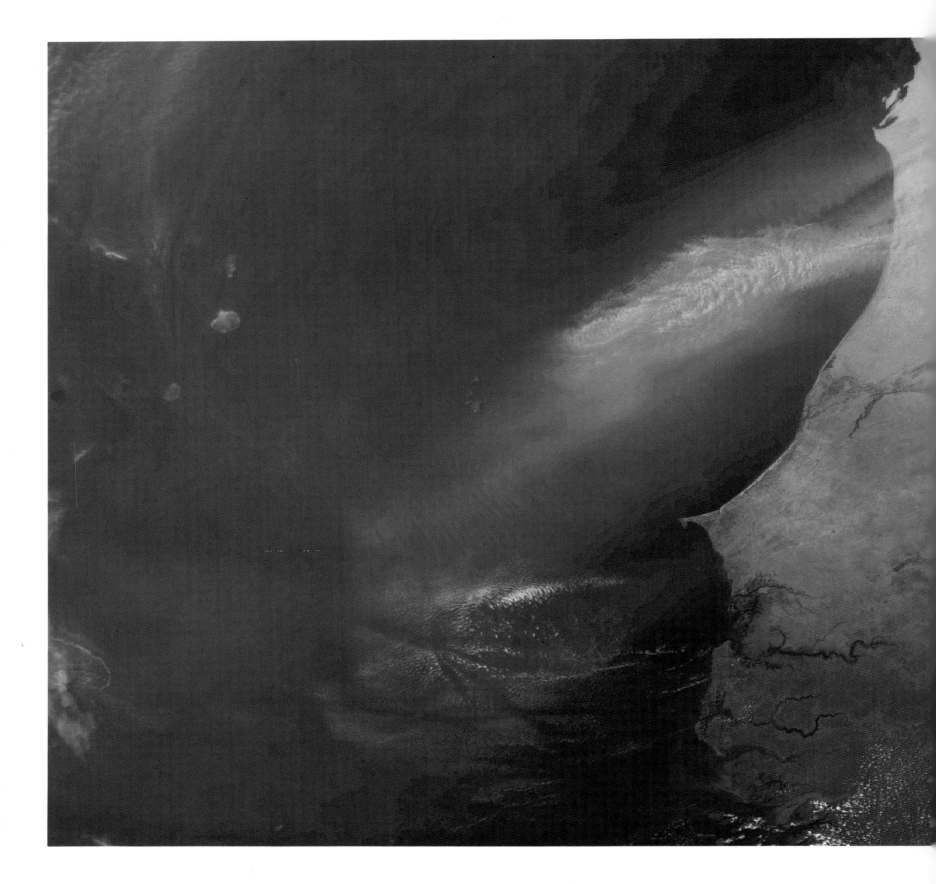

One-fifth of the Earth's Land, with 80 Million People, Is Threatened by Desertification.

Desertification, Western Africa. In many semiarid regions of the tropics, the loss of vegetation through either natural or human forces has caused a loss of topsoil. Overgrazing, particularly by livestock, results in the degradation of plants that otherwise would help hold water and soil during rainstorms. In the absence of plant life, floods wash away valuable topsoil, and what is left is often picked up by the wind, leaving only sand behind. This insidious process that destroys

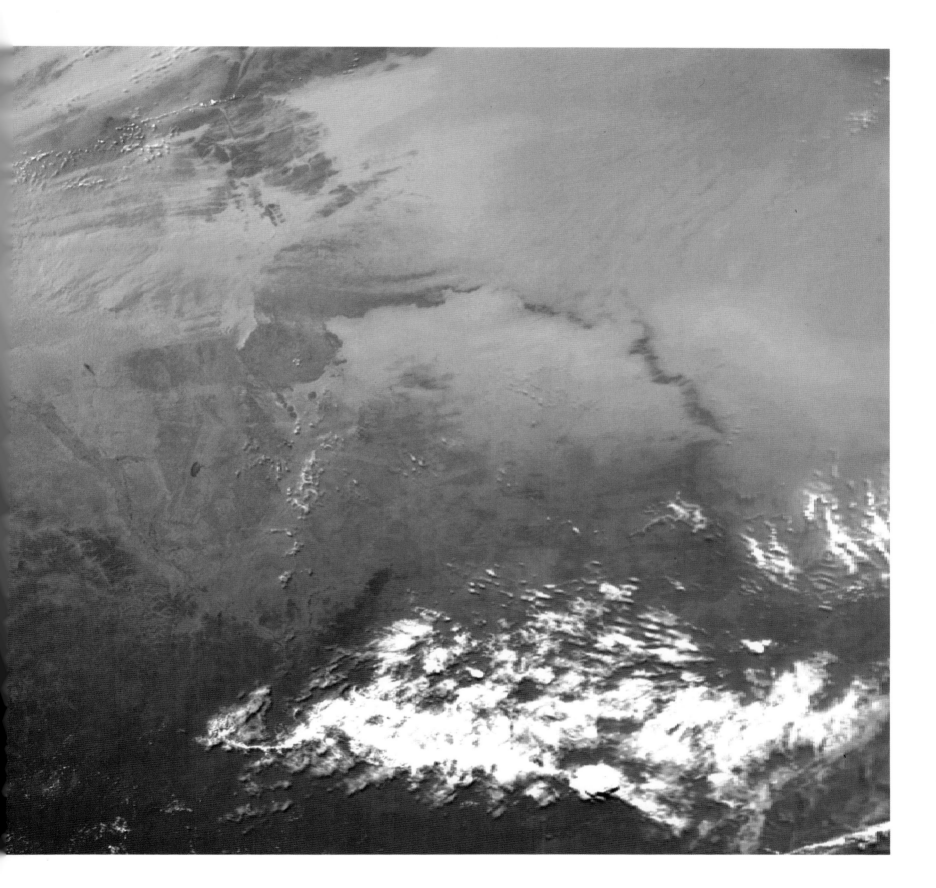

the fertility of the soil is known as desertification. It is an environmental disaster that has occurred chiefly in the dry areas of the tropics and most recently has contributed to the famine in the Sahel, the southern area of the Sahara Desert that extends from Senegal on the Atlantic Ocean inland to Chad.

In this large satellite image of the west coast of Africa, Senegal is in the center, with the capital of Dakar located on the long pointed promontory jutting into the Atlantic

Ocean. To the south of the promontory is Gambia, which is surrounded by Senegal. To the north of Senegal is Mauritania. Part of Guinea-Bissau is visible to the south. Vegetation is red; desert regions, beige. The most striking feature is the dust storm blowing off the coast of Mauritania and passing over the capital, Nouakchott. Dust from such storms can be carried by winds across the entire Atlantic to as far away as Brazil.

Tropical Storms. These powerful engines of energy are born at sea and can cause great destruction when they reach land. Their winds can blow with a fury of up to 250 miles per hour, enough to drive straw through steel. Tropical storms form in the latitudes between 20° north and 20° south of the equator and are known by many names around the world: hurricanes in the Atlantic Ocean and eastern Pacific Ocean, typhoons in the western Pacific Ocean, and cyclones in the Indian Ocean. These storms are generated by the interaction of the sun with the ocean and the atmosphere. As the sun warms the ocean, evaporation transfers heat from the water to the atmosphere. The warm ocean serves not only as a source of heat but also as an unlimited source of water that fuels these tempests. The rotation of the Earth sets the winds spiraling around a calm center with a counterclockwise direction in the Northern Hemisphere and a clockwise direction in the Southern Hemisphere.

► **Hurricane Elena, Gulf of Mexico.** This large photograph shows Hurricane Elena on September 1, 1985. The storm is many hundreds of miles across, with a calm eye in the center.

▼ **Hurricane Gilbert, Gulf of Mexico.** These two weather satellite images were made on September 14 and 15, 1988. Over the two days, Hurricane Gilbert moved rapidly west through the Gulf of Mexico. The hurricane, which is over 1,000 miles across, occupies the entire gulf.

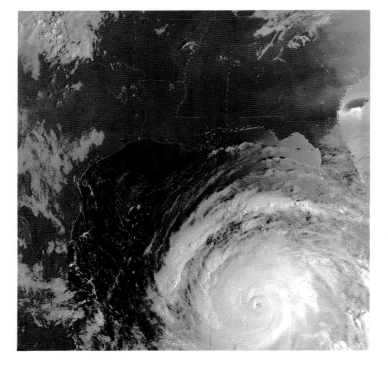

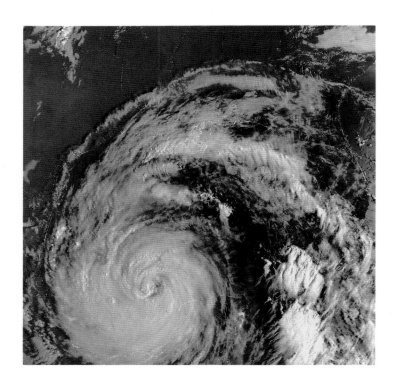

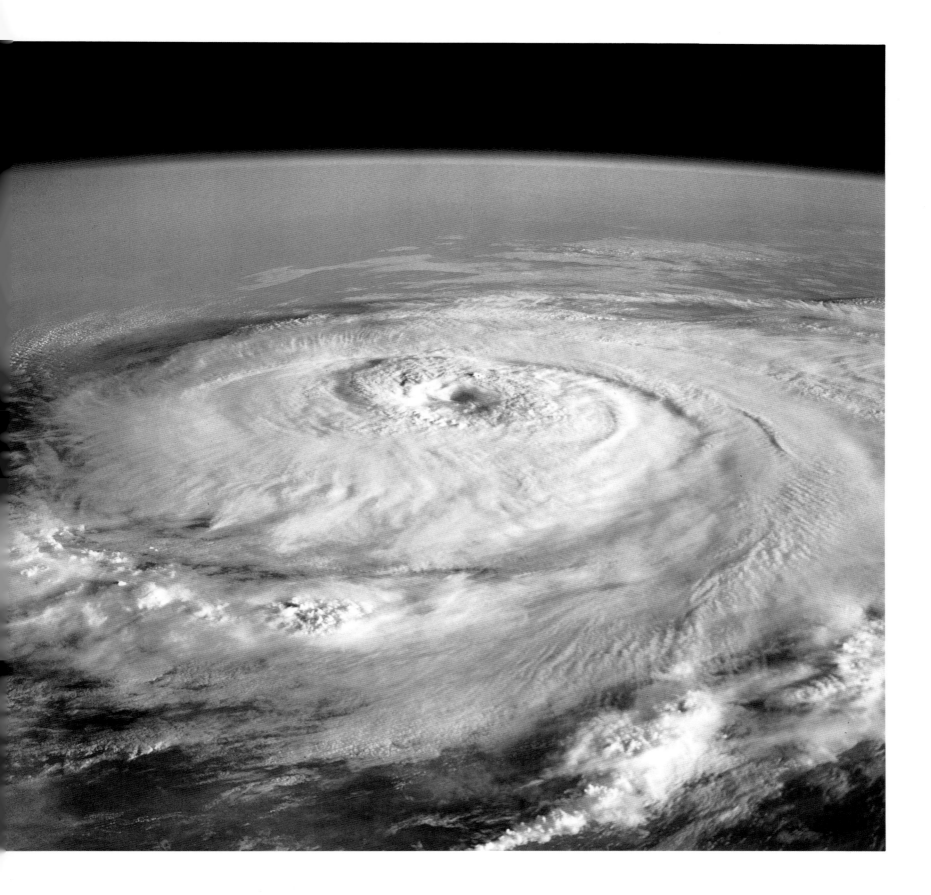

It is the wind that comes out of our mouths now that gives us life. When this ceases to blow, we die. In the skin of our fingers we can see the trail of the wind; it shows us where the wind blew when our ancestors were created.

Navaho legend

► **Sahara Desert Winds, Tibesti Mountains.** The power of the wind not only picks up and disperses soil into the air, but also slowly gouges the land, leaving distinct erosional features. This Space Shuttle image of the Sahara Desert along the borders of Chad and Libya in north-central Africa shows the two aspects of air: how it marks the land and how it absorbs other gases and particulate matter. The long, linear features result from the force of winds sweeping down the Tibesti Mountains. Parallel bands of long trails of sand and darker volcanic material are also seen. The circular feature in the center is the remnant of an ancient volcano that has been totally eroded. Smoke from fires appears in the lower left. The remaining trees and shrubs of the Sahara continue to be cleared for fuelwood and charcoal production, further leaving the soil bare and vulnerable to erosion by the desert winds.

►► **Thunderheads, Africa** (following pages). Thunderstorms are part of the cycle of the global heat transport system. Without them, the solar energy absorbed by the Earth would be trapped at the surface, causing a significant global rise in temperature. Thunderstorms efficiently and effectively transfer this heat back to the upper troposphere (the lowest region of the atmosphere) where most weather occurs. The condensation of water vapor into the towering thunderheads releases the heat up to 5 miles into the atmosphere.

Thunderheads, a popular term for the anvil of cumulonimbus clouds, punch up into the stratosphere (above the troposphere) over tropical Africa. The low angle of the sun highlights the shapes of the clouds. At the Earth's surface, the thunderstorm releases heavy winds and rain.

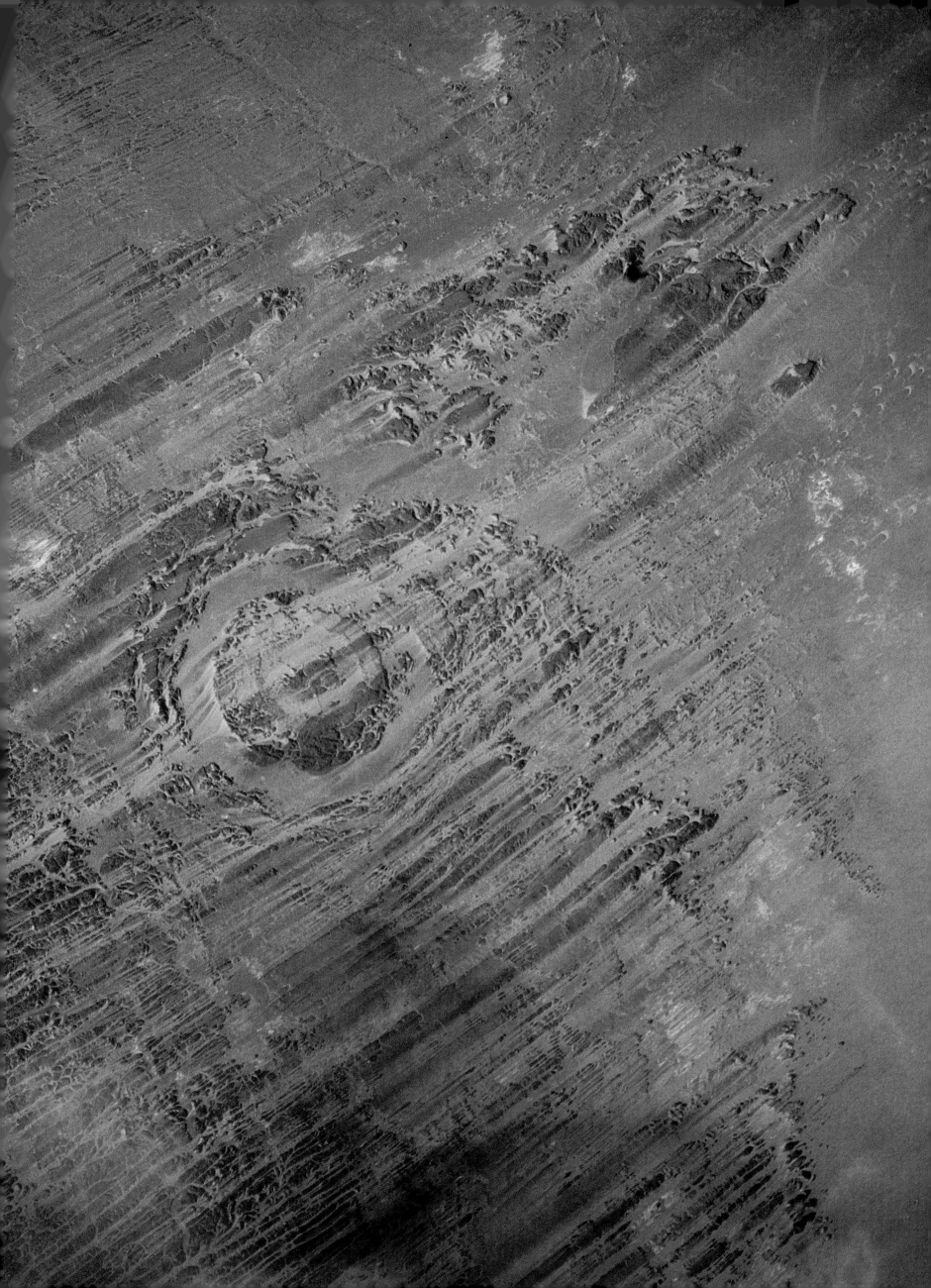

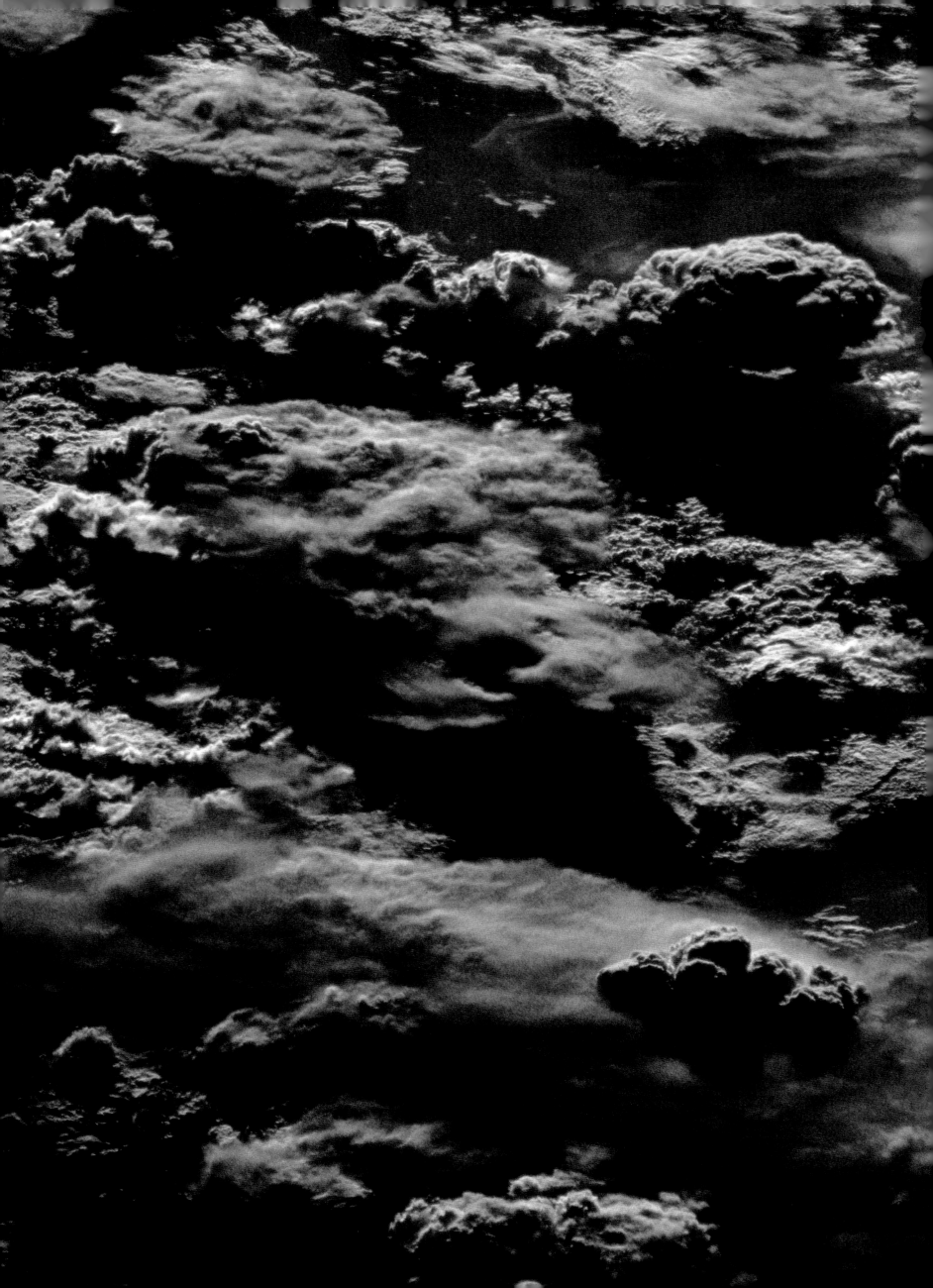

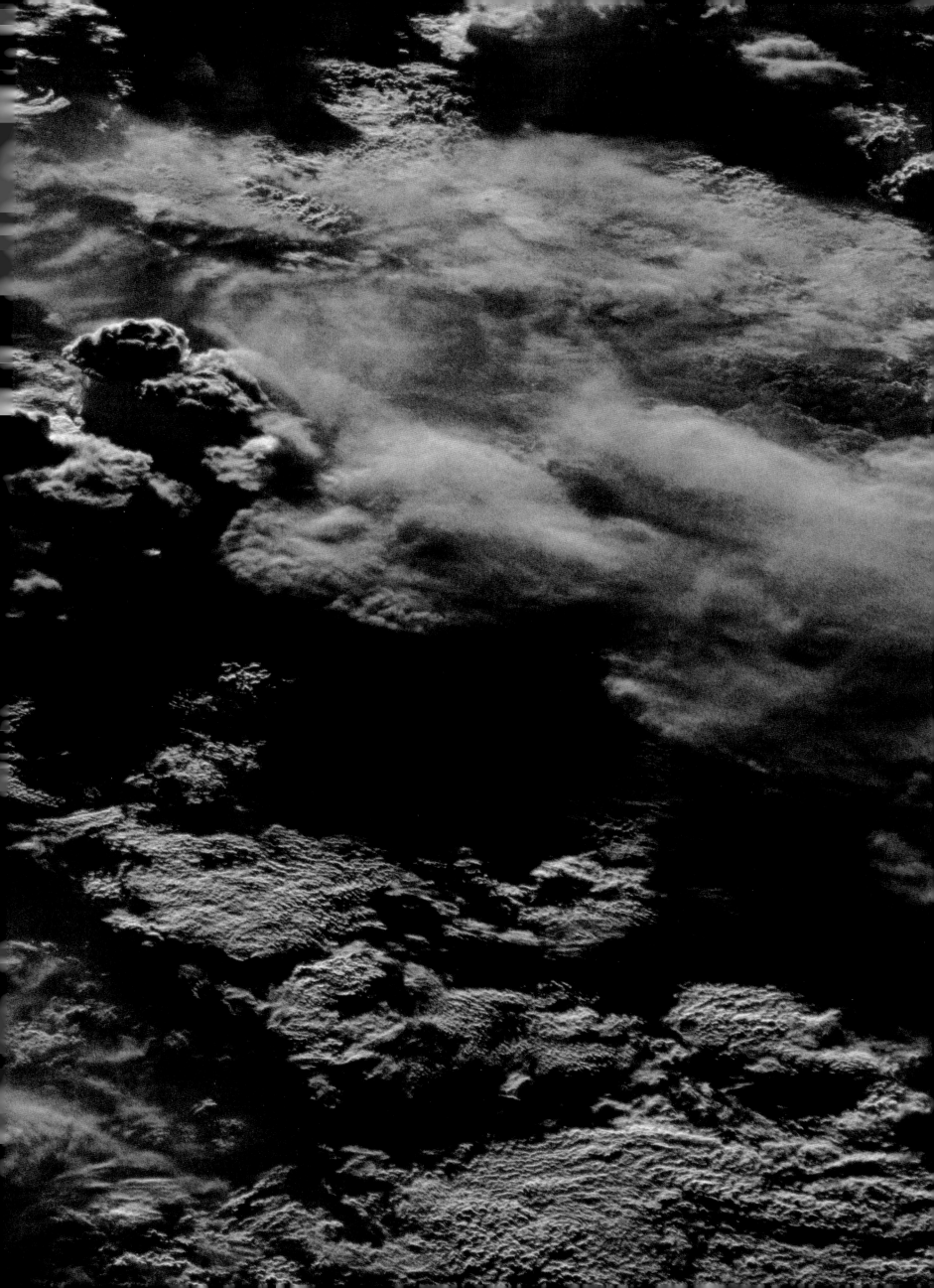

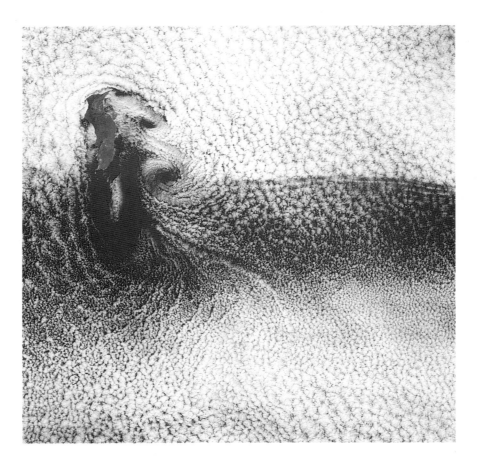

Guadalupe Island Wakes, Mexico. The trade winds propel clouds from east to west across the
Pacific Ocean. The warm air, combined with the hundreds of square miles of warm ocean, results
in the formation of cumulus and stratocumulus clouds. Cloud patterns generally show the
direction of the winds. When the air currents are intercepted by a high landmass, such as an
island, complex airflow patterns are created, and the clouds divide in order to bypass the obstacle.
An island wake or ship wave pattern is formed, similar to the deflection of water around a boat
or of air around an airplane wing.

▲ This wake effect occurs around Guadalupe Island, in the Pacific Ocean, 180 miles to the west
of Baja California, as the even rows of cumulus clouds circumnavigate the island.

► Another view of the Guadalupe Island wake, center right of the image, includes downstream
turbulence developing into cloud vortices. Punta Eugenia on the west coast of Baja California appears
at the top of the image. Isla Cedros, located offshore, also manifests the island wake effect.

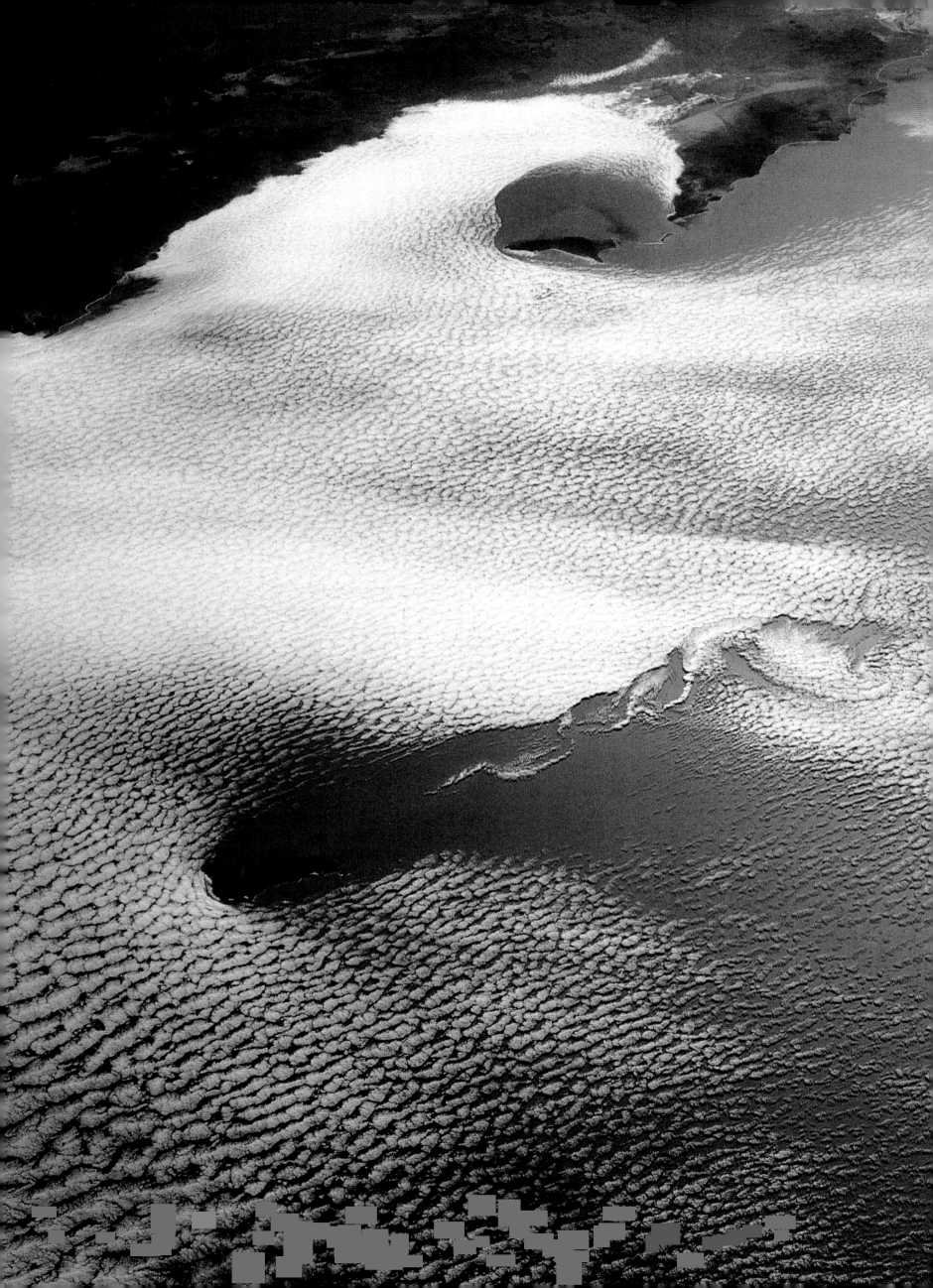

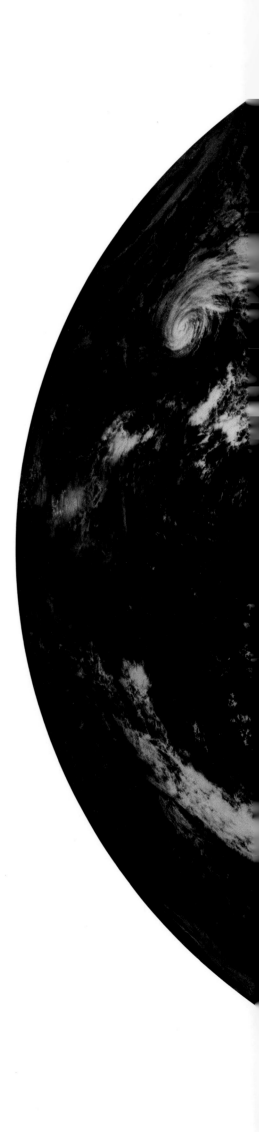

Weather and Clouds. Satellite weather pictures are part of our daily television diet. The movements of storms and clouds are tracked hour by hour and can be used to forecast general weather conditions at least a few days in advance. Weather satellites orbit the Earth at over 22,000 miles. Synchronized with the planet's daily orbit, they are always above the same point on the surface. The cloud patterns that are revealed, combined with balloon and meteorological ground measurements, help us to interpret the weather. Even though 160 nations share data, predicting the weather for more than a fortnight can be difficult. The complexity of the Earth's atmosphere, with many forces interacting and creating chaotic events, is still beyond the predictive calculations of the best supercomputers.

▶ The full image of the Earth shows the partially cloud-covered North American continent at the top. South America is clearly seen in the lower right. The Pacific Ocean dominates most of the image, with major storms in the North and South Pacific. The storm to the west of Baja California contains a hurricane moving in a counterclockwise direction. A large storm is in the center of the South Pacific to the west of South America.

▼ This image, taken during one of the Apollo moon missions, shows the Earth from an altitude of 23,000 miles. The African continent and part of the Arabian Peninsula are clearly visible. Storms and associated clouds swirl above the Earth's surface.

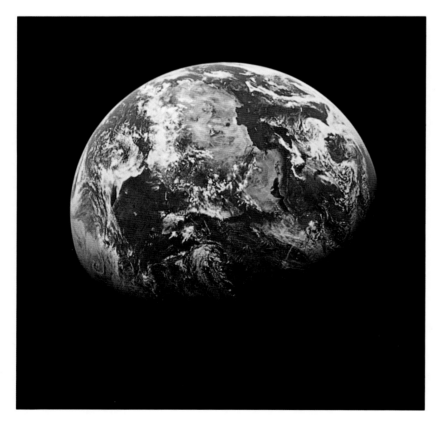

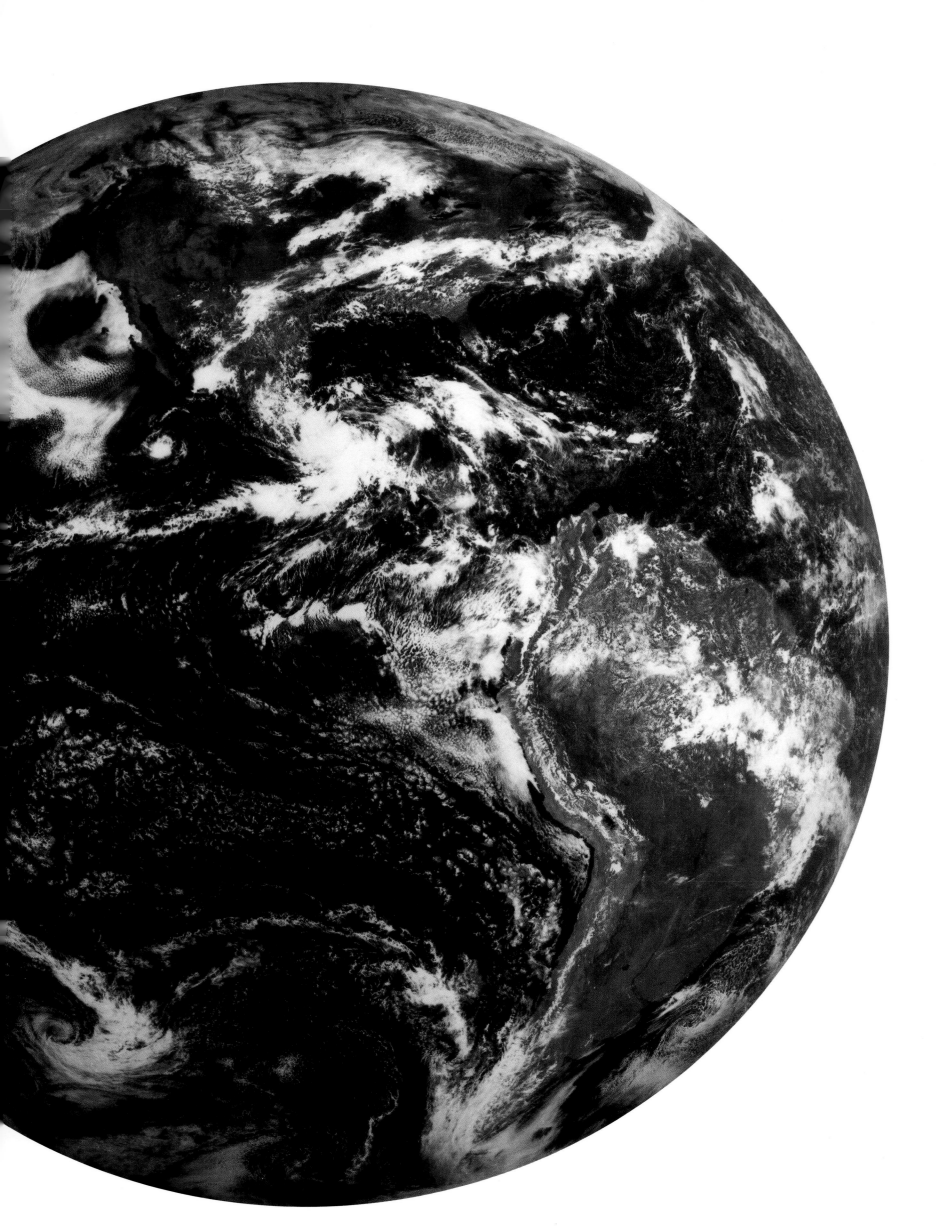

Mount Pinatubo, Philippines. Mount Pinatubo was dormant for over six hundred years, but when it began spewing smoke, gases, and rocks in mid-June of 1991, it produced the most powerful volcanic eruption of the century. For hundreds of years, titanic pressures of magma had built up inside the 4,795-foot-high mountain. When the volcano finally erupted, it blew a deadly mixture of volcanic fragments and gases that roared down the mountain at speeds of up to 100 miles per hour. Hundreds of thousands of inhabitants fled the area. Although approximately three hundred individuals died, the toll could have been much worse. Fortunately, geologists had been monitoring the volcano and were able to warn most residents prior to the main eruption. The various satellites that observed the eruption provided scientists with the opportunity to study its impact on climate.

▼ This image shows the main island of Luzon on July 5, 1991, a few weeks after the main eruption, with Mount Pinatubo still smoking. The smoke clouds, measured by radar, reached 15 miles high. The South China Sea is on the left; the Philippine Sea is on the right.

► This series of images shows the eruption over a twelve-week period. The massive amounts of sulfur dioxide released into the atmosphere combined with water droplets to form sulfuric acid, which may linger in the stratosphere for up to three years. Note the dramatic progression of the sulfuric acid aerosol as it completely encircled the Earth north and south of the equator. These droplets act as a shield that reflects the rays of the sun back into space, causing a slight global cooling, predicted to last for several years. This cooling may temporarily counteract the greenhouse warming of the past decades but could complicate research into global climate change. Another impact of the stratospheric volcanic cloud may be a dramatic, though temporary, depletion of ozone resulting from additional chemical reactions.

BLASTING 15 TO 20 MILLION TONS OF SULFUR DIOXIDE INTO THE STRATOSPHERE,
MOUNT PINATUBO WAS THE LARGEST VOLCANIC ERUPTION OF THE CENTURY.

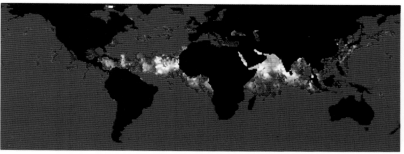
Week 1

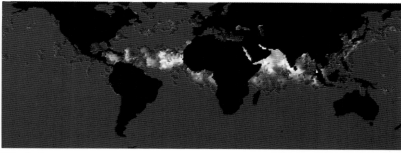
Week 4

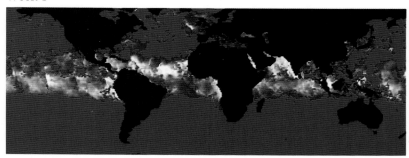
Week 6

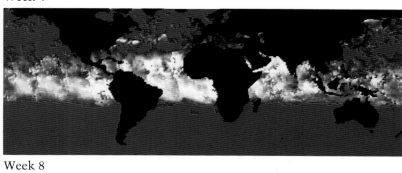
Week 8

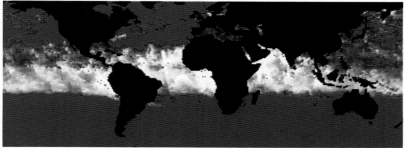
Week 10

Week 12

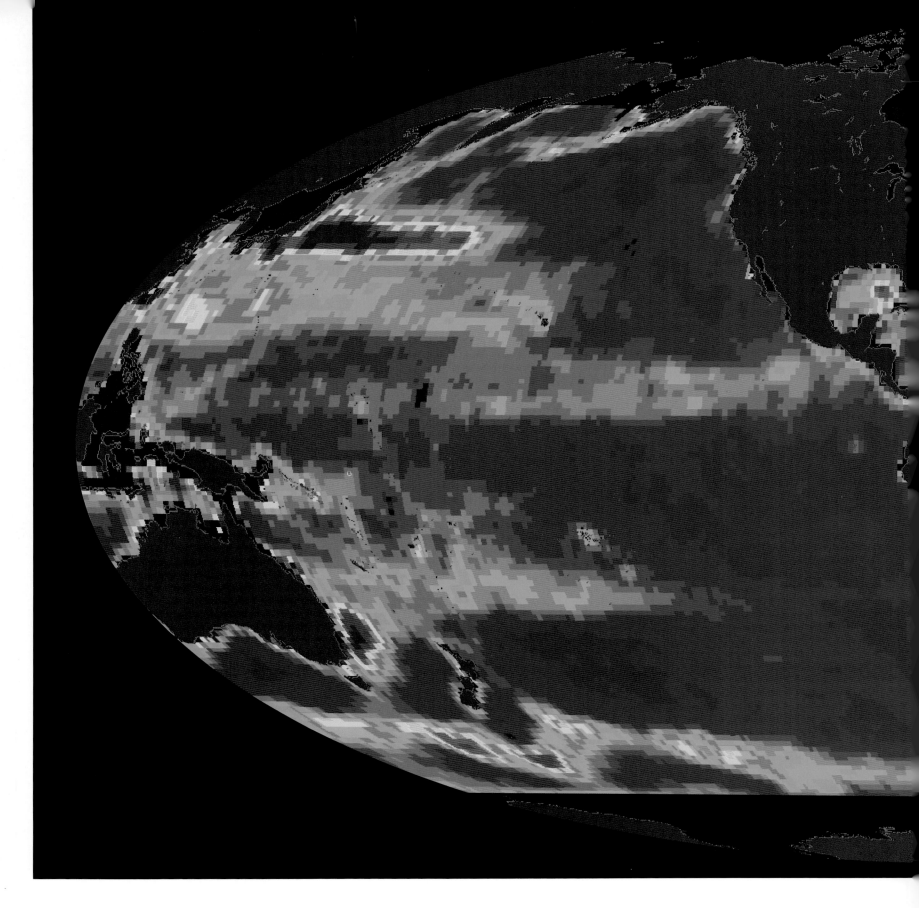

WATER

Our planet really should be called "Water" rather than "Earth," since water covers over 70 percent of its surface. As a liquid in the ocean, a solid in snow and ice, and a gas in water vapor, water plays the essential role in the global climate machine.

Water is the matrix of life on our planet. It is the only substance that naturally exists as a liquid, a solid, and a gas. Water evaporates from the oceans into the air, falls from the clouds as rain or snow, and flows from streams and rivers to return again to the sea, constantly replenishing and recycling itself. Where there is water there is usually life.

The largest water component is the ocean. Without oceans our planet would be unbearably hot or cold. Ocean currents help to modulate global temperatures by redistributing heat from the tropics to the poles. Oceans are also like a great thermostat that holds more

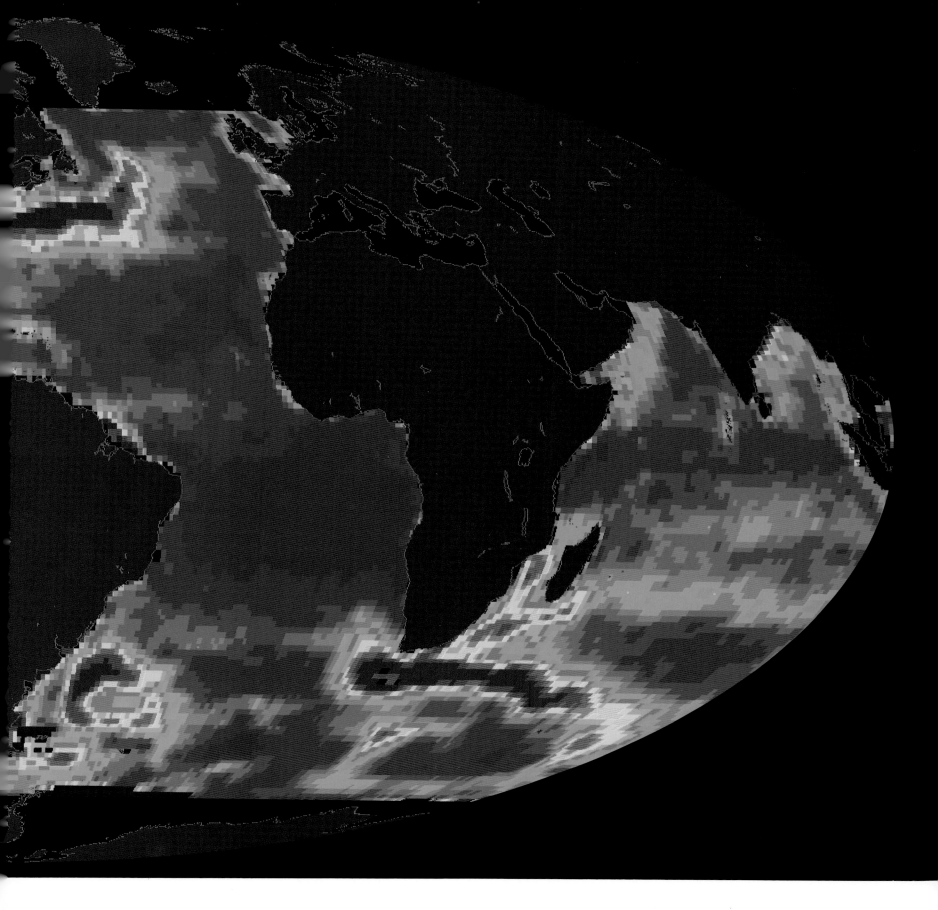

heat than the atmosphere and gives it up slowly, thus moderating temperatures.

Water vapor is the most changing constituent of the atmosphere and is a main contributor to the greenhouse effect that warms our planet. As a solid in the form of snow and ice, water further influences the heat distribution on Earth.

Traditionally the oceans have been studied by ship surveys. But this is a very costly and time-consuming effort and can never give a complete picture of the entire ocean at one time. Satellite imagery and a wide variety of ocean sensors offer the unique opportunity to study the water of our planet both globally and locally. Some sensors have gathered more data in three months than oceanographic sampling did in one hundred years. When combined with data collected by ships, buoys, and current

meters, satellite imagery gives us a more accurate view of the global oceans.

The global ocean currents shown above were recorded by an altimeter using a radar beam that measures the distance between the spacecraft and the sea surface with a precision of two inches. This image of the differences in the height of the sea surface is a composite of millions of repeated measurements taken over a three-month period. The topography of the ocean surface is directly related to the fluctuation of its currents. The most active, rapid-moving currents show the most variability; slower currents show less change. The major strong currents, known as Western Boundary Currents, are seen in red and orange. These currents include the Gulf Stream in the North Atlantic, the Kuroshio of Japan, the Agulhas Current of South Africa, and the Brazil Falkland off South America.

The red patches around Antarctica are part of the West Wind Drift. The satellite sensors revealed the relatively calm nature of the ocean currents (seen as blue) over most of the ocean surface.

Water is everywhere, in crashing waves, drenching storms, and rivers eroding the land. Moist soil allows plants to grow, and large reservoirs and small wells quench our thirst. By understanding water and its flow, we expand our penetration of the mystery of this almost magical substance on which many people desperately depend, and which others often take for granted.

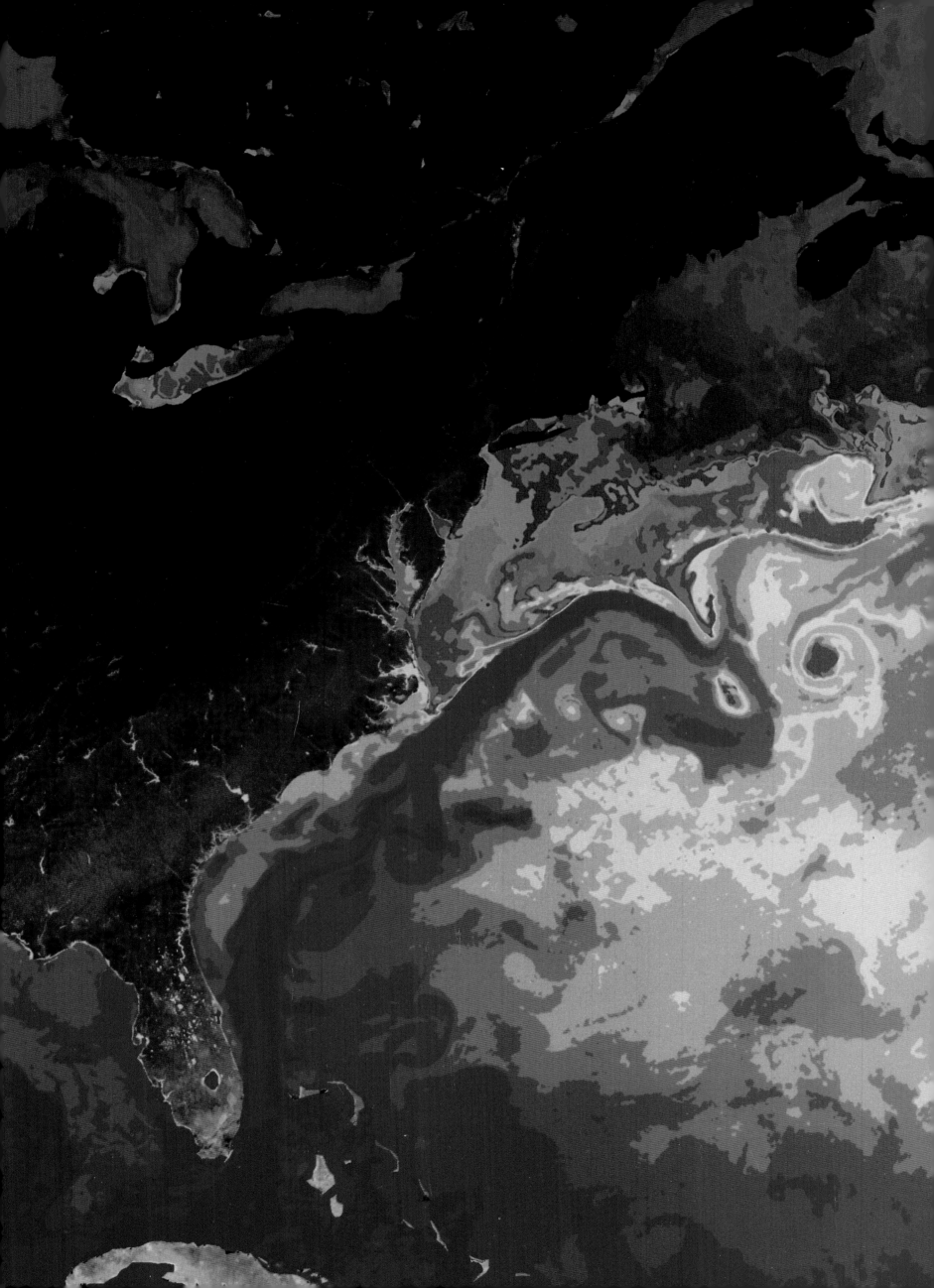

Gulf Stream, North Atlantic Ocean. The atmosphere and the ocean work together as one of our planet's great thermal engines, transporting heat from the equator toward the poles. Without this mechanism, the tropics would be too hot to support life and the polar regions far colder than they are now. The Gulf Stream, off the east coast of North America, plays a key role in moving warm tropical water toward the polar regions. The existence of the Gulf Stream has been known for a long time. Benjamin Franklin published the first chart of the Gulf Stream in 1786, based on ship data. Only recently, however, have satellite sensors revealed the complexity of this powerful and constantly changing current.

This satellite image, covering 4.4 million square miles, shows the different temperatures of the sea surface in the early summer for the western North Atlantic Ocean. Computer colors have been added to distinguish the temperatures. Reds and oranges are the warmest waters (76°–84° F); yellows and greens, intermediate (63°–74° F); blues, cooler (50°–61° F); and purples, the coldest (36°–48° F). The Gulf Stream appears as a red, warm river moving northward from the tip of Florida to Cape Hatteras in North Carolina. Cooler water (green and blue) travels southward from Labrador. The current then travels offshore and begins to meander through some of the cooler water. As the warmer water flows northeast, it releases its heat to the atmosphere. When the Gulf Stream reaches the middle of the North Atlantic, it can no longer be distinguished from the surrounding waters.

There is no drop of water in the ocean, not even in the deepest parts of the abyss, that does not know and respond to the mysterious forces that create the tide.

Rachel L. Carson, environmental scientist

Strait of Gibraltar. Ancient Mediterranean civilizations viewed the Strait of Gibraltar as an alluring gateway to mysterious realms to the west. Today we know that the strait is part of a complex and dynamic process of water movement between the Mediterranean Sea and the Atlantic Ocean. Surface water flows through the strait from the Atlantic, evaporates in the warmer Mediterranean, and becomes denser with the increase in salinity. This heavier water sinks and then returns to the Atlantic beneath the surface inflow, eventually spreading across the North Atlantic Ocean.

▼ The patterns on the ocean surface, as seen from the Space Shuttle, mirror subsurface events. The patterns are defined by variations in the reflections of sunlight off the sea surface. The Atlantic is at the lower left, Europe (Spain) at the top left, and Africa (Morocco and Algeria) at the bottom. The movement of water from the Atlantic into the Mediterranean is indicated by the turbulence at the western opening of the Strait of Gibraltar. The narrowness of the eastern side of the strait constricts the incoming Atlantic water. As a result, the water moves more rapidly, creating internal waves where it meets the deeper water flowing in the opposite direction, from the Mediterranean. These internal waves show up as the crosshatched pattern.

► This is an overview of the Mediterranean looking east. The Atlantic is at the bottom, with the narrow Strait of Gibraltar above it. Scientists still debate how water broke through the strait into the Mediterranean basin over 5 million years ago. They speculate that it took less than a hundred years for the Mediterranean to fill with water from the Atlantic.

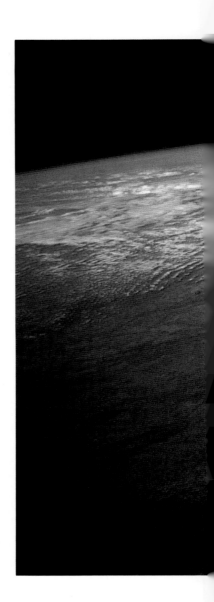

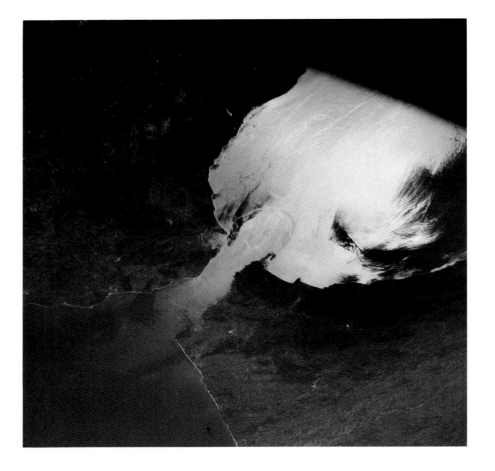

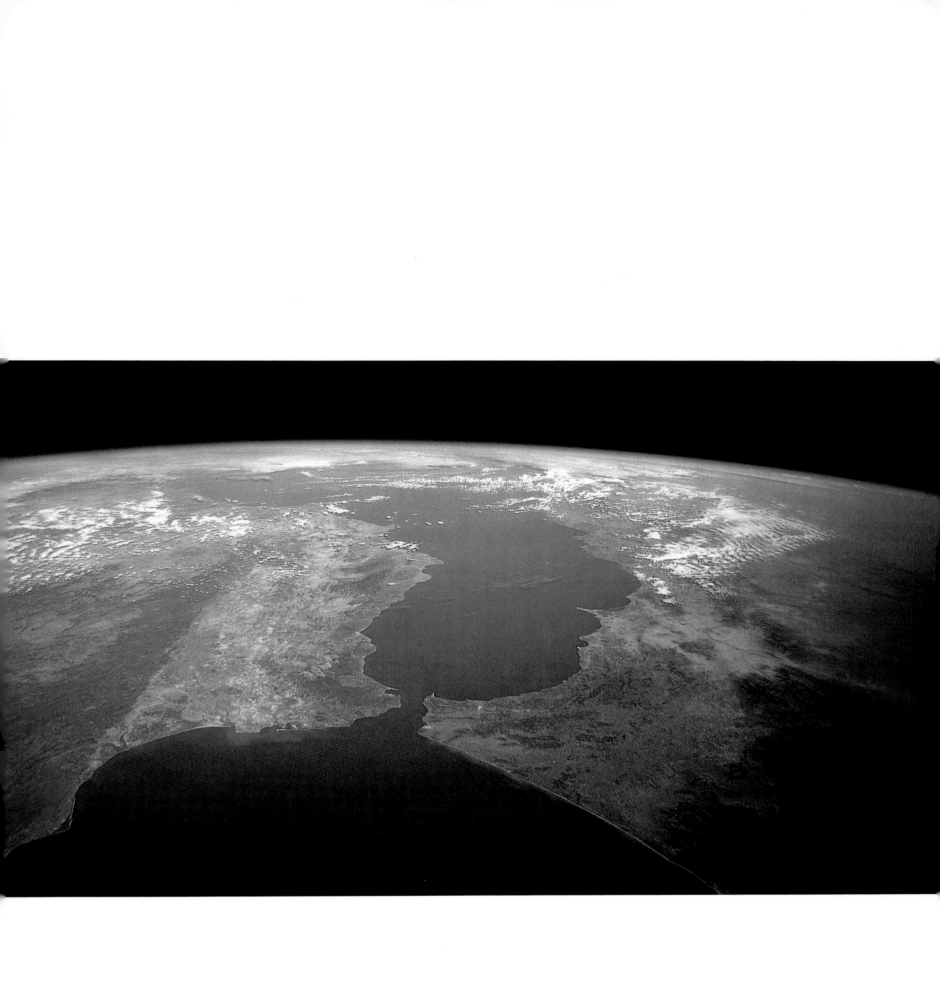

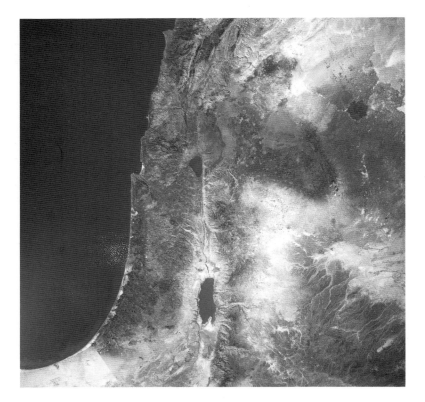 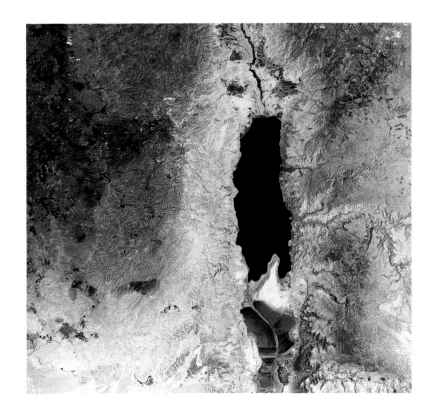

Dead Sea, Israel, and Jordan. The process of continental drift not only forms mountain ranges when the Earth's plates collide, but also creates other important geologic features. In certain regions, the spreading of the Earth can result in the formation of new oceans or seas, such as the Gulf of California. The splitting of the Arabian Peninsula from Africa 35 million years ago created the Red Sea. The same forces caused a rift valley, or trench, in the Earth's crust separating what is now Israel and Jordan. The images here are a pictorial sequence zooming in on the Dead Sea.

▲ The image on the top left is an overview of Israel, Jordan, Lebanon, and Syria. Israel bounds the Mediterranean Sea and appears dark green-brown due to the extensive agricultural development in the arid tan desert, clearly defined at the border between Israel and Egypt in the lower left. The Dead Sea is at the bottom, and the Sea of Galilee is at the top. The rift valley between them is seen as a lighter line to the right of the Jordan River, which connects them. The river separates Israel from Jordan and Syria.

The image on the top right shows the Dead Sea with the Jordan River flowing into it from the north. The river descends in elevation as it flows through the rift valley at the top of the image, dropping from 700 feet above sea level to 1,300 feet below sea level when it enters the Dead Sea. The numerous hot springs that surround the Dead Sea reflect the geologic activity in the region. Tel Aviv, Israel, is the dark gray area on the Mediterranean coast partially obscured by clouds. The Dead Sea is shrinking due to evaporation and has the highest salinity of any body of water in the world.

► The detailed image of the southern portion of the Dead Sea shows the evaporation flats (in light blue) that are being used for commercial salt and mineral production.

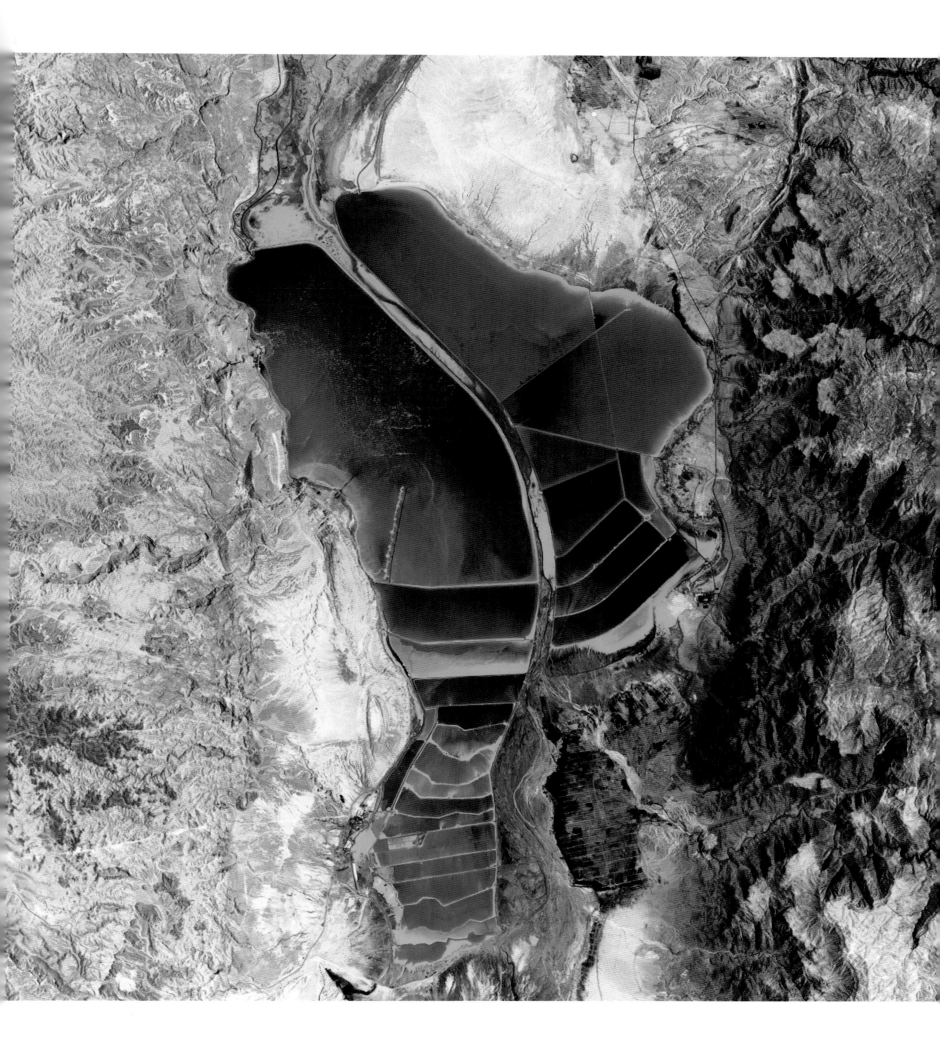

NINETY-SEVEN PERCENT OF EGYPT'S POPULATION LIVE AND WORK ALONG THE
NILE RIVER, WHICH REPRESENTS ONLY 2-1/2 PERCENT OF THE LAND.

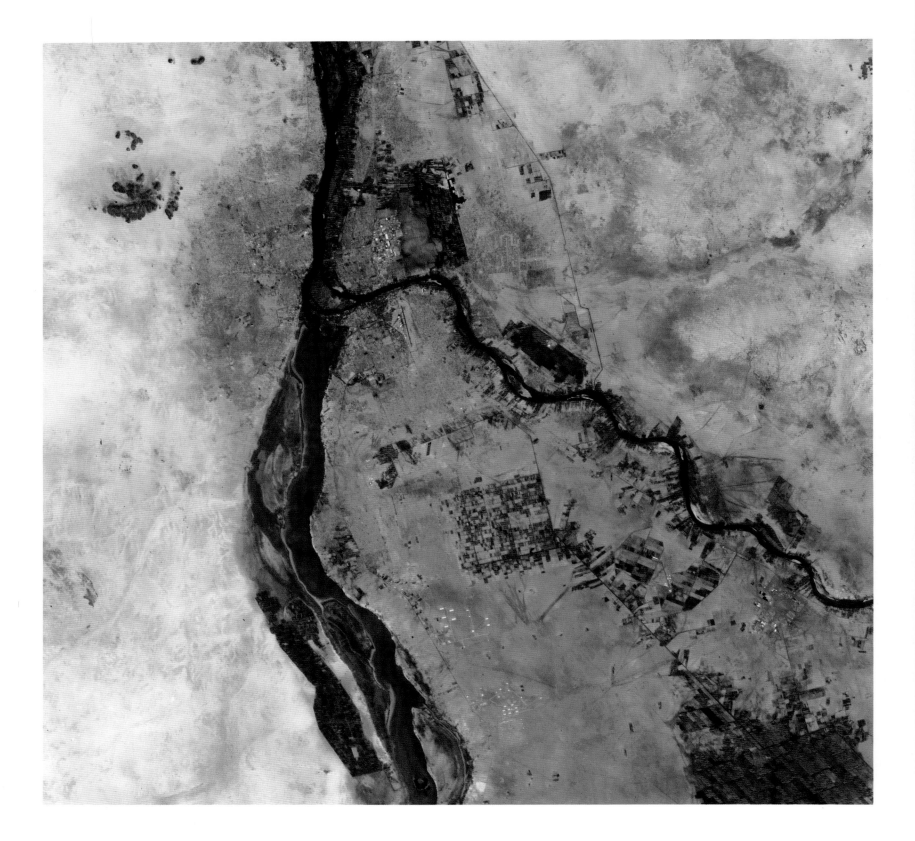

Nile River Flood Cycle. The flooding of the Nile River into its valleys was a symbol of resurrection for the ancient desert civilizations of Africa. The yearly flood enriched the land with water and nutrients. Since most of this region is desert, with little rainfall, the overflowing of the river beyond its banks was seen as miraculous. For thousands of years, the Nile sustained the agriculture that allowed the Egyptian civilization to evolve and prosper.

The annual flood cycle of the Nile River continues to bring to the surrounding land rich mud and soft silt—the natural fertilizers that allow crops to flourish. We now know its waters come from the mountains of Ethiopia and the highlands of east Africa. These two images compare the Nile before and after flooding in Khartoum, the capital of Sudan.

◀ Taken before the flood, this image shows the narrow Blue Nile flowing into the broader White Nile. The urban areas of the capital city are gray-blue, the vegetation is red, and the surrounding desert is tan. Here the Nile merges into one river from its two branches: the White Nile, to the west, and the Blue Nile, to the east.

▼ When the White Nile overflows its banks, the width of the river triples in some regions, leaving a few small islands, which are higher in elevation. The Blue Nile doubles in width. Numerous ponds and lakes are scattered throughout Khartoum. Increased cultivation is seen in the rectangular grid in the center of the image.

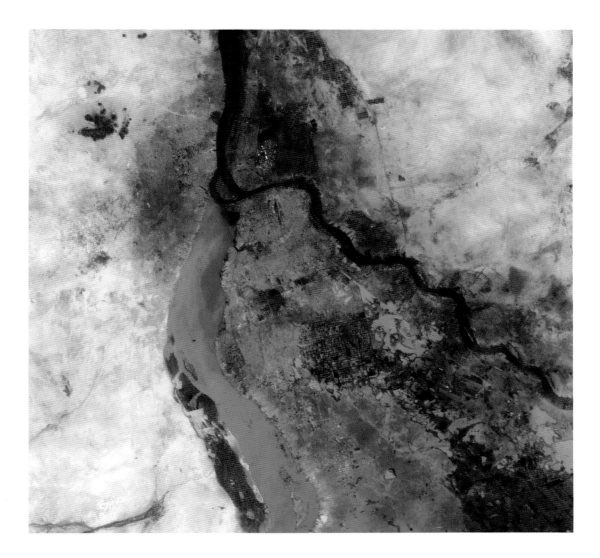

► **Kuskokwim River, United States.** Water plays a critical role in the erosion of the land. Rivers are one of the main forces that cut through the landscape and carry sediments on their journey to the sea. The sediments often contain nutrients important for the growth of marine life. As the rivers enter the ocean, they deposit sediments in fan-shaped deltas.

The radar sensor that took this image of the Kuskokwim River in Alaska and its sediment deposits in Kuskokwim Bay, an inlet of the Bering Sea, operates independent of weather and sunlight. Because radar sensors can penetrate clouds and transmit images day or night, they are very useful in providing high-resolution images of polar regions such as those in Alaska, where clouds and darkness are frequent.

The 600-mile-long Kuskokwim drains the large Kuskokwim Mountains in central Alaska. The sediment deposits are the dark areas in the bay and along the coastline. They are separated by bright, curving water channels, which are deeper than the darker deposits. The appearance of the channel changes daily due to the combination of strong tidal forces, the variable flow of the river into the bay, and local wind conditions.

▼ **Denali National Park, United States.** A stream fed by melting ice flows down from the lower mountain ranges of central Alaska.

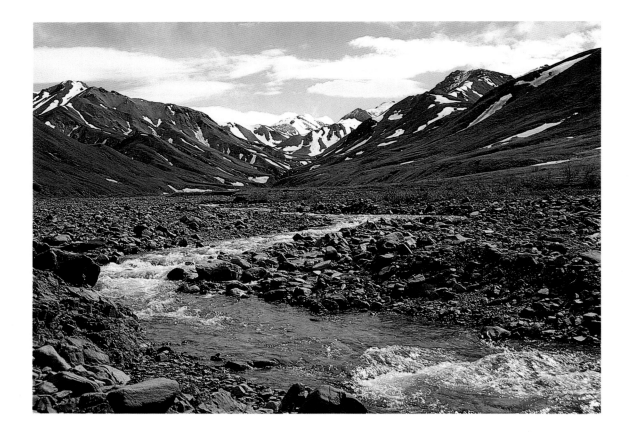

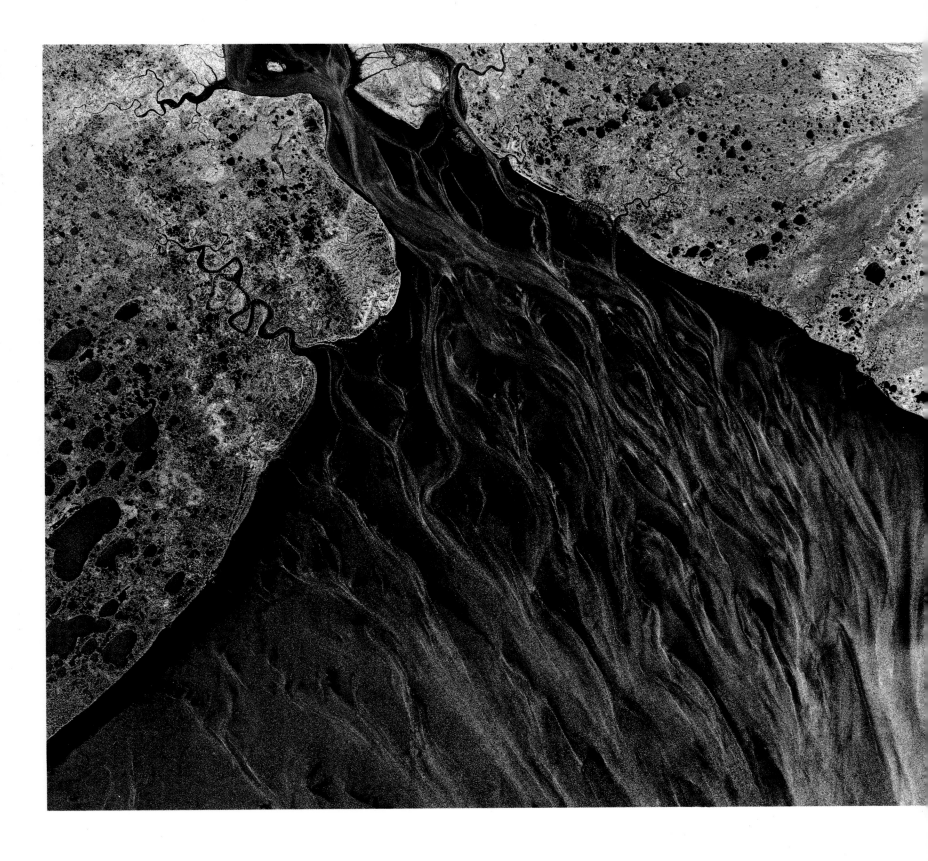

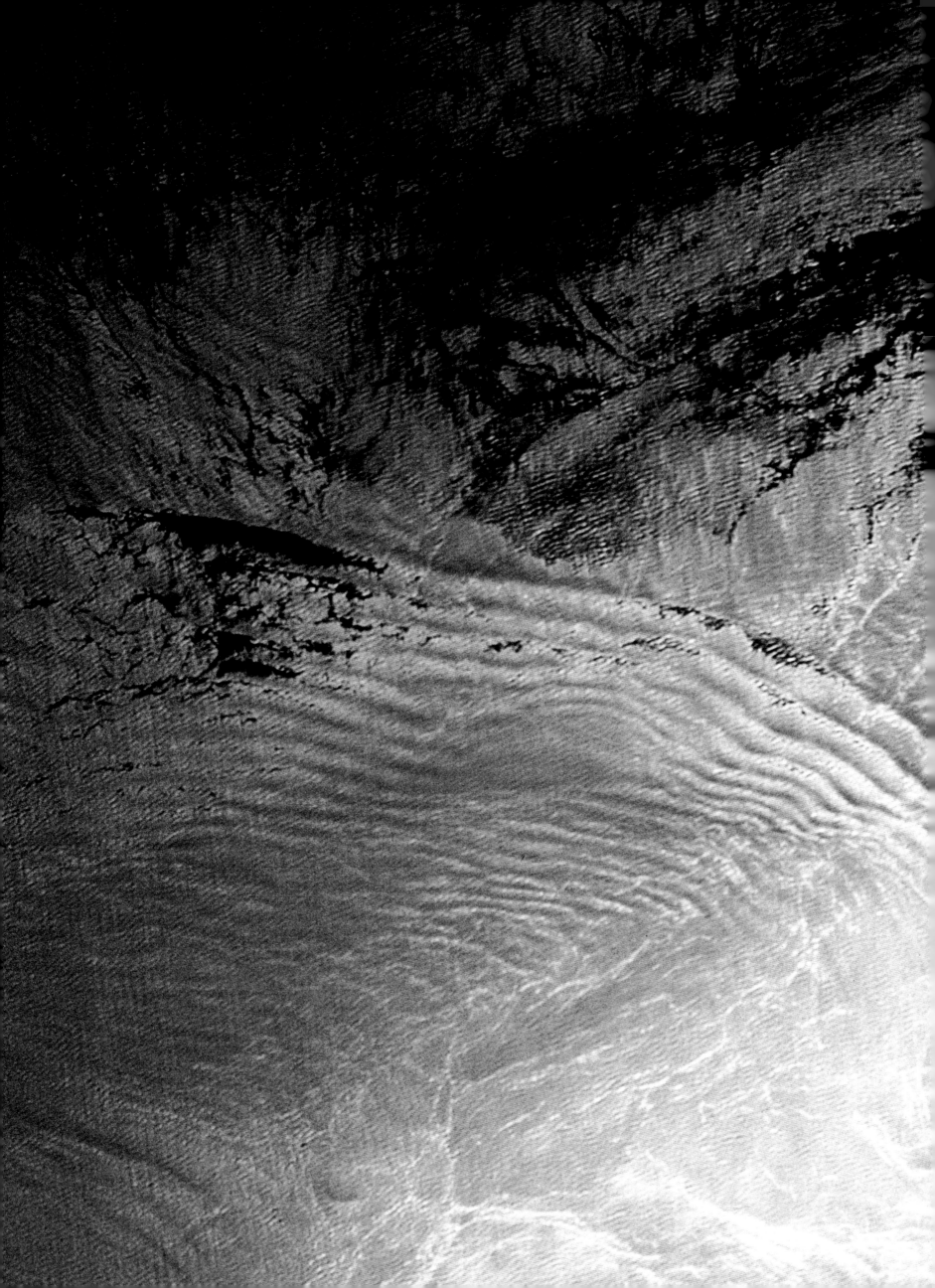

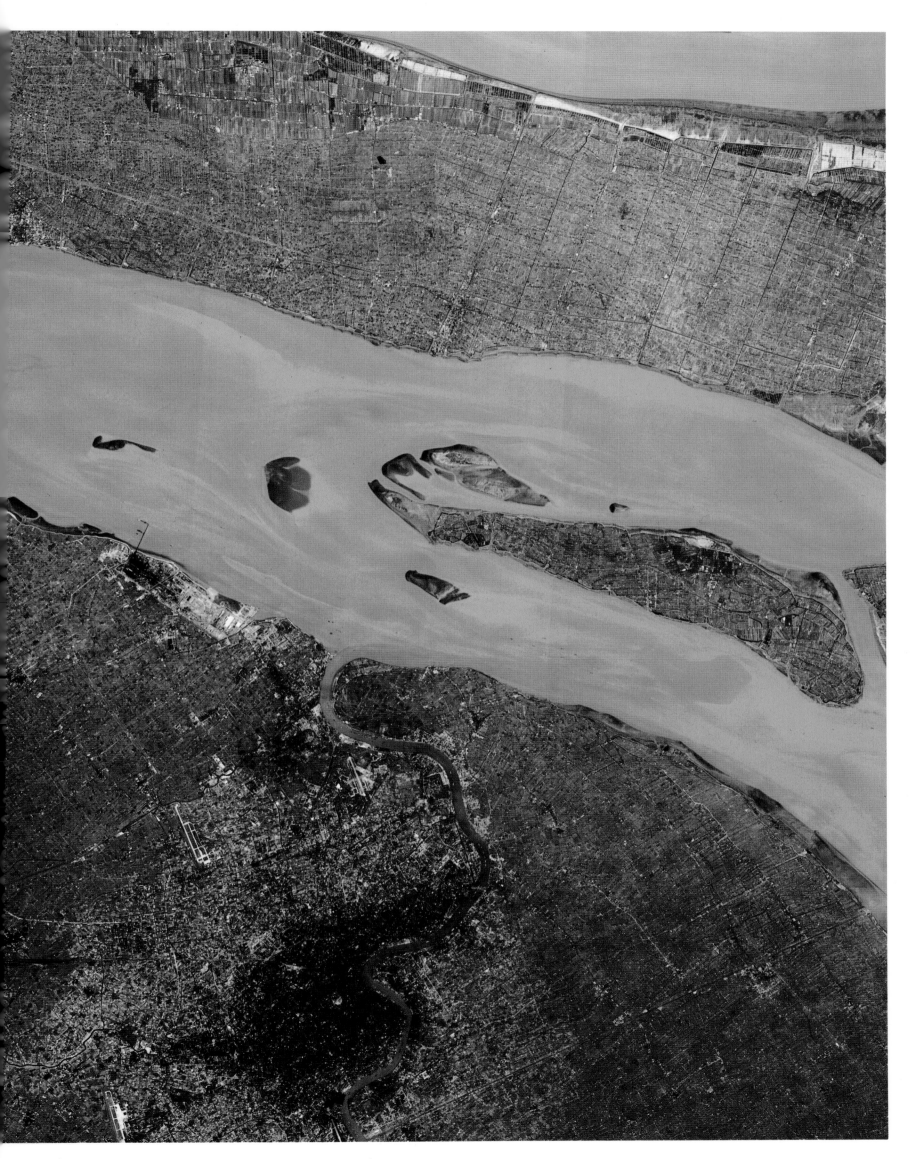

Impact Crater Lake, Elgygytgyn, Siberia.
Nearly 4 million years ago, an asteroid struck
the Earth in northeastern Siberia and formed
an immense crater called the Elgygytgyn
impact crater. The remoteness of the region
prevented the crater from being discovered
until the early 1960s. Its extraterrestrial origin
was not determined until the 1970s. The
diameter of the crater's rim is approximately
12 miles, and the surrounding area contains
material dispersed from the asteroid's impact.

Satellites have provided unique tools to
study inaccessible regions such as this one
in Siberia and to understand the evolution
of landforms. We can imagine that the
immediate impact of the asteroid would have
resulted in extensive destruction to the land
and forest. After millions of years, water
flowing from many small rivers and streams
filled the crater. In this image, rivers and
streams are thin blue lines, vegetation is red,
and exposed landforms are gray-green.

Its substance reaches everywhere;
it touches the past and prepares
the future; it moves under the
poles and wanders thinly in the
heights of the air....
If there is magic on the planet,
it is contained in water.

Loren Eiseley, naturalist

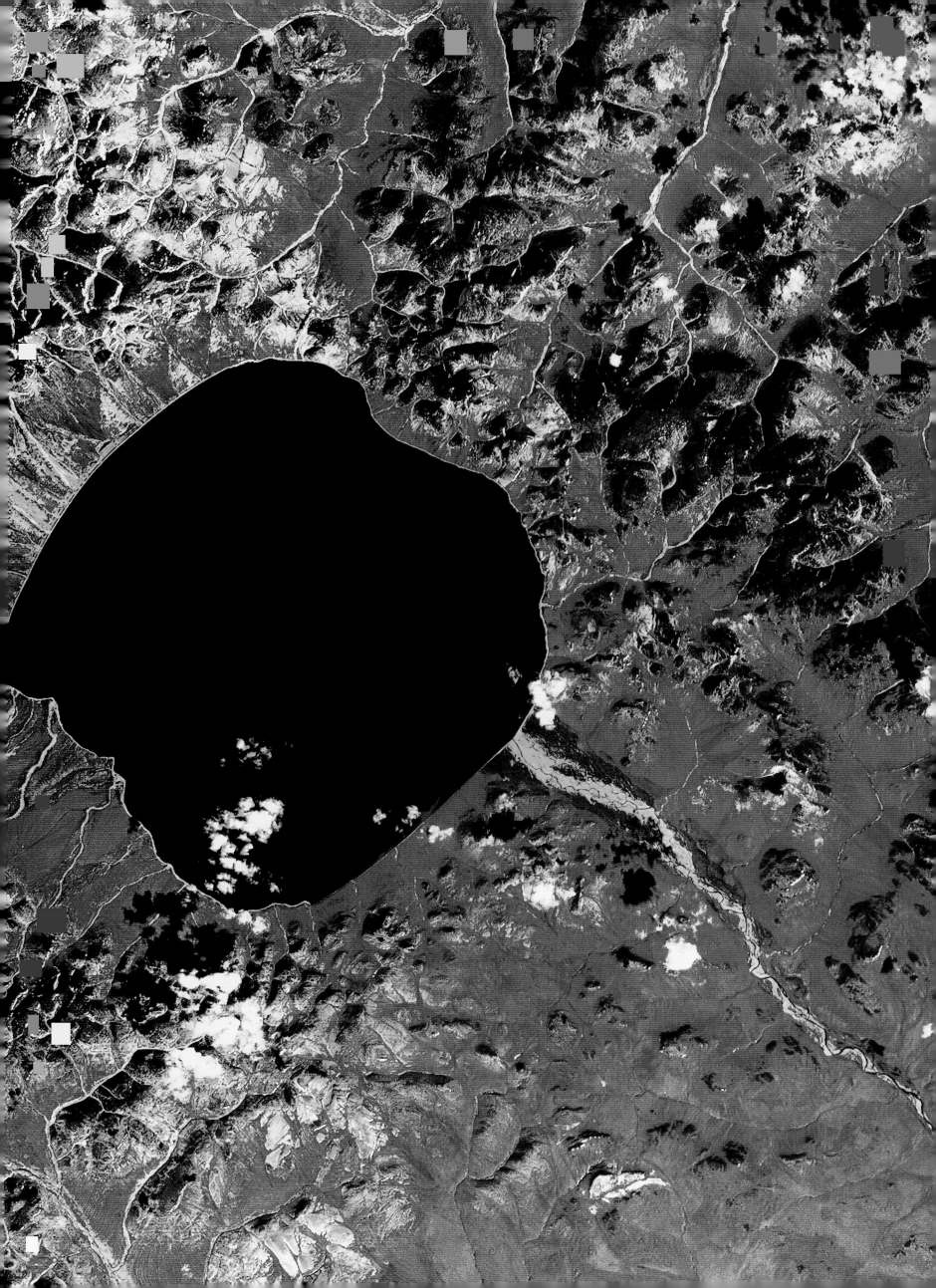

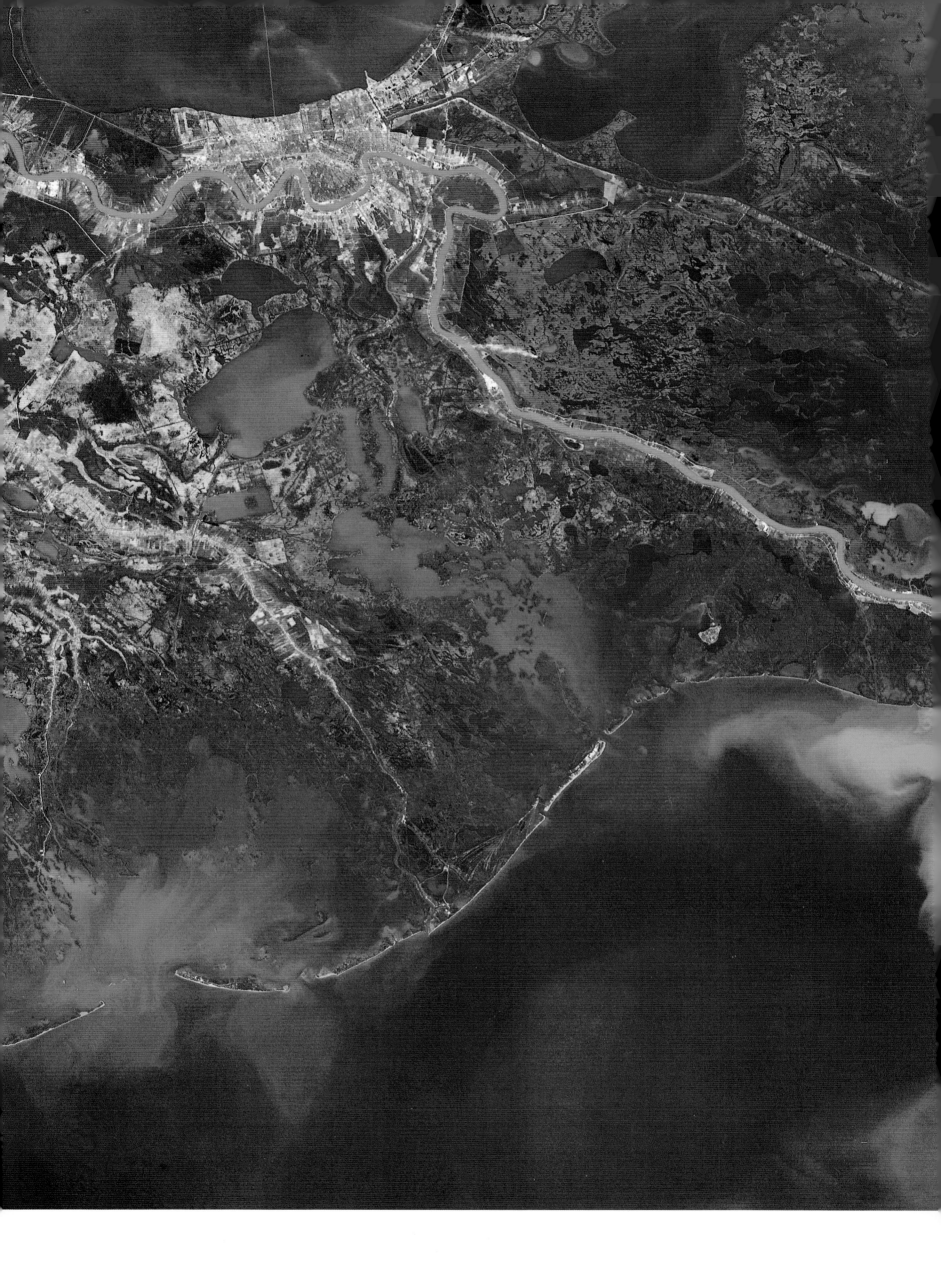

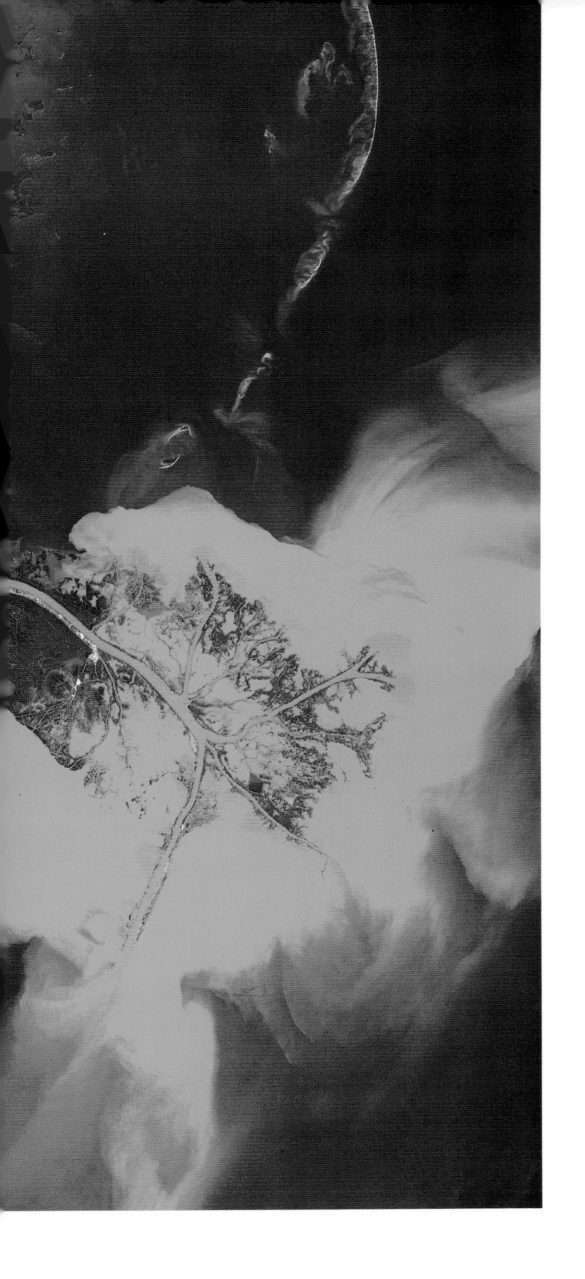

Mississippi River Delta, United States.
River deltas have played an important role in the development of civilizations since ancient times. The word *delta* is derived from the fourth letter of the Greek alphabet, which is triangular in shape. This same shape is formed by sediments that are deposited by rivers flowing into larger bodies of water.

The Mississippi River, the largest river system in North America, drains over 2 million square miles between the Appalachian Mountains to the east, the Rocky Mountains to the west, and Canada to the north. As the river winds south to the Gulf of Mexico, it carries the eroded land suspended in its flow. The sediment load discharged by this great river has been estimated to be over 5 billion pounds annually. The sediments are deposited onto the continental shelf in a pattern known as a birdsfoot delta.

Seen here is the birdsfoot delta of the Mississippi River reaching into the Gulf of Mexico and covering an area of approximately 625 square miles. The sediments carried by the Mississippi force the flow to split into several channels. Vegetation is red. A network of marshes is at the very tip of the river channels. Light blue plumes of muddy water spread into the gulf. The white regions are areas of developed land on the natural levees along the course of the Mississippi.

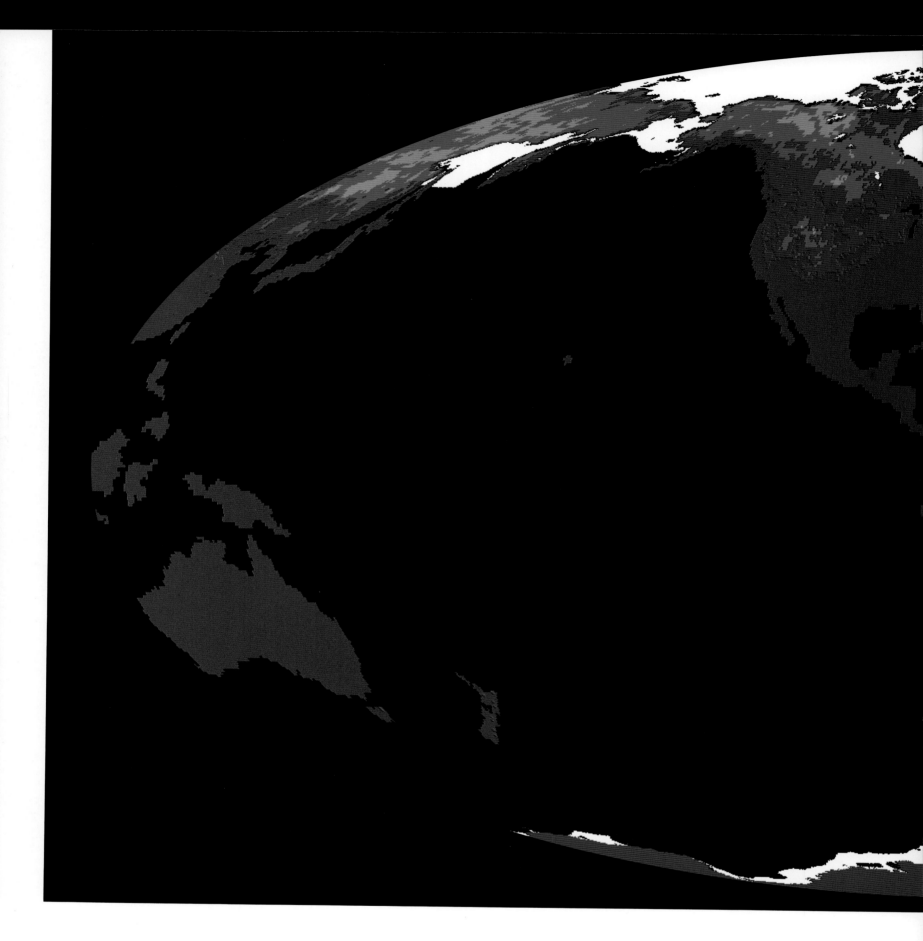

ICE

Ice and snow are the frozen aspect of water and in this unique form play a crucial role in the Earth's climate and heat transport system. The orbit and inclination of the Earth cause the predominant locations of ice and snow to exist in the polar regions, though even at the equator snow can be found at high altitudes. The history of our planet includes many cycles of warming and cooling. There is evidence that massive glacial activity occurred over 2 billion years ago, and there have been at least six ice ages in the last 1 million years. The process of planetary cooling, encompassing periods of glacial advance and retreat, can last millions of years.

The movement of ice sheets during different glacial periods may have influenced the social evolution of the human species, as resources were more limited during times of cooling than during warmer periods. Early humans had to learn to hunt, make clothing

and tools, and communicate more effectively to survive in the colder climate. These challenges created by climate change required adaptations that may have stimulated the development of the human mind and of human society.

Today we know that snow and ice play major roles in shaping our planet. Glaciers are major agents of erosion. They often follow valleys cut by streams and rivers. As glaciers grow and move downslope, they carry huge boulders that gouge the land underneath. When glaciers melt, they leave behind jumbled deposits of rocks and gravel. Ice sheets can cover whole continents, as in Antarctica, an area larger than the United States and Mexico combined. Antarctica holds 90 percent of the Earth's ice, and in places the ice sheet is over 2 miles thick.

The temperature difference between the poles and the equator is one of the main climate engines driving the large-scale circulation of the atmosphere and the oceans. Warm air and water move toward the poles, redistributing heat, water, gases, and nutrients on a global scale. These processes help determine the climate and habitability of our planet.

Among the unique aspects of the polar regions are major annual cycles of snow on land and ice at sea which influence regional and global temperatures. Land and sea experience rigorous cold during the continuous darkness of the winter months. If the ice sheets of Antarctica and Greenland were to melt entirely, the global sea level would rise by over 200 feet. Sea ice also influences the circulation of ocean waters: as temperatures drop, the colder, denser water at the poles sinks and moves to lower latitudes.

The remoteness and inhospitable conditions of the polar regions and of certain mountainous areas on the planet make research difficult, if not impossible. Satellites have helped to overcome these limitations by providing long-term measurements of both land and sea. Passive sensors that measure light and microwave radiation can indicate the extent and type of sea ice, and radar sensors can measure the volume of ice and snow.

The image here shows global snow and ice cover. Sea ice is white; shallow snow, dark blue; moderate snow, medium blue; and deep snow (greater than a foot), light blue. The permanent ice caps of Antarctica and Greenland are purple.

The annual cycles of ice and snow have deep roots in our prehistory, during the ice ages. Today the potential of global warming caused by human activity makes early detection of any changes in snow and ice levels critical for the economic and social well-being of the world.

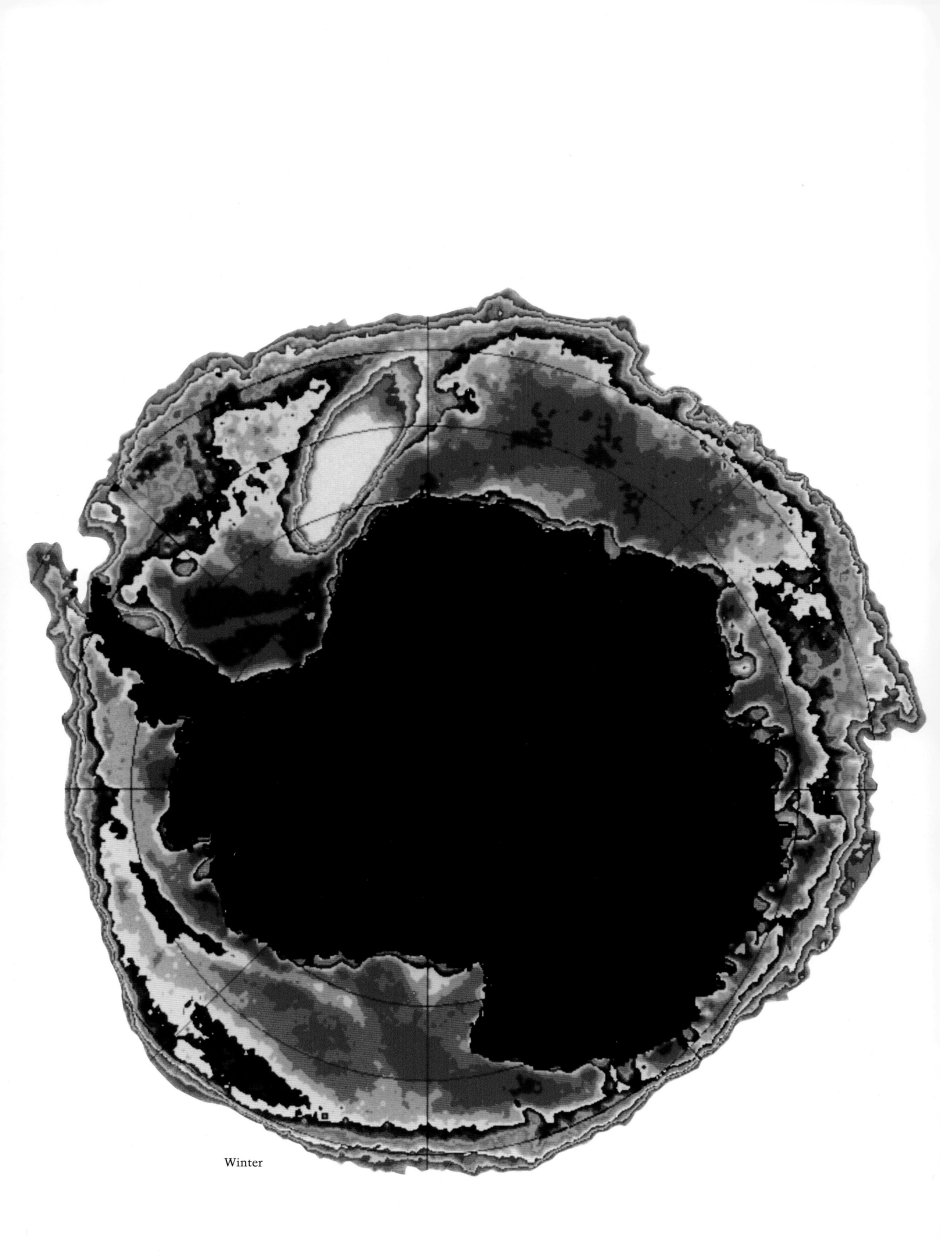

Winter

Antarctic Sea Ice. Antarctica is a foreboding continent. Shrouded in darkness for half the year, it is a desert of ice with the coldest temperatures and fiercest winds ever recorded anywhere on Earth. Its ice and snow influence the Earth's climate, acting as an insulating barrier that regulates the rate at which heat is transferred between the atmosphere and the oceans.

Until the advent of satellite observations, annual and year-to-year changes of polar sea-ice cover were very difficult to obtain and measure accurately. Satellites with microwave sensors allow continuous monitoring of sea ice day or night, even through cloud cover. Microwave radiation is naturally emitted from the Earth's surface, just as heat radiation is emitted from our bodies or from hot rocks on a summer day. Scientists are able to convert these microwave measurements into ice concentrations through a series of mathematical formulas.

This series of images shows seasonal patterns in the freezing and melting of sea ice around Antarctica. The Antarctic landmass is in black. Ice concentration decreases from high levels near the coast (red) to low levels near the outer ice margins (blue and green). Four main Antarctic seasons, from winter through the following fall, are depicted. In winter, Antarctic sea ice covers an area greater than the United States. Ice extends more than 600 miles out from the continent in areas such as the Ross and Weddell seas. During the summer, continuous daylight and heat melt more than 80 percent of the winter ice. These massive seasonal expansions and contractions strongly interact with the atmosphere to affect climate. Any long-term increase or decrease in sea-ice cover may provide an early warning of climate change, a critical monitoring capability available only from satellites.

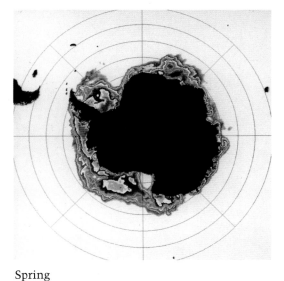

Spring

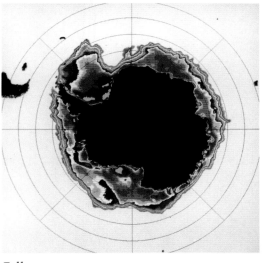

Summer

Fall

► **Weddell Sea, Antarctica.** A year in Antarctica consists of months of continuous darkness in winter, followed by months of continuous daylight in summer. The annual breakup of the vast sea ice around Antarctica begins with the growing daylight hours and the effect of the sun's warmth. By the end of summer, the sea ice surrounding the continent has diminished by over 80 percent.

In this image, thousands of icebergs have broken off, or calved, from the Filchner Ice Shelf in the Weddell Sea. The ice shelf, in the lower left, with a thickness of hundreds of feet, is a smooth white. The large, trapezoidal iceberg in the center is approximately 3-1/2 by 5-1/2 miles. A smaller iceberg has been heaved, or rafted, on top of it by the currents and moving masses of ice. Sea ice, in between the icebergs, is light blue, and open water is black.

▼ **Bering Sea, the Arctic.** Annual cycles of melting and freezing affect the Arctic as they do Antarctica. In this photograph of first-year ice floes in the Bering Sea, a small-scale version of ice rafting can be seen in the upper right.

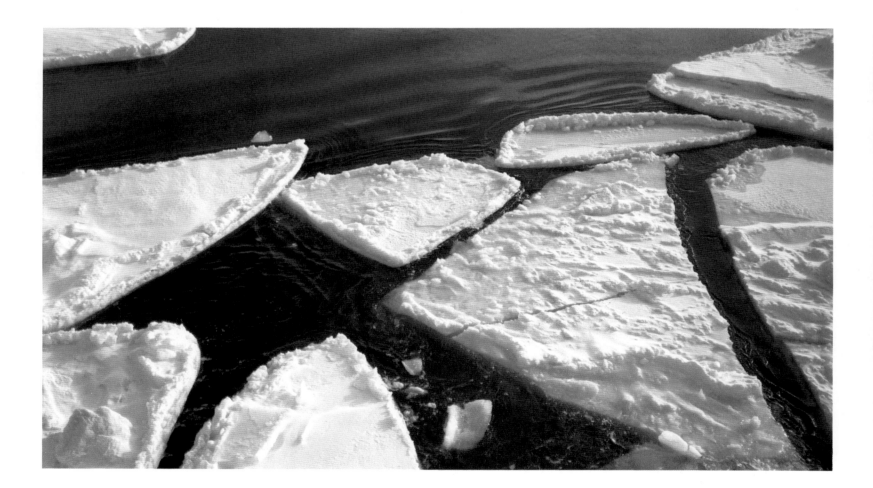

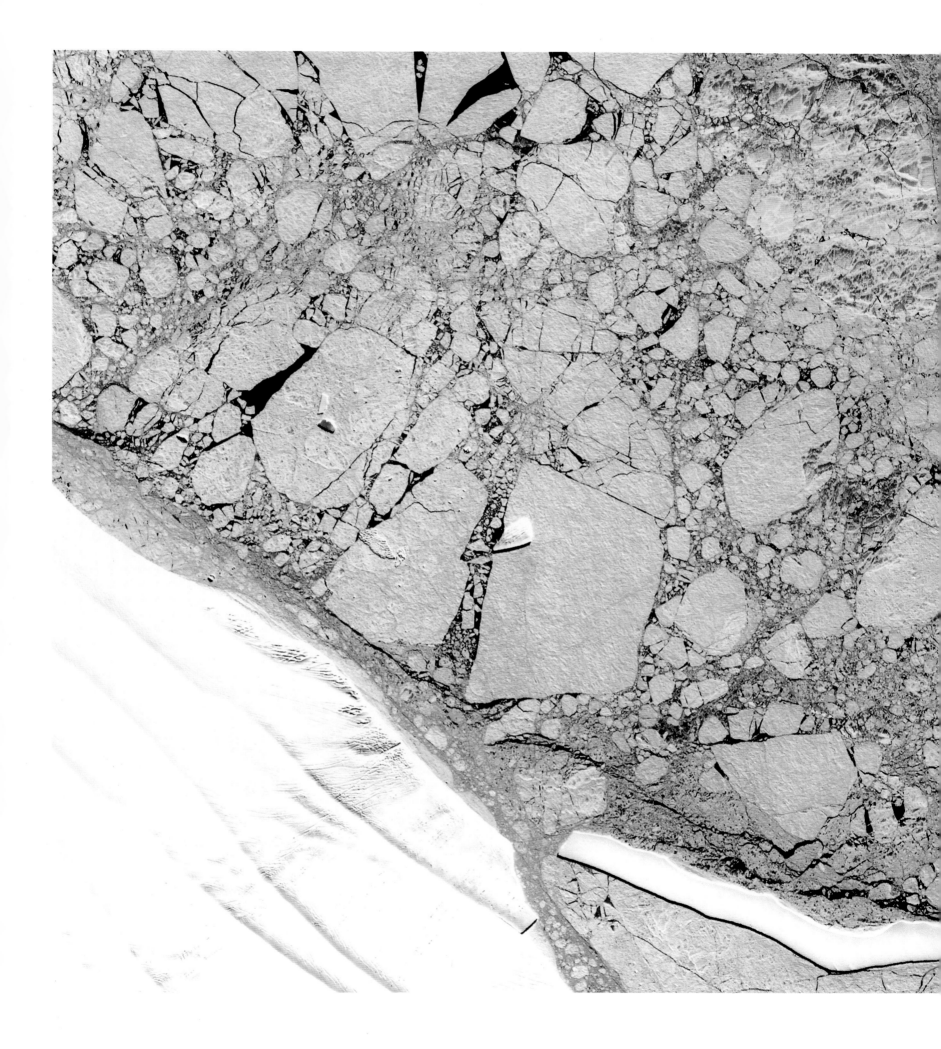

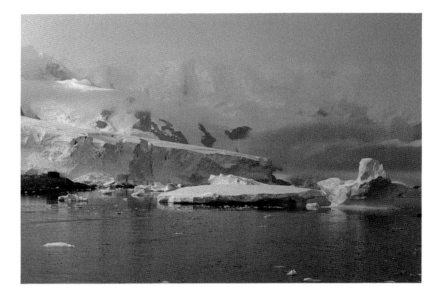

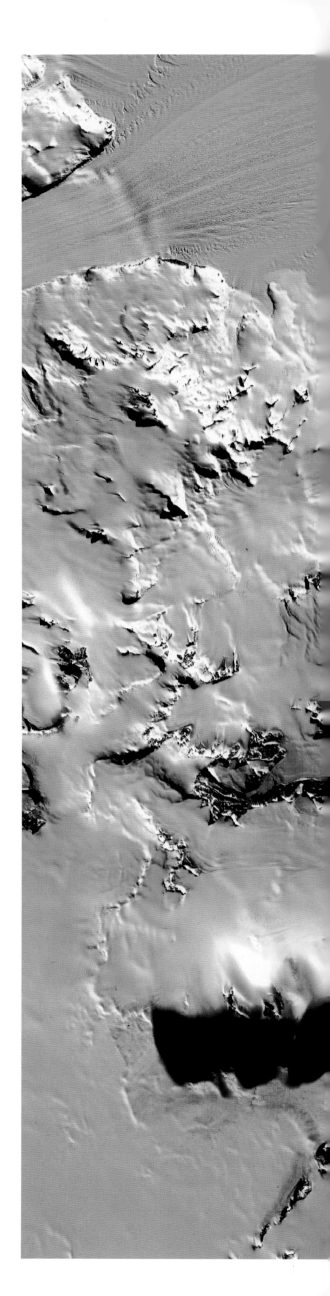

► **Byrd Glacier and Ross Ice Shelf,
Antarctica.** Antarctica contains 90 percent
of all the Earth's ice. Its glaciers move ice
from the continent's interior to the sea.
Yet little is known about these glaciers
compared with those in populated regions
such as Switzerland or Alaska. Satellites
provide essential data about their features,
properties, and movement.

Polar ice responds to warming by melting
and flowing from the land and eventually
toward the ocean, thus decreasing in size.
With cooler temperatures, more snow falls
and compacts to ice, thereby increasing a
glacier's size. Long-term warming can cause
a rise in global sea levels. Cooling will result
in the opposite effect: a decrease in sea levels.
Understanding these dynamic changes—the
surge and retreat of glaciers—gives us insight
into past and future climatic environments.

Here we see a false-color image of the
Byrd Glacier and Ross Ice Shelf. Scientists
use satellite and aerial photography to track
changes and movement in glaciers. They
have determined that each year the Byrd
Glacier flows seaward at a rate of 1,300 feet
and discharges some 11 cubic miles of ice
into the Ross Ice Shelf.

▲ **Elephant Island, Antarctica.** Calving
icebergs and glacier.

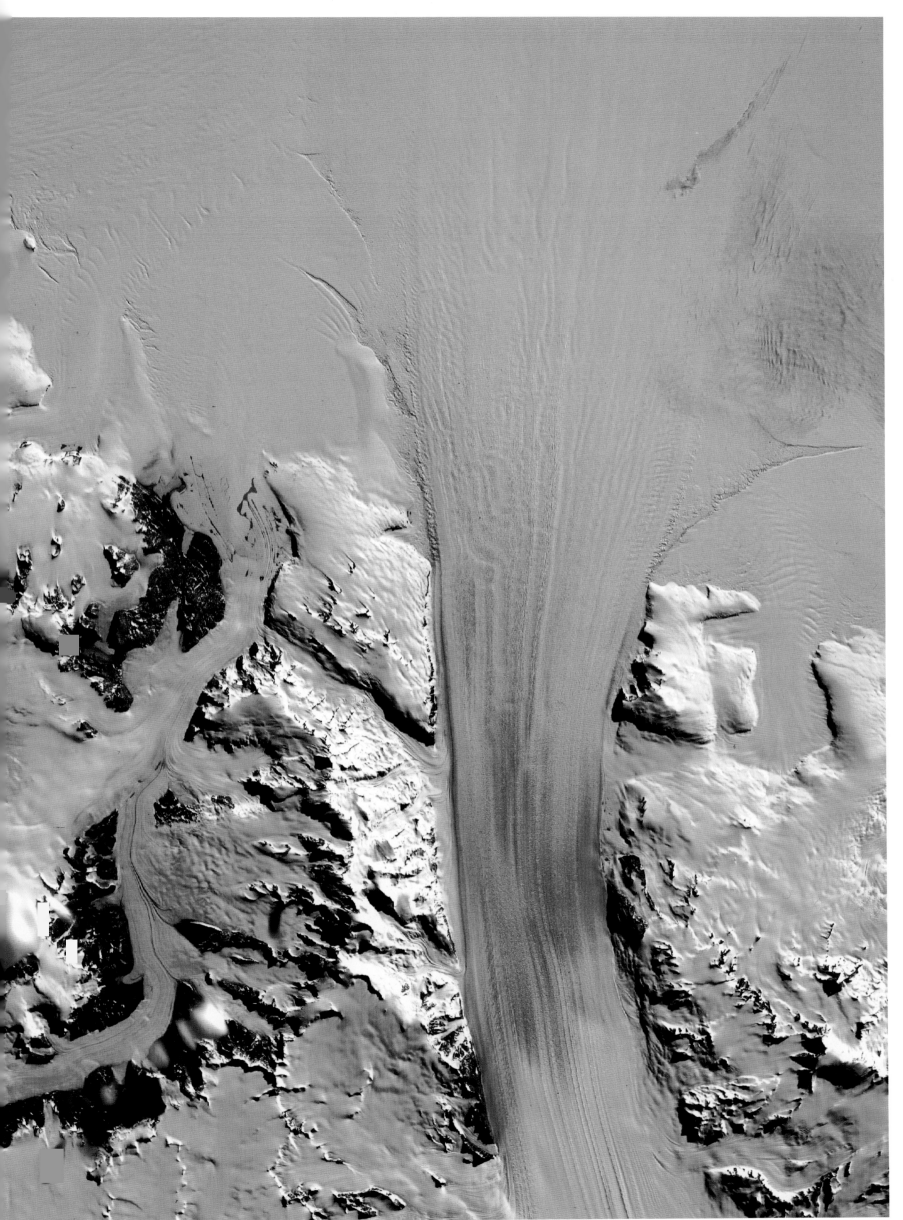

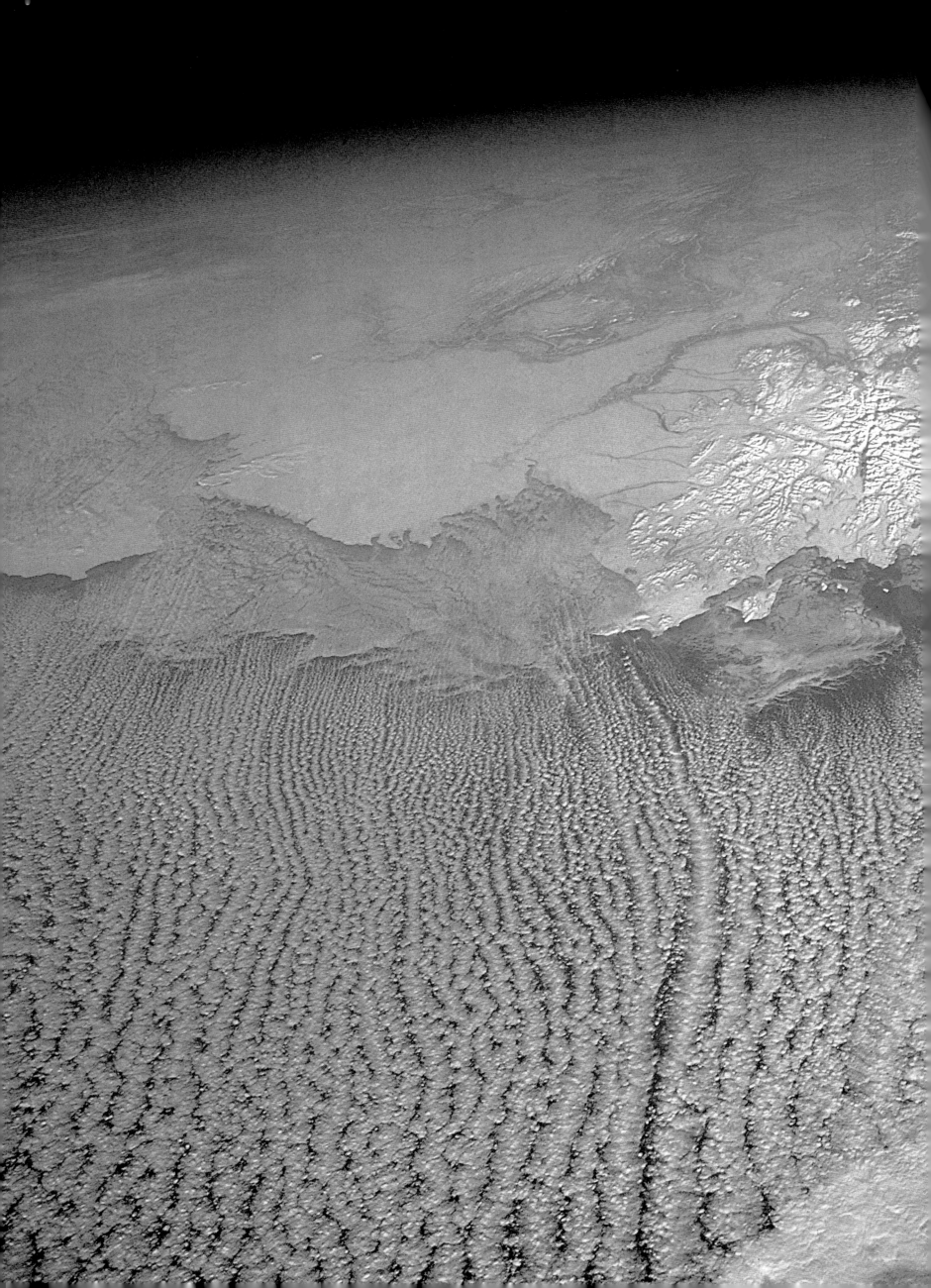

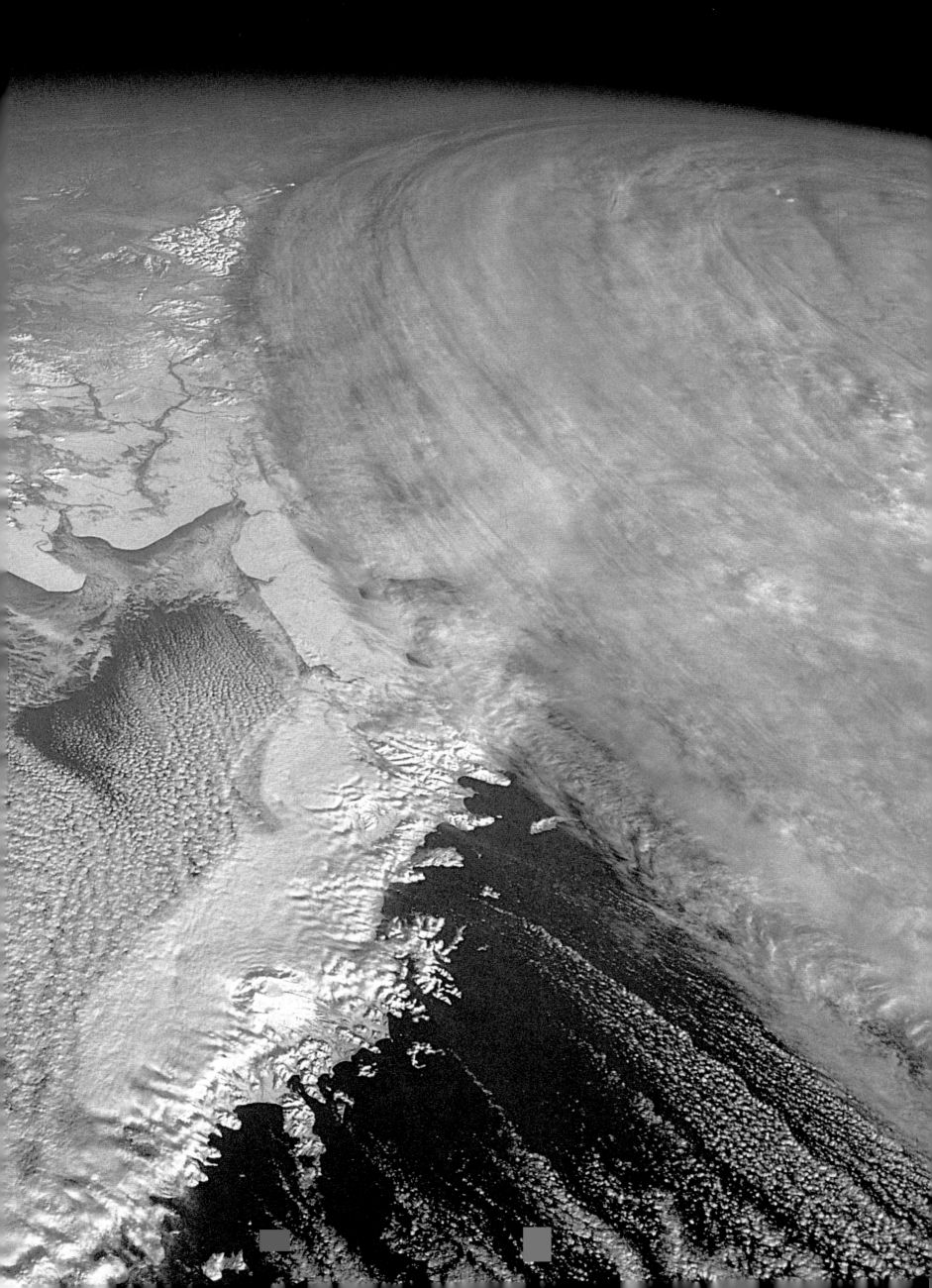

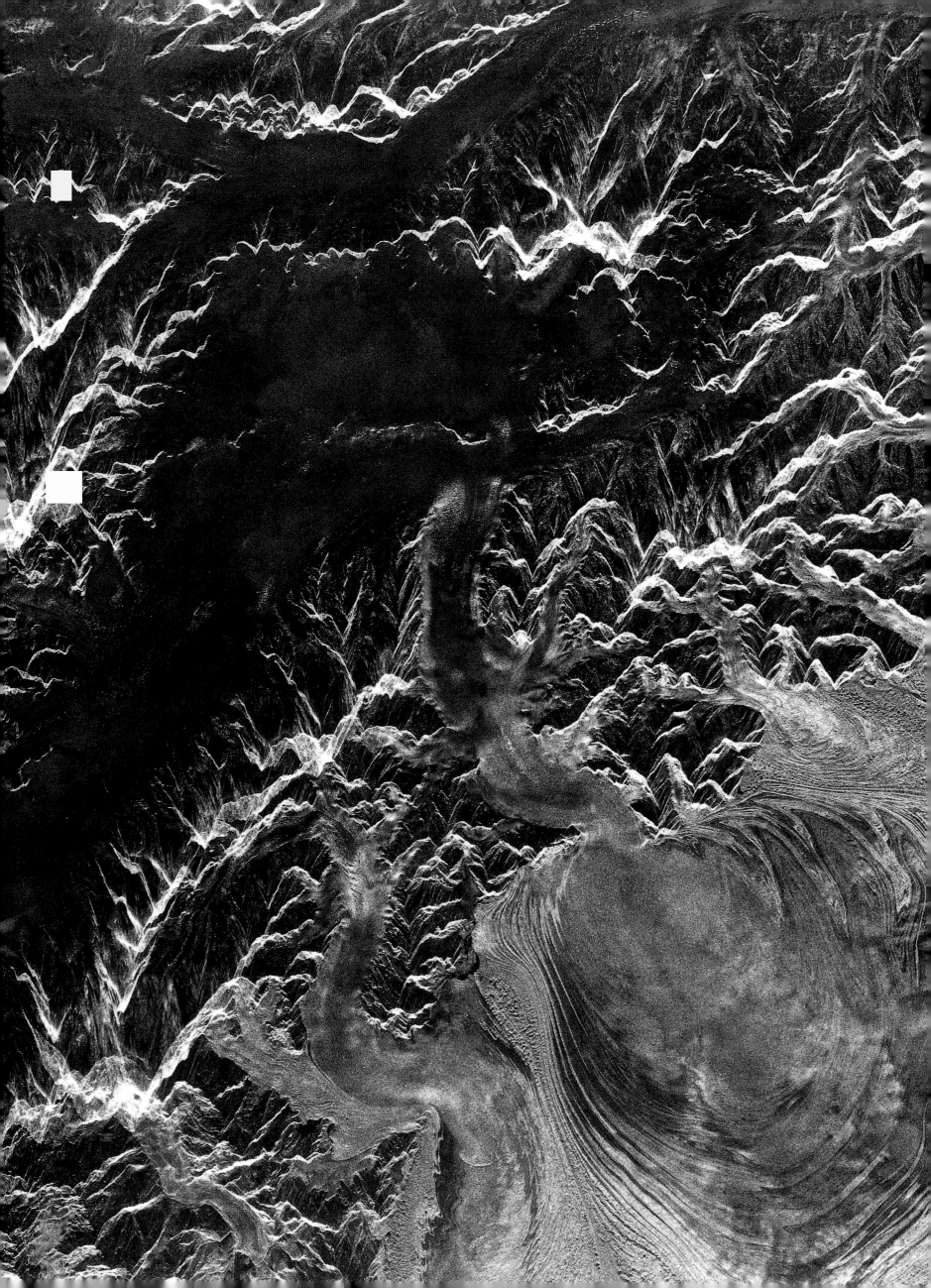

◄ **Malaspina Glacier, United States.** The Malaspina Glacier in Alaska is the largest piedmont glacier in North America. A piedmont glacier is formed by the coalescence of a number of valley glaciers flowing down from steep mountain slopes. Here the mighty river of ice heads westward out to the Gulf of Alaska from the Saint Elias Mountains in southeast Alaska. Smaller valley glaciers can been seen merging into the main body of the Malaspina.

Glaciers are important indicators of changing temperature and climate. Their shape and their advance and retreat represent a record of the past. Glaciers in relatively temperate climates are most sensitive to melting from global warming. Satellite imagery such as this provides numerous ways of looking at glaciers through the use of different sensors.

▼ Many crevasses form the surface of the Malaspina Glacier. This photograph, taken from the ground and including a helicopter for scale, gives a sense of the glacier's immense size.

◄◄ **Winter Storm, United States** (previous pages). This Space Shuttle view of western Alaska looks to the east during a violent winter storm. The Alaska Peninsula and Aleutian Range are at the bottom, where Arctic winds are seen blowing toward the south. The edge of a large storm covers the Gulf of Alaska, at the upper right. The Bering Sea is in the lower left, Bristol Bay is in the center, and the Alaska mainland is in the upper left.

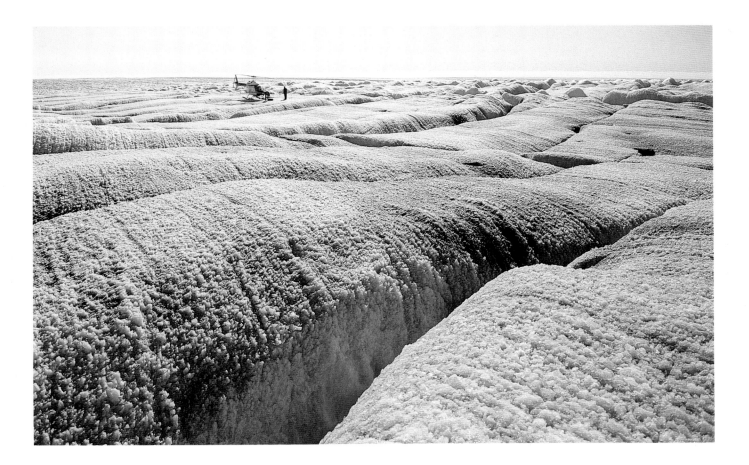

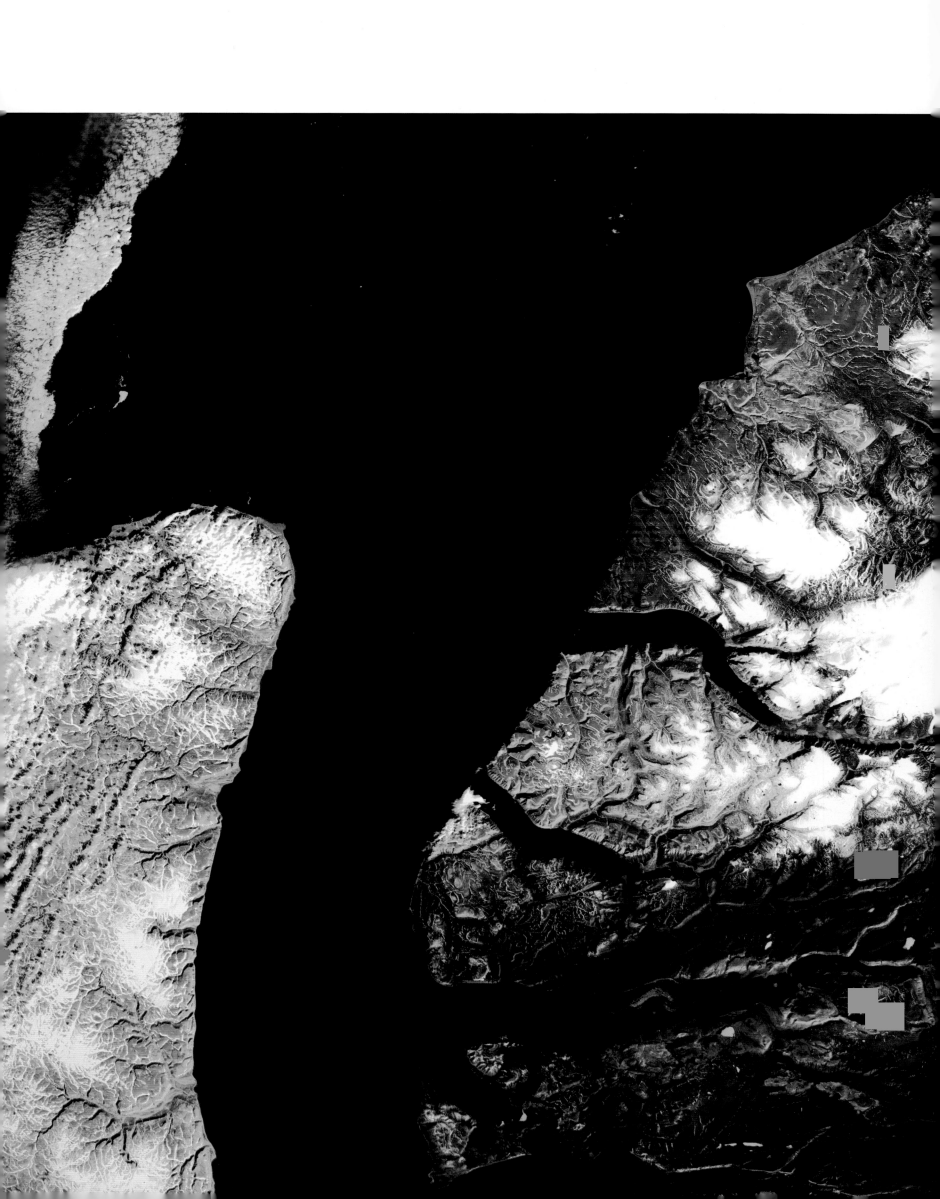

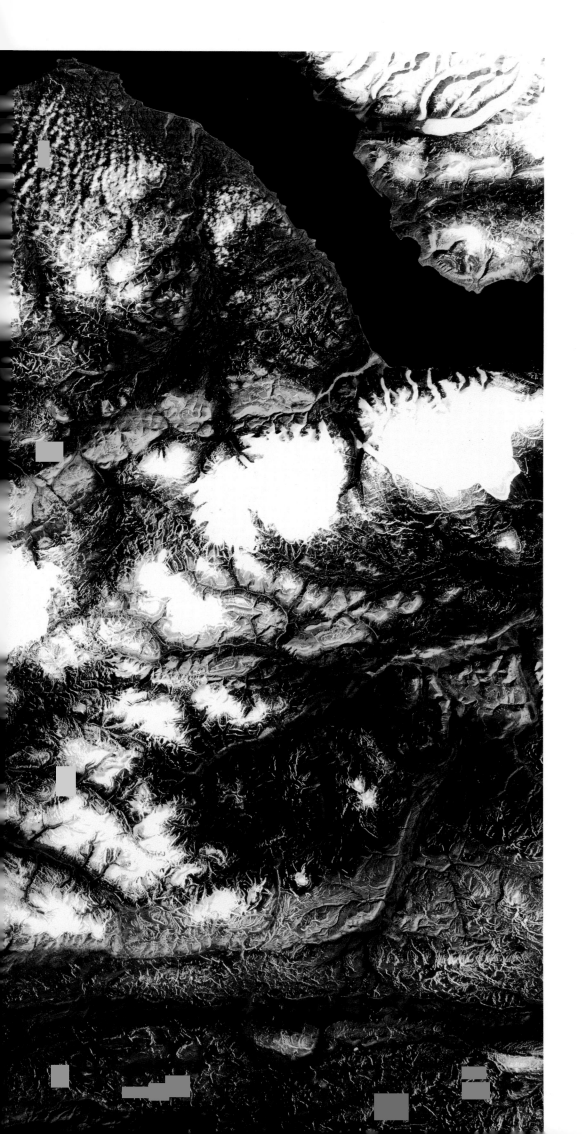

Baffin Island, Canada. Part of the Northwest Territories of Canada, Baffin is the largest island of the Canadian Arctic Archipelago. Admiralty Inlet, a 180-mile-long fjord at the northern tip of the island, empties into Lancaster Sound. The inlet, in the center of this image, is bounded by two peninsulas: Brodeur, to the lower left, and Borden, to the right. Ice is white and shades of blue; glaciers are dark gray-blue. The deep glaciated valleys along the inlet fill with water to form smaller fjords.

From dark and icy caverns
 called you forth,
Down those precipitous, black,
 jagged rocks,
Forever shattered, and the
 same forever?
Who gave you invulnerable life,
Your strength, your speed,
 your fury and your joy,
Unceasing thunder and
 eternal foam?

Samuel Taylor Coleridge, poet

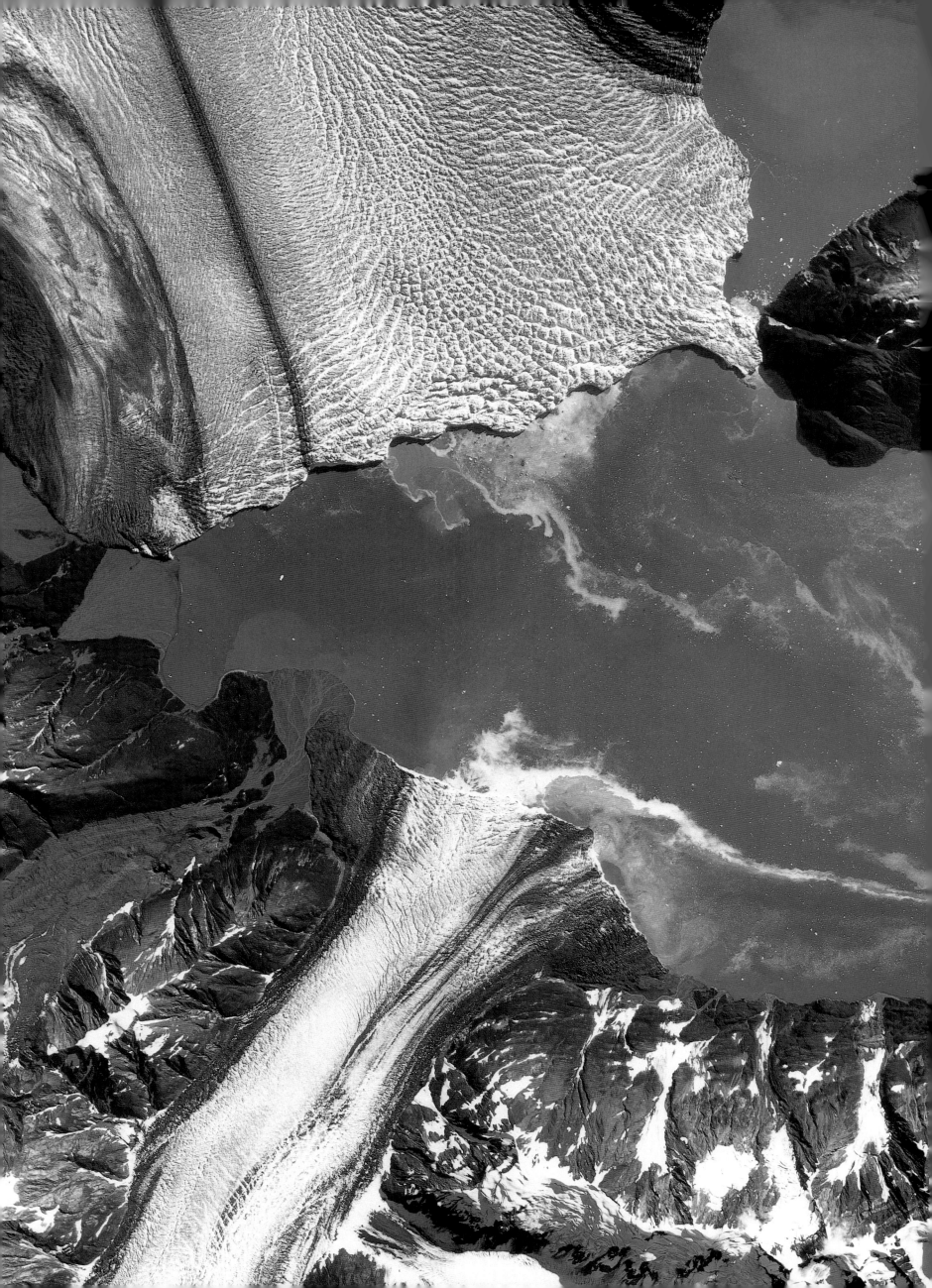

◄ **Hubbard Glacier, United States.** The end of the last ice age, about ten thousand years ago, signaled a climatic warming and the retreat of massive glaciers that had covered most of North America. The advance and retreat of glaciers are part of the cycle of temperature and climate shifts on the Earth. Glacial advances can change the local ecology, alter the course of rivers, and destroy human habitation. Glacial retreats can open new bays and expose the underlying land.

High-altitude aerial photography provides the most accurate view of the Earth's surface and shows changes in polar regions that are normally difficult to monitor. This aerial view of the Hubbard Glacier, near Yakutat in southeast Alaska, was taken during a very dramatic event, in May 1986, when the glacier advanced rapidly and sealed the entrance to Russell Fjord. The white glacier, with its compressed pressure ridges, dominates the upper portion of the photograph. It encroaches on the landmass known as Gilbert Point. Russell Fjord is on the right, and Disenchantment Bay is at the bottom. The vegetation appears red; the snow, bright white. The small ice dam closing the entrance to Russell Fjord has transformed the fjord into Russell Lake.

Four months after this picture was taken, the ice dam failed and discharged 1.3 cubic miles of lake water into the bay. The outburst was thought to have produced the greatest short-lived discharge of water in North America in the last ten thousand years.

▼ **Mendenhall Glacier, United States.** The foot of the Mendenhall Glacier, near Juneau, Alaska, as it enters the Lynn Canal.

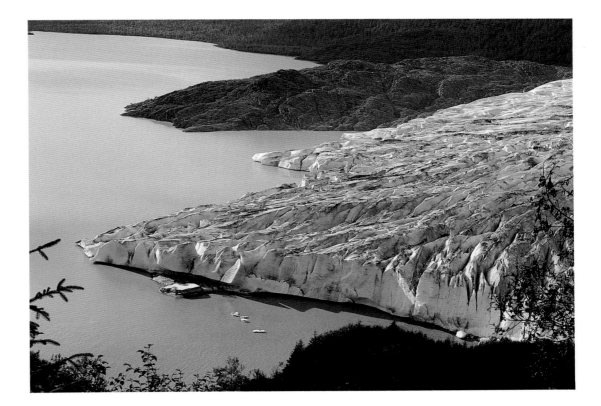

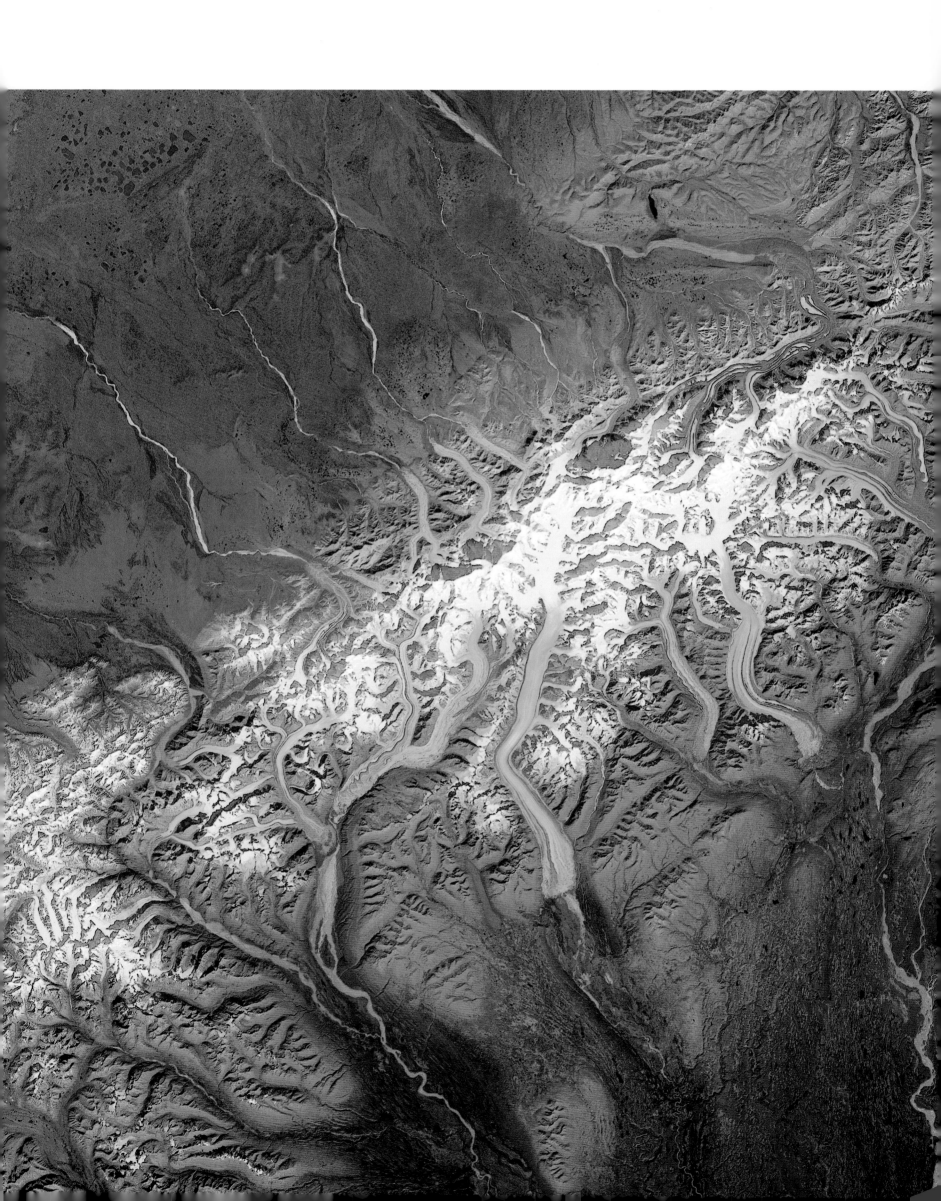

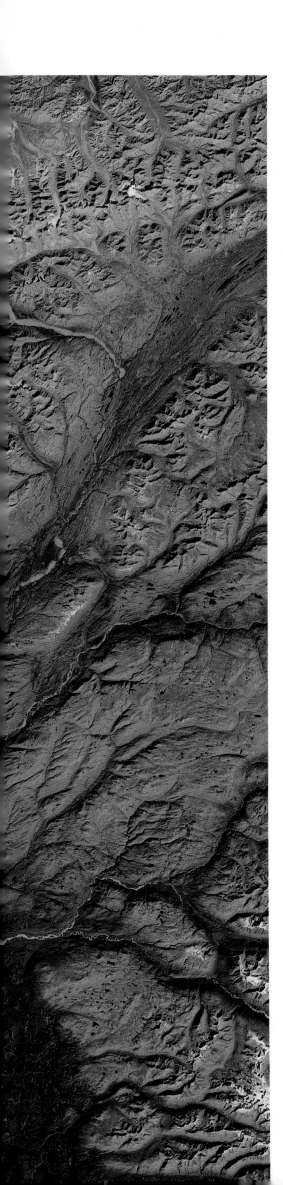

Denali National Park, United States. The Alaska Range is a magnificent chain of mountains towering over vast stretches of untouched wilderness. Although most of the mountains are between 7,000 and 9,000 feet in elevation, the range holds the highest mountain in North America. Reaching 20,320 feet, it is commonly known as Mount McKinley. To native Alaskans, it is Denali—"the high one."

Like other great mountain ranges, the Alaska Range is part of a region where geologic plates come in contact. Here they represent the largest crustal break in North America, running 1,300 miles across the full width of Alaska. The range also forms an important divide where rivers flow either to the south into the Gulf of Alaska or to the west into the Bering Sea.

In this false-color image, Denali National Park, with its many white-topped mountains, is in the center. Numerous blue-green glaciers flow to the northwest or the southeast. Mount McKinley is at the center of the mountain range, directly above Tokositma Glacier, which is to the right of the longer Kahiltna Glacier. The glaciers have helped sculpt the spectacular, sharp relief of Denali. Rivers fed by the glaciers are dark blue; vegetation is red.

TWENTY THOUSAND YEARS AGO, ICE COVERED
ONE-THIRD OF THE EARTH'S LAND SURFACE—MORE THAN THREE
TIMES THE AREA OF TODAY'S GLACIERS.

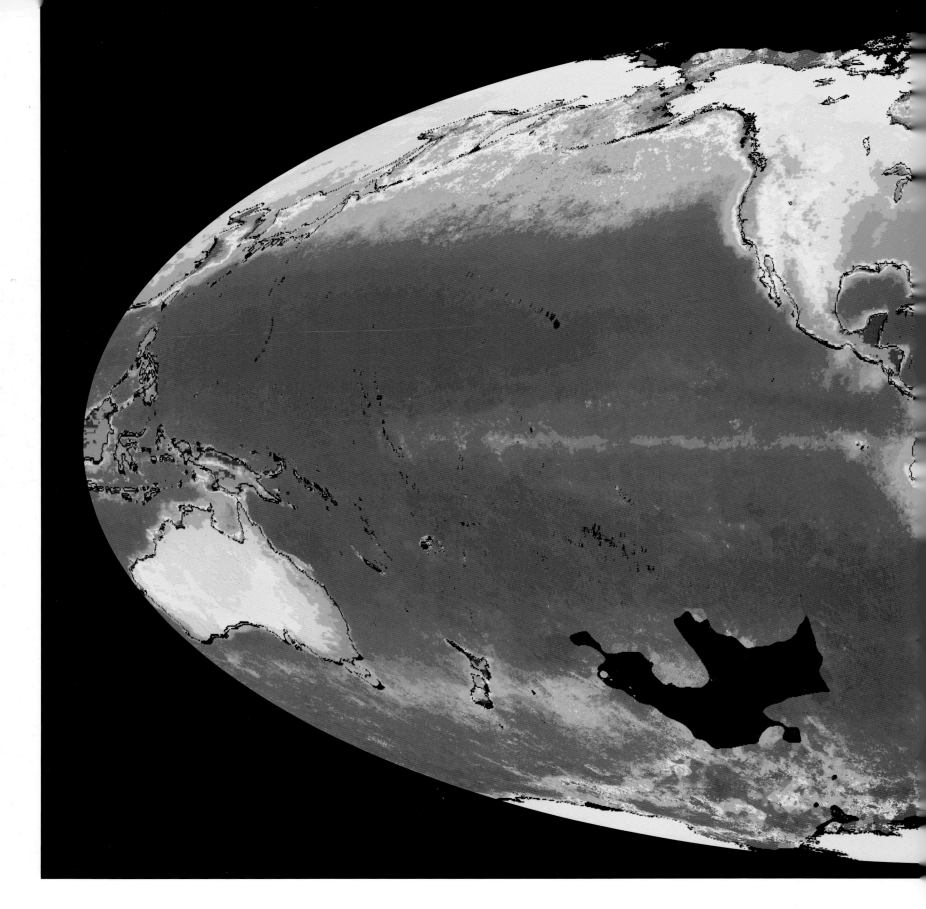

LIFE

Our planet is blessed with life-forms familiar and bizarre, in all sizes and shapes. Life has thundered through the past on the footsteps of giant dinosaurs and lies hidden as tiny bacteria living in thermal vents deep within the ocean. Plants provide the oxygen essential for all life on Earth and are the basis for almost all food chains. Animals create an intricate web of hunter and hunted, leading to wonderful adaptations of survival and ingenuity: from the acute vision of the soaring falcon to the complex social structure of the industrious ant. Some forms, such as the bristlecone pine, can live over four thousand years; others, such as bacteria, reproduce themselves within hours. Life has penetrated nearly all the regions of the planet, from lichens in frozen Antarctica to blue whales migrating throughout the oceans.

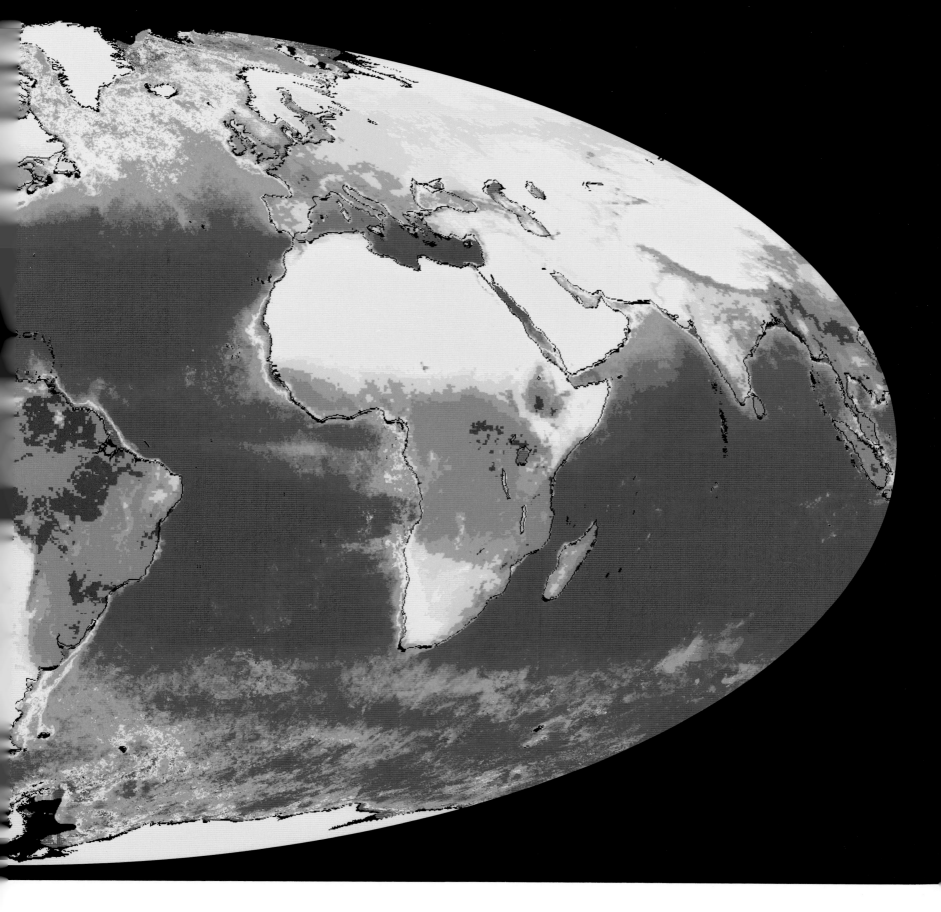

The plants and animals in this diverse tapestry have their own rhythms, with cycles of birth, maturity, reproduction, and death. Humans have observed these cycles for a long time and taken advantage of them to grow and harvest crops for food and medicine, and to hunt animals for nourishment and clothing.

Our fascination with and observations of life have had many expressions. In rural societies today, as in prehistory, women gather food to sustain the tribe between hunts. Shamans and medicine people collect wild herbs and barks to heal and soothe. Scientists observe life-forms in the field and the laboratory, seeking to decipher their natural history, physiology, and behavior.

We are only recently at the point where we can study life from space. It is not with the detail that enables us to count the number of corn stalks in a field or to observe the behavior of gorillas in the wild. Satellites can, however, track the movements of animals banded with radio receivers that emit a signal. Currently, the most powerful use of satellites is to measure the amount of vegetation covering the Earth. Sensors can measure the amount and type of plant cover on land and the total biomass of plant life in the water.

The satellite image shown above is the first truly global view of plant life on the planet. One of the most striking features is found in the oceans where vast areas are as unproductive as any desert (seen as violet and blue). The main productive plant life is in the coastal regions (seen as yellow-red-orange). Here river runoff and upwelling from within the ocean provide nutrients essential for marine plants, known as phytoplankton, to grow. On land, the most productive regions are green, while those areas with less vegetation are tan and yellow. Like the ocean, vast areas of land are deserts with very little productivity.

Eventually satellites will allow us to describe with great detail the types of vegetation on the ground. For now, these global and regional images are the first step in understanding the extent of vegetation and its annual cycles. They help to identify where deserts may be expanding, when the planet's annual greening begins, and how human impact through agriculture, forestry, and fishing is affecting the sustainability of these same resources.

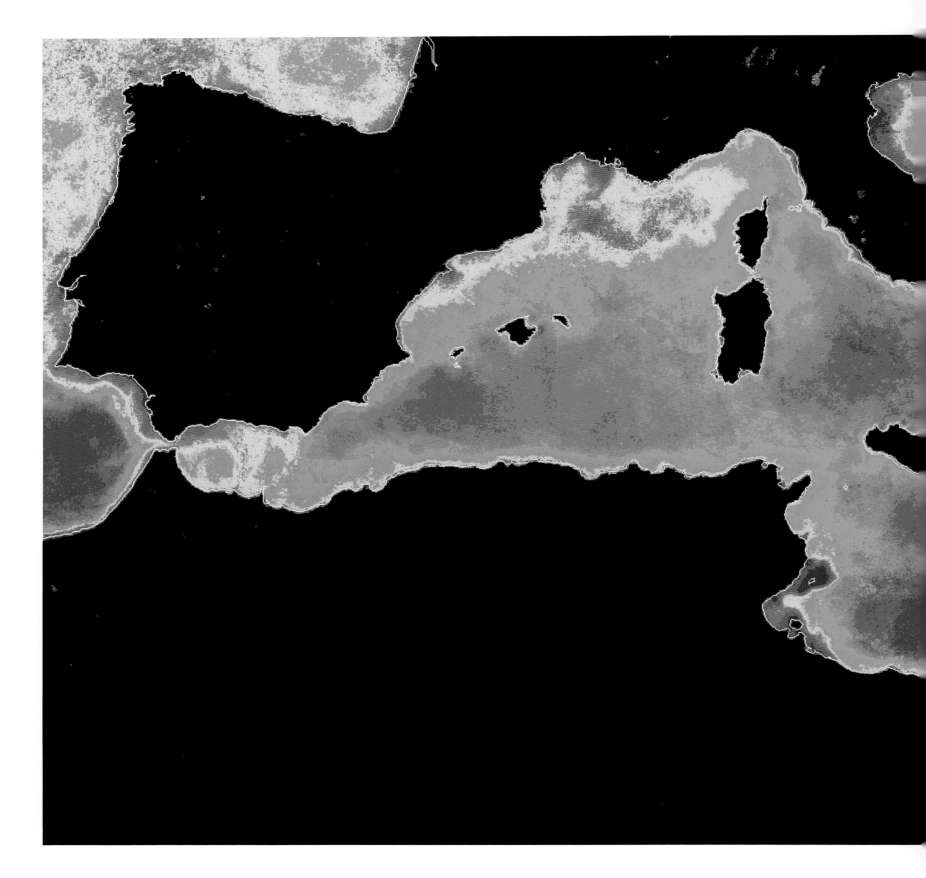

TWENTY PERCENT OF THE BEACHES ALONG THE MEDITERRANEAN
ARE TOO POLLUTED FOR SAFE SWIMMING.

Mediterranean Sea. A combination of geography, circulation patterns, and the effect of the narrow Strait of Gibraltar has limited the concentrations of marine plants, or phytoplankton, in the near shore regions of the Mediterranean.

The image here shows that the relatively clear, phytoplankton-poor waters (in blue) predominate as compared with the phytoplankton-rich waters of the Atlantic Ocean. The higher concentrations of phytoplankton

(in yellow, orange, and red) occur especially along the coasts of Spain and southern France and in the Black Sea. The circular pattern, or gyre, near the Strait of Gibraltar is caused by complex circulation patterns resulting from the exchange of water between the Mediterranean and the Atlantic Ocean. Surrounding countries are shown in black for reference.

As the cradle of Western civilization, the Mediterranean often provided an adequate marine bounty to a population much smaller than what it is today. Today this great sea has also been used as a sewer for the 350 million people who bound its shores—plus another 100 million annual tourists. A decade ago, 85 percent of the sewage that flowed into the Mediterranean was untreated. Ironically, this discharge helped to create some of the areas of high phytoplankton productivity, but it also often caused noxious carpets of algae that choked other marine life-forms and fouled beaches. Fortunately, some efforts are under way to improve the marine environment. Since 1978 seventeen Mediterranean nations have signed a series of protocols agreeing to stop dumping waste in the sea and to police land-based pollution. The April 1991 oil spill of 42 million gallons at Genoa, Italy, the largest such Mediterranean spill to date, indicates that this enclosed sea is still vulnerable to human activity.

Tropical Reef, Bahama Islands. Eleuthera Island, one of the Bahama Islands, rises above the water on the eastern edge of a submerged coral reef which is part of the Great Bahama Bank. Corals are small marine animals with hard calcium skeletons which live in association with marine plants and can grow only in shallow, sunlit waters. Reefs are the accumulation of coral skeletons, debris, and living corals. Each succeeding coral generation grows atop the skeletal remains of the preceding one. Eventually corals build up from the shallow seafloor to sea level. When sea levels drop, reefs can evolve into islands by accumulating sands, on which ocean-borne plants and animals establish themselves.

In this false-color image, the lush tropical vegetation of the 80-mile-long island appears bright red. Shallow water is aqua and deeper water is darker blue. The underwater, fringing reefs to the west of the island are seen as irregular bands of light and dark blue. Wave patterns in the Atlantic Ocean are also visible on the western side of the island. Reefs play an important role in protecting the fragile shorelines of islands by deflecting and dissipating the force of incoming waves.

Coral reefs can often be important indicators of past geologic and climatic conditions. Ancient reef remains have been found at depths beyond which corals can grow in the ocean, indicating the subsidence, or settling, of the seafloor through geologic time. The patterns of reefs and the depth of their growth can also reflect a rise or fall in sea level.

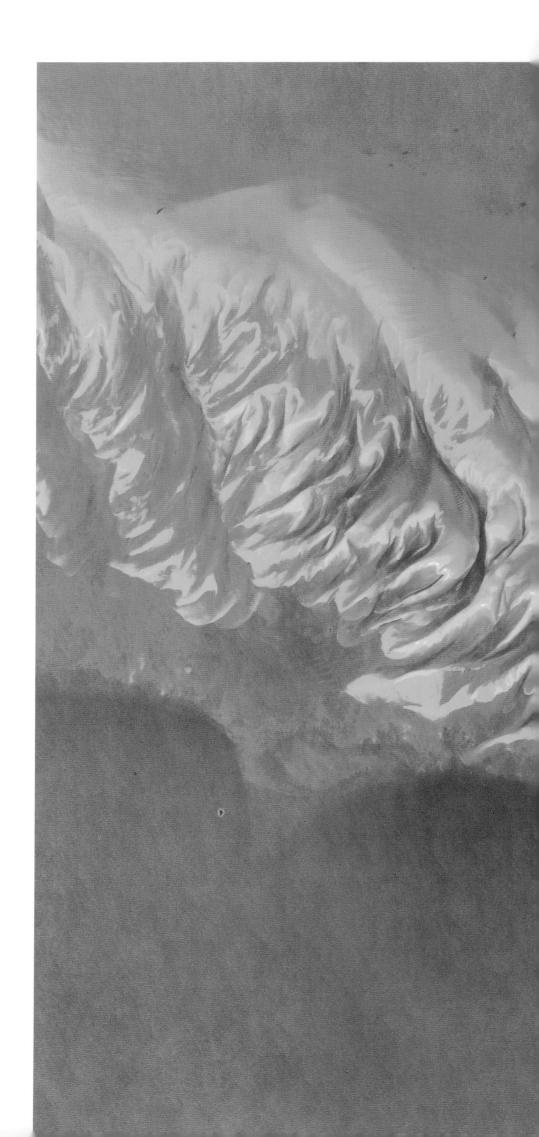

CORAL REEFS SUSTAIN A HALF-MILLION DIFFERENT SPECIES OF LIFE.

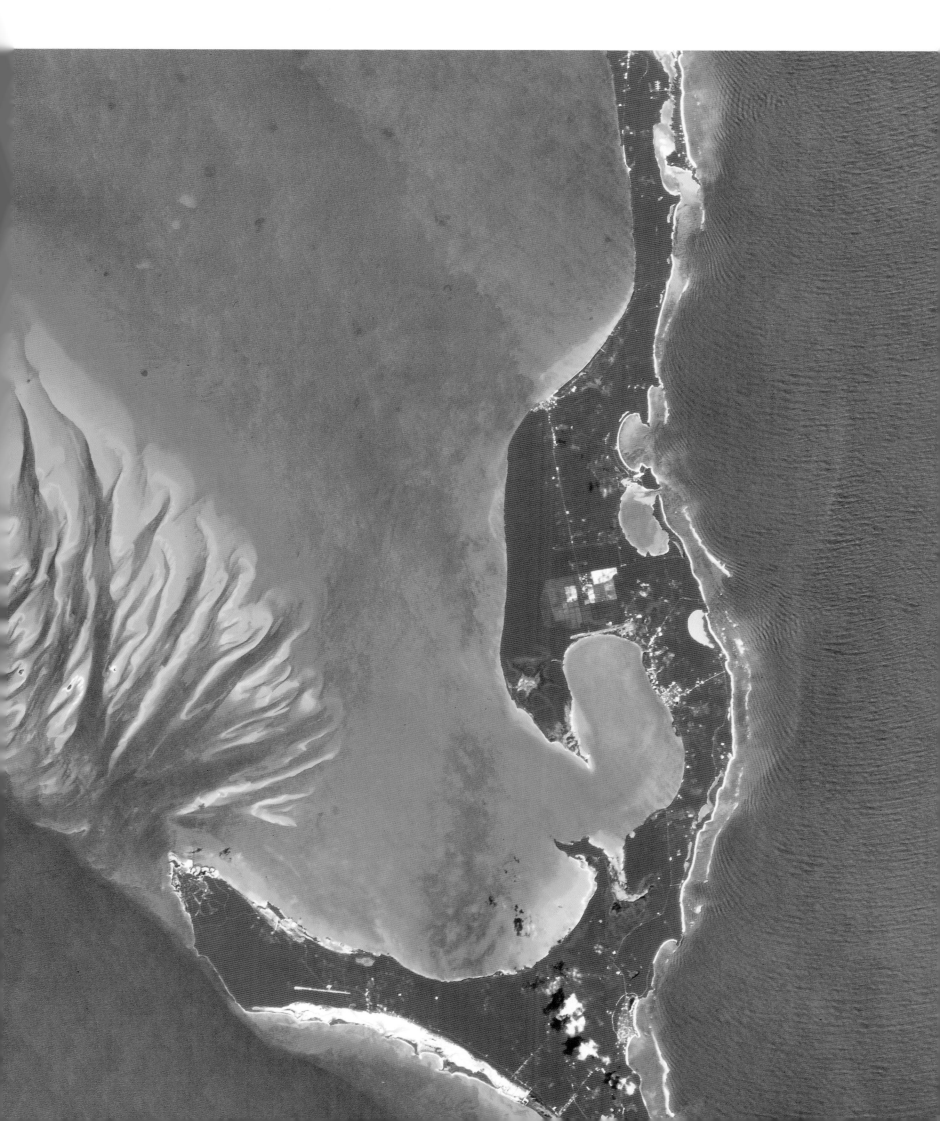

Ocean Seasons, Baja California, Mexico. Although most of us can watch the seasons change by observing leaves bud, grow, turn color, and finally fall, few can appreciate similar cycles in the sea. A special NASA sensor is able to measure chlorophyll—the pigment that colors plants green—and thus measure the cycles of marine plants. Because these plants, termed phytoplankton, are at the base of the food chain, satellite measurements are an indicator of ocean productivity.

The 800-mile-long Baja Peninsula of Mexico was created by forces that are still separating it from the mainland and opening up the long, narrow Gulf of California. The dynamics of the gulf's geography affect phytoplankton cycles.

► This image shows phytoplankton abundance as the satellite passed over the region for one day. Orange and red indicate high levels of plant life; green and yellow, intermediate levels; and purple and blue, low levels. Notice the high levels along the coasts and in the northern region of the gulf. Eddies and jets of water extend for hundreds of miles in long filaments of phytoplankton-rich water on the Pacific Ocean side of Baja. These high concentrations are caused by wind-driven upwelling that pulls up nutrients from deeper water. The southern area of the gulf contains low-nutrient surface water, while the northern regions above the Midriff Islands are rich in plant life due to strong tidal currents that mix the water and bring up nutrients.

▼ These two images, which average three months of data, reveal the seasonal variations in the distribution and abundance of phytoplankton. The most striking features are the low level of phytoplankton in the summer (left) and the high concentration in the fall (right). The increase is due to upwelling caused by strong northwest winds in the fall, in both the Pacific and the gulf regions. The satellite data upon which the observations here are based exceed all at-sea measurements of phytoplankton made in this area to date.

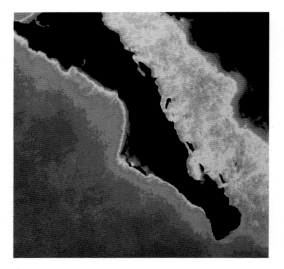
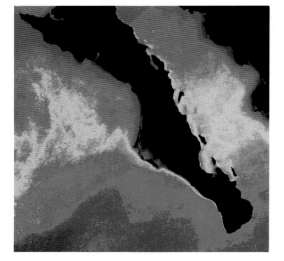

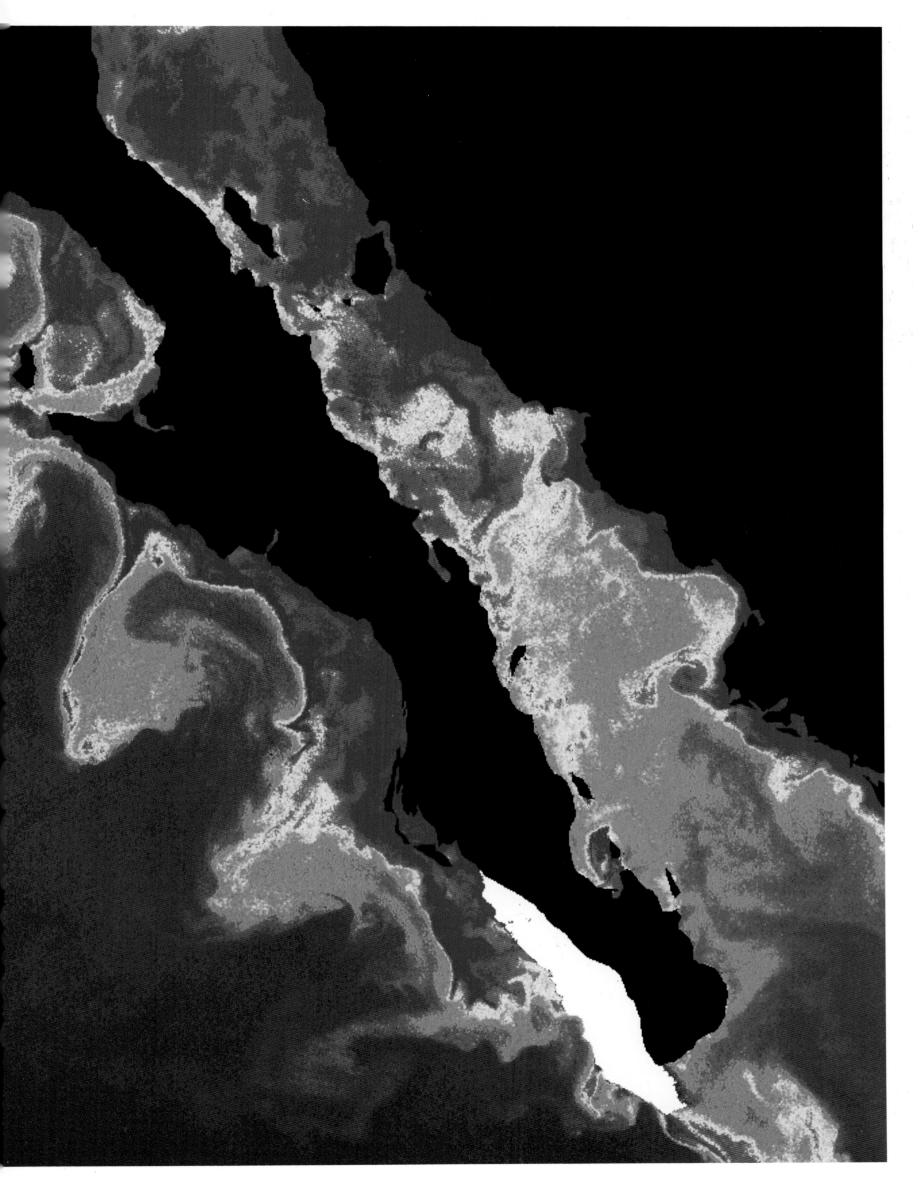

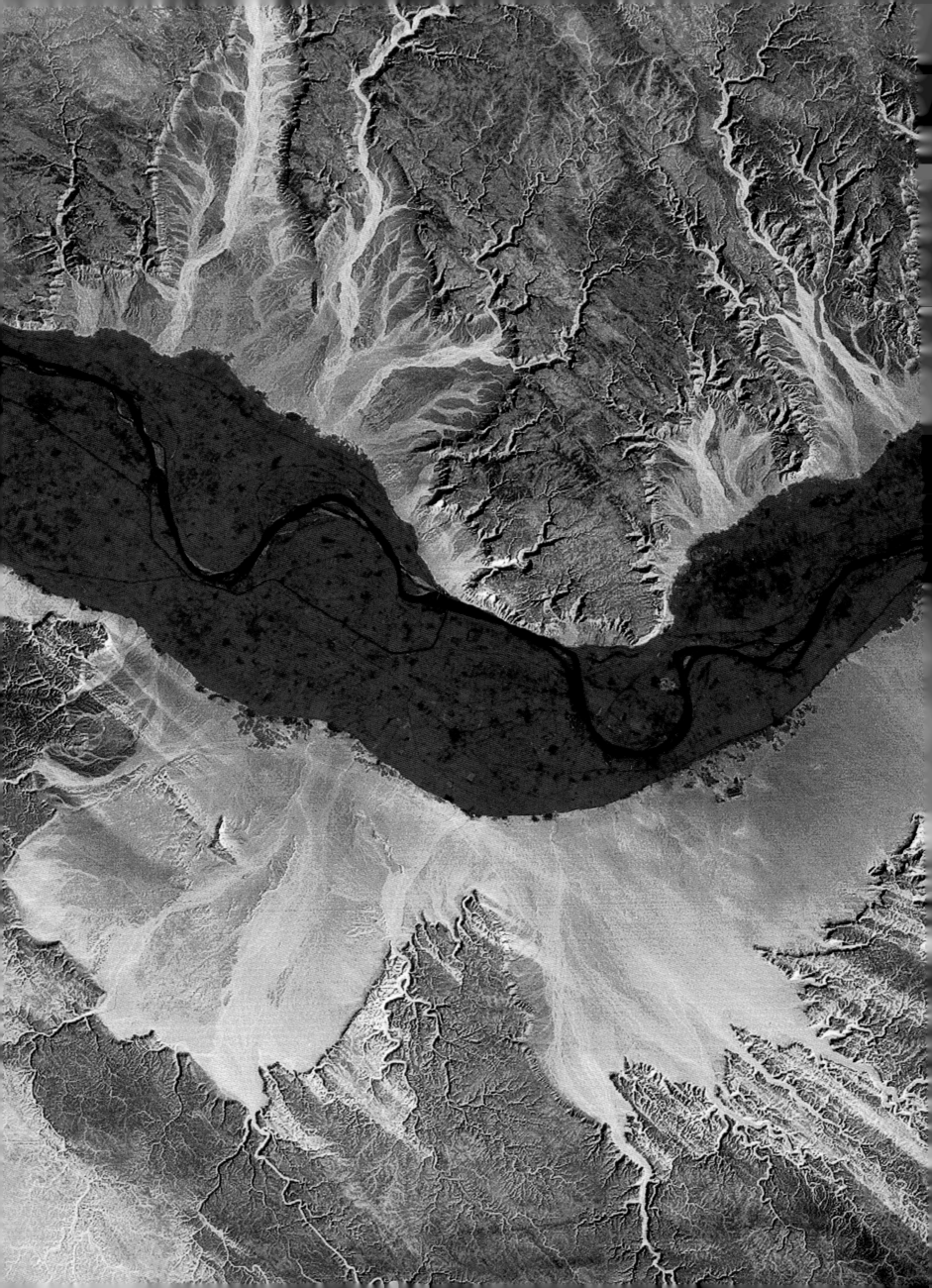

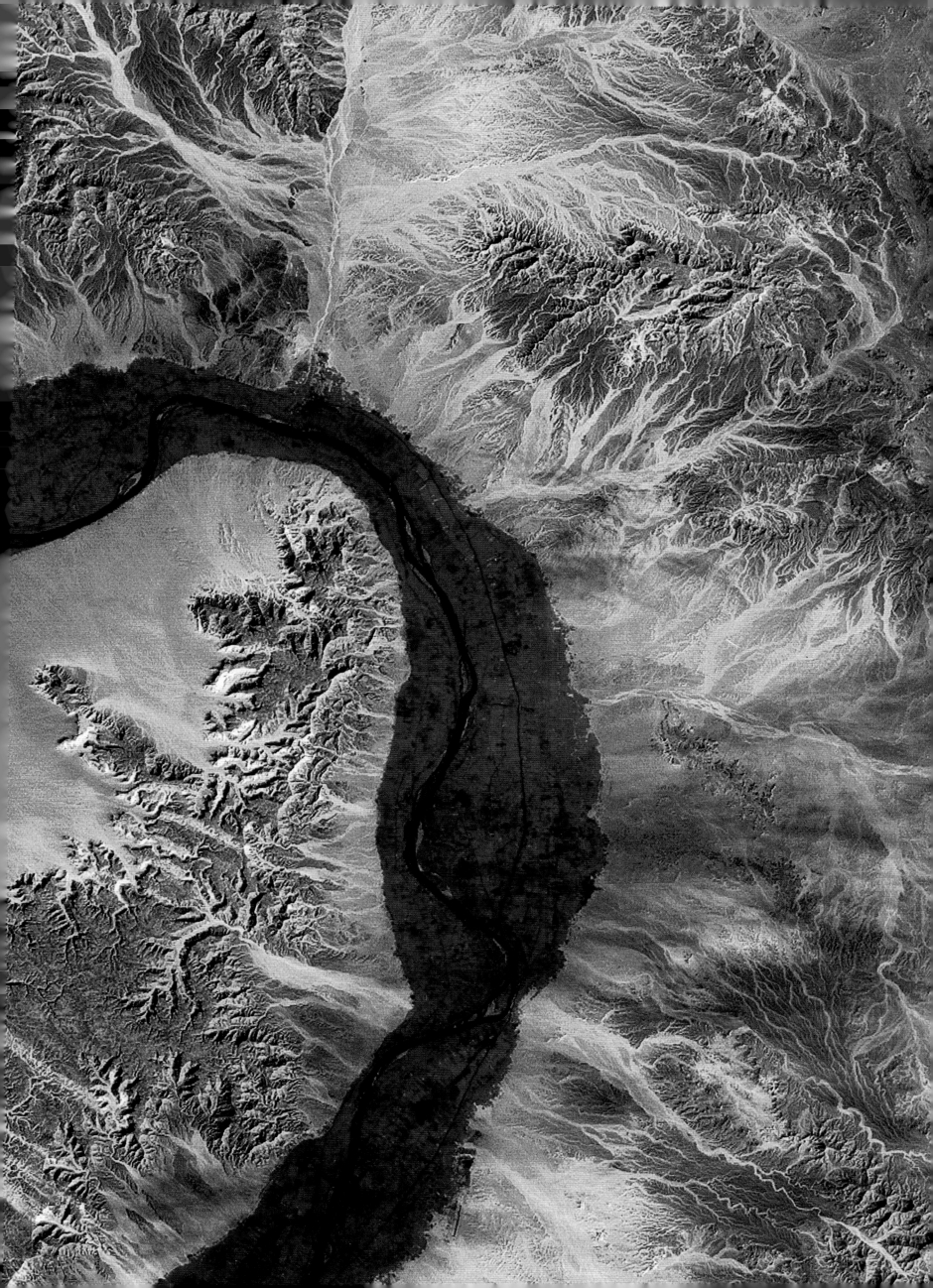

◄ **Forest Details, Central America.** One of the promising aspects of observing terrestrial vegetation by satellite is the ability to see not only the overview of a region but also the details. Newly developed techniques use airborne multifrequency radars to study tropical rain forest ecology. Shown here is a composite image of a 1,600-square-mile area of Central American forest. Parts of three countries are included: Mexico, on the top and bottom right; Guatemala, on the top left; and Belize, on the bottom left. A large portion of the image is undisturbed rain forest in Belize and Guatemala, which appears green. Forest that has been clear-cut for agriculture appears at the top center as dark blue, rectangular plots. Marshland formed by water flooding from the Booth River in Belize is at the right.

These sensor techniques are most sensitive to objects of about the same size as the radar wavelength. Thus, by using different wavelengths, the sensors can identify specific details of vegetation of different sizes. These distinctions can be enhanced by employing computer colors and sophisticated mathematical models so that eventually tree trunks, twigs, stems, and leaves in the upper forest canopy, as well as grasses, can all be distinguished. In this image grasses appear blue. By combining this data with information on the water content of vegetation gathered from the ground, the total biomass of the vegetation can be analyzed. All these observations further our regional and global understanding of the relationship between the living and nonliving components of our planet.

◄◄ **Nile River, Egypt** (previous pages). This great river in Africa is intimately associated with the civilization of ancient Egypt, which had its birth over five thousand years ago. The river's annual cycle of flooding ensured the fertility of the Nile Valley within the deserts that make up most of Egypt. Shown here is the Nile River where it forms a U-shaped bend north of the Aswan High Dam in southeast Egypt. The river is about 1/2 mile wide, with vegetation, shown in red, extending approximately 4 miles out from its banks. The desert is tan.

Yellowstone Fires, United States. When over 793,000 acres of Yellowstone National Park in Wyoming, Idaho, and Montana burned in the summer of 1988, many people were concerned that the first and most cherished national park in the United States lay in charred ruins. In the aftermath of the fires, there was serious debate about forest management practices: should a fire be controlled or allowed to burn? Fires, however, are an important process in the natural history of most forests. They allow different ecosystems to evolve in the forest life cycle. The Yellowstone fires, though spectacular, were part of an inevitable cycle. Within the soft ash lay seeds released from pinecones opened by the searing heat, waiting to sprout with the next heavy rains. Satellite imagery helped identify the progress of the Yellowstone fires and the extent of their damage.

▼ On July 22, the fires had already started, with a major fire burning to the northeast of the lake (right side of image).

► The large image shows the fires on September 8, when they were burning intensely in the park (outlined in red). White smoke plumes can be seen throughout the park. Burned forest areas are dark magenta; shrubs and grassland are light magenta; untouched pines are green. Yellowstone Lake is in the center of the image. The small image shows the park on October 2, when the fires had been extinguished by heavy rains, snow, and cooler temperatures. The extensive loss of trees and vegetation is seen in the red regions.

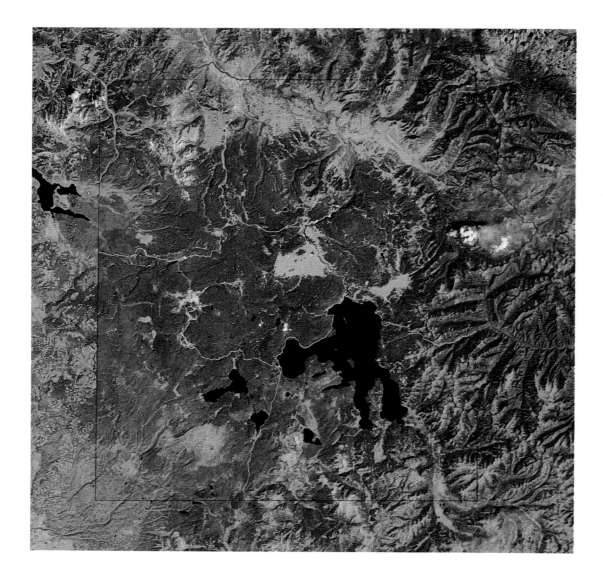

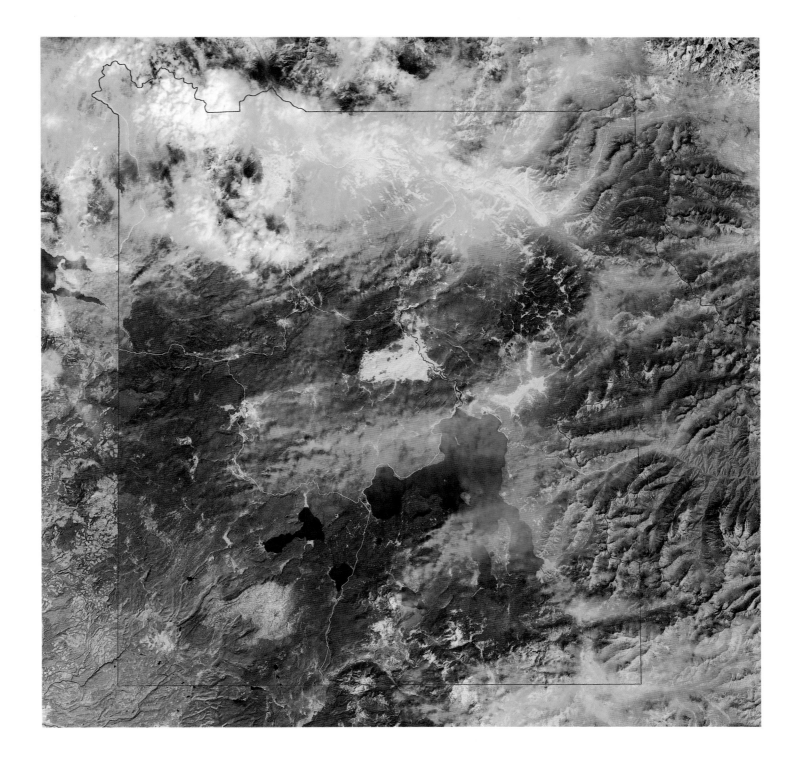

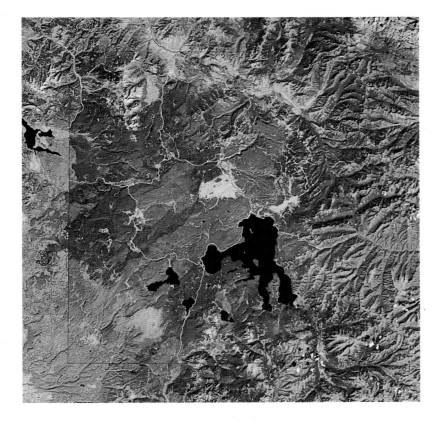

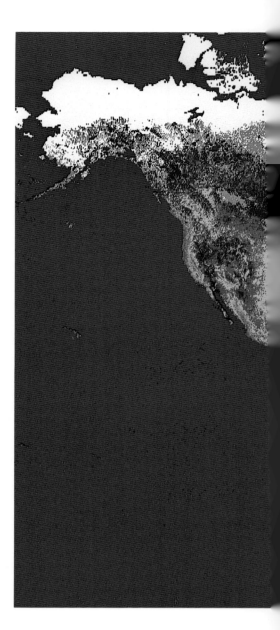

Global Seasonal Greening. The rhythms of the seasons sweep over the planet with cycles of greening of the Earth's vegetation. As winter subsides and days lengthen, the increase in temperature and light enables seeds to germinate and the soil to blossom with life.

Satellites monitor greening cycles on a global scale by using sensors that can measure the density of vegetation. These two false-color images comparing the summer and winter of 1987 are based on the seasonal duration of green vegetation. Regions with the most vegetation are green; those with less vegetation are shades of brown and tan; those with very little vegetation are gray. White indicates areas where the data have been omitted.

The winter image (January/February), at the top, shows little green vegetation throughout most of the Northern Hemisphere. The United States has very low levels of green vegetation, except for the southern states. The Southern Hemisphere, which is experiencing summer, has more green vegetation. The summer image (July/August), below, indicates a dramatic increase in green vegetation in the Northern Hemisphere. Regions of the world with long growing seasons, such as the equatorial rain forests of Africa and South America, have the greatest amounts of annual green vegetation. Satellite images showing seasonal vegetation are being used not only to monitor global vegetation but also to observe climatic conditions around the world.

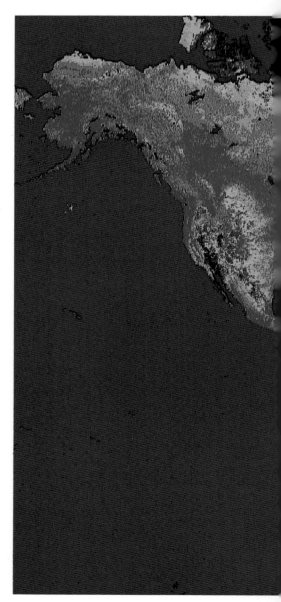

Rain smell
 I am full of hunger
 deep and longing to touch
wet tall grass, green and strong beneath.
This woman loved a man
and she breathed to him
 her damp earth song.

 ...

I remember it in the wide blue sky
when the rain smell comes with the wind.

Leslie Marmon Silko, poet

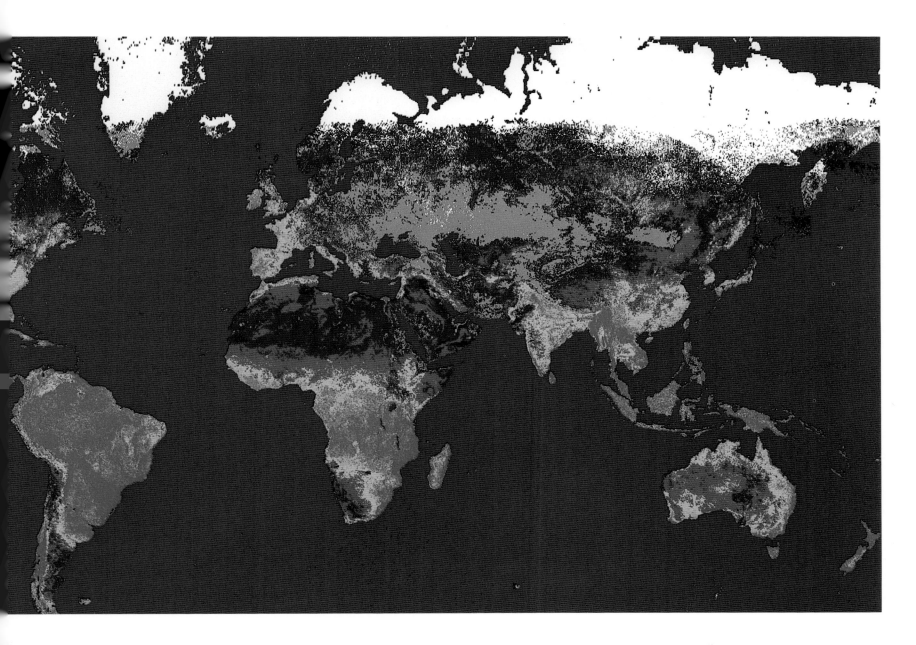

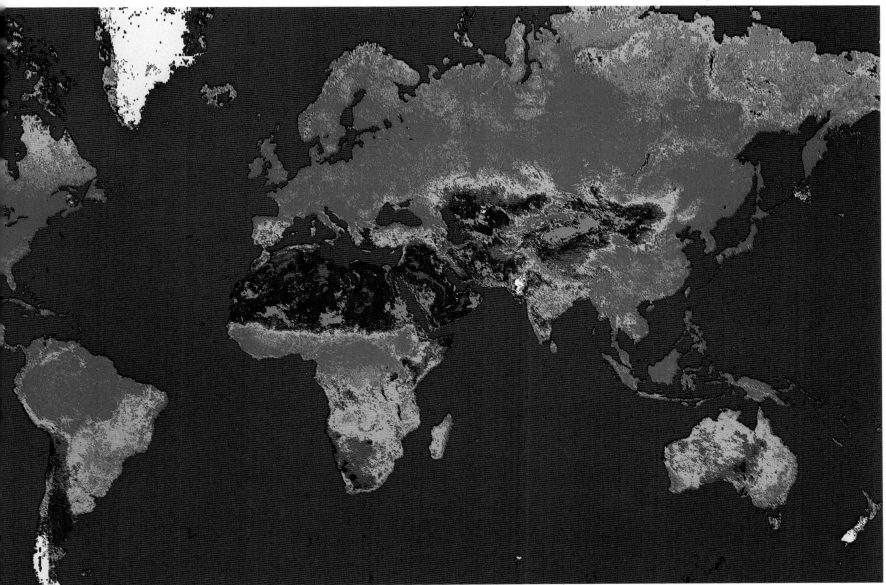

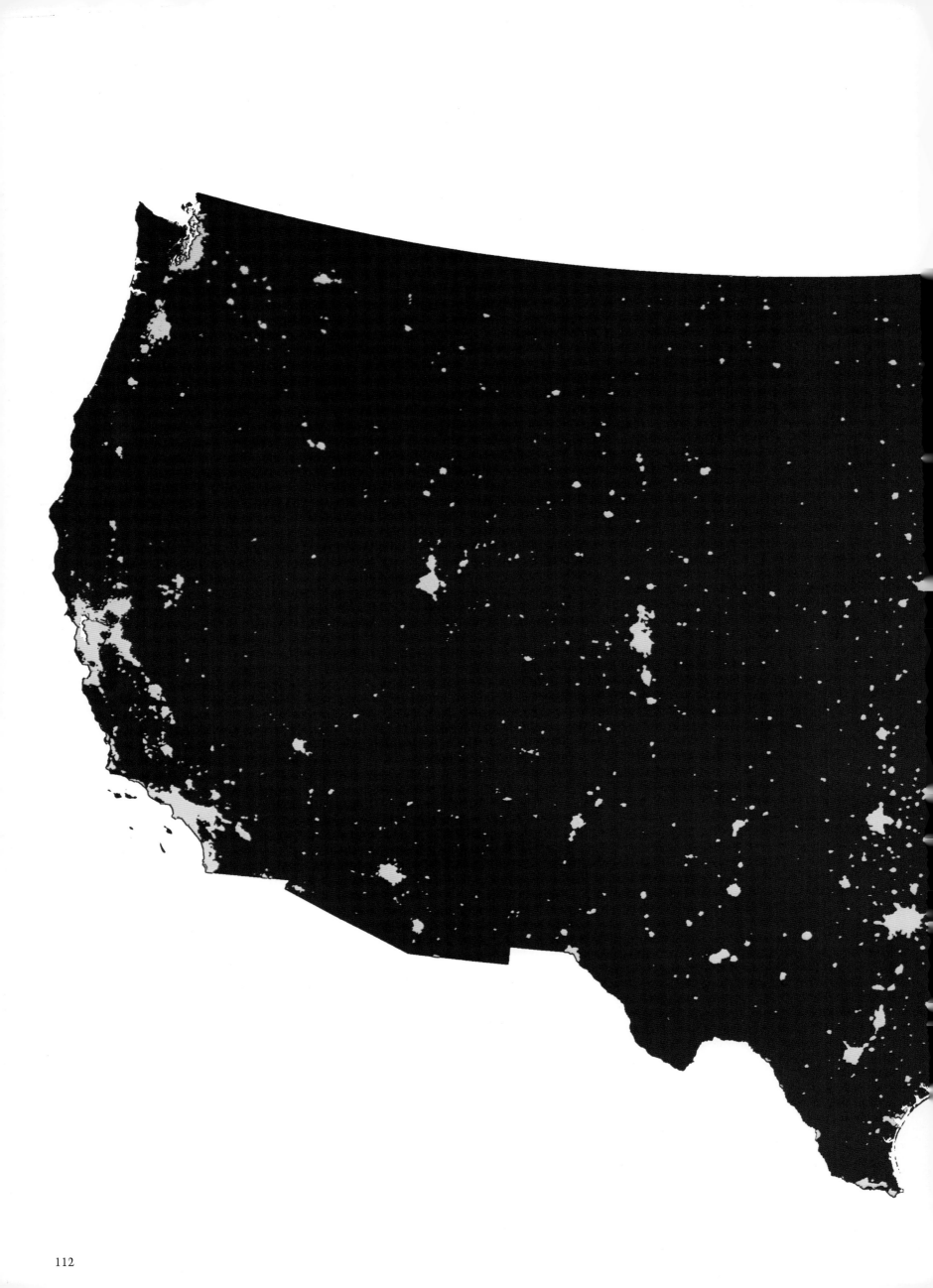

Nightlife, USA. The natural features of our planet in daylight are the main focus of this book. In contrast, this image shows the presence of human activities as reflected by computer composite satellite sensing that detects illumination at night. This electric tapestry of street and building lights leaking into space includes the main urban areas of the United States. Extensive metropolises glow brightly on both coasts, along the Gulf of Mexico, and around the Great Lakes.

HUMAN IMPACTS

We have hands that create tools and a mind that pushes the limits of their use. We leave our imprint everywhere we go, from cave paintings to footprints on the moon. Nature has been very forgiving. We have survived natural catastrophes and our own excesses. There has always been somewhere else to go. But now we are engaged in an environmental experiment on a global scale. And the Earth speaks to us with our greatest challenge: understand human impact; live in balance.

HUMAN IMPACTS

The human species is at the evolutionary pinnacle of life on Earth. In the span of 1 to 2 million years, we have evolved from an intelligent primate standing upright on the African savannah to an organism that has been able to adapt to and colonize almost every region of the planet. In our search for security in the face of the uncertainties of the natural world, we have almost become the mythic gods we once worshipped. We harnessed fire to keep us warm and developed tools to expand our material capabilities. We pioneered agriculture and animal husbandry to provide us with a steady source of food. We created language, writing, art, and science to explore our world and to leave a record of the workings of our minds and the achievements of our cultures. For a young species, we have amassed an impressive list of accomplishments. Humans can plumb the depths of the oceans, fly though the air, visit the Moon, send probes to the end of the solar system, and watch the ebb and flow of daily events around the world by pushing a button and gazing at a glowing tube.

The evolution of our brain, and its thin cortex with billions of cells transmitting and storing messages, has given us wondrous skills. Yet our power to create is matched by our one great flaw: the power to destroy. Recorded throughout history are the civilizations whose cultural legacies have enriched our species. The ability of civilizations to thrive and expand their domains is sadly mirrored by their involvement in continual warfare and other self-destructive behaviors.

The human impact on our planet has been both positive and negative. Our widespread mark ranges from irrigation in the desert and freeways connecting whole continents to massive oil spills in the oceans and cities decimated by missiles raining from the air. Over thousands of years, we have evolved beyond

being only one species among many in the natural world to having the ability to affect it on a global scale, with potentially disastrous results for ourselves and for other life-forms. So despite our technological prowess, the great philosophical questions are still with us: Who are we? Why are we here? Where are we going?

The satellite images in the previous chapter allow us to perceive some of the natural rhythms that constitute the pulse of the planet. The images in this chapter are like a report on the human impact on the Earth as viewed from space. They do not allow us to see the positive contributions of the many cultures inhabiting the planet. Yet what they do reveal is our ability to manipulate the natural world to achieve our own ends. In the process we have taken advantage of resources and opportunities. But we have also threatened the well-being of the environment that has served us so well. The most impressive aspect of the images is how they show the scale of our impact as seen from space and the magnitude of the patterns we are imposing on the Earth's surface. The images of urban centers can be seen as great accomplishments of our civilization, or they can also be seen as overextended systems that are not in balance, with their unhealthy levels of air pollution, traffic, and poverty. Ultimately, our interpretation of these images depends on our values and how we would ideally choose to live.

What is clear is that satellites enable us to track our impacts through time, and some of the portraits are disconcerting warnings. Fires viewed from space often indicate not only the destruction of forests but also the extinction of species. The ozone hole over Antarctica is enlarging, and the protective ozone layer of the atmosphere over the rest of the planet is thinning. The tiny glowing dot of heat energy from the April 1986 accident at the Chernobyl nuclear plant in the Soviet Union was seen from space. Satellites also record the forests destroyed by acid rain. These and other pressing environmental concerns are all functions of human impact.

The biggest immediate global challenge we now face is trying to assess whether—or how—the climate is changing due to our impact. We know that gases resulting in the greenhouse effect, such as carbon dioxide, warm the Earth and that their concentrations are increasing from the effects of industrial activities and our use of the automobile. These impacts will probably result in additional global warming. We can predict, using computer models, the general outcome of this scenario if it continues unaltered. Studies indicate that the global mean temperature will probably increase 5°F by the end of the twenty-first century. This could cause a global mean rise in sea level of up to one foot by 2030.

The satellites in place now and those planned for the future, such as NASA's Earth Observing System, will be watching the progress of our impacts. If sea levels rise, we will certainly see the coastal geography change for many regions. Island countries such as the Maldives in the Indian Ocean, which are close to sea level, may even disappear, as will low-lying delta regions. These satellite images are a record of our activities—a snapshot of where we are headed. They offer us a new perspective on the age-old questions of who we are and why we are here. They also offer a warning about where we are going. The warning resonates with truth: an unwelcome fate will be inflicted on those who do not consciously create their destiny.

Ozone Hole over Antarctica. Satellite and airborne sensors have recorded the growing hole in the ozone layer. The ozone hole is a dramatic example of the impact of human presence on the Earth. The threat to the ozone layer and the environment comes from man-made chemicals known as chlorofluorocarbons (CFCs).

Atmospheric ozone protects life from the harmful solar ultraviolet (UV) radiation. For humans, ozone depletion could mean increased incidence and severity of skin cancers, cataracts, and suppression of the immune system. Increasing UV light threatens the marine and aquatic microscopic plants that are the foundation of the food chain. CFC chemicals used in air-conditioning, spray cans, and blown foams are the main destroyers of ozone. In addition, CFCs are potent gases that add to the warming of the atmosphere. Each additional CFC molecule contributes to this greenhouse effect a thousand times more than a carbon dioxide molecule does.

This sequence of polar projections (with South America and Antarctica in black outline) shows, from below left to right, the ozone hole in 1979, 1987, 1988, and 1991 in October of each year, the time of maximum ozone loss. Very low levels are in purple, intermediate levels in blue-green, and higher levels in yellow-red. Antarctic ozone depletion varies from year to year, but a general trend showing decreasing levels is apparent. The lowest recorded levels of ozone occurred in 1991. Scientists have concluded that ozone depletion occurs year-round and worldwide, with a rate of loss in the 1980s that was triple the rate of the 1970s.

The ancient fear that fire from the sky would rain down and destroy the world has been supplanted today with the threat from CFCs, which is much more real. Fortunately, satellite observations have helped convince world leaders that the production and use of CFC chemicals need to be controlled and phased out. In 1990, ninety-three nations signed the Montreal Protocol, which will eliminate all CFC use by the year 2000. Although this is a good start for CFC control, many cities are enacting even more stringent limits that would take effect sooner.

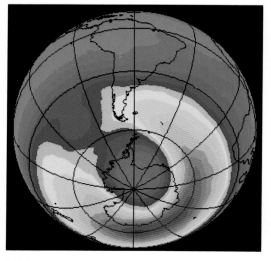

1979

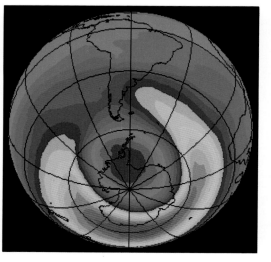

1987

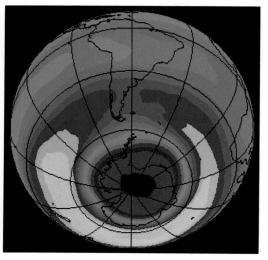

1988

EACH CHLOROFLUOROCARBON MOLECULE DESTROYS 100,000 OZONE MOLECULES.

1991

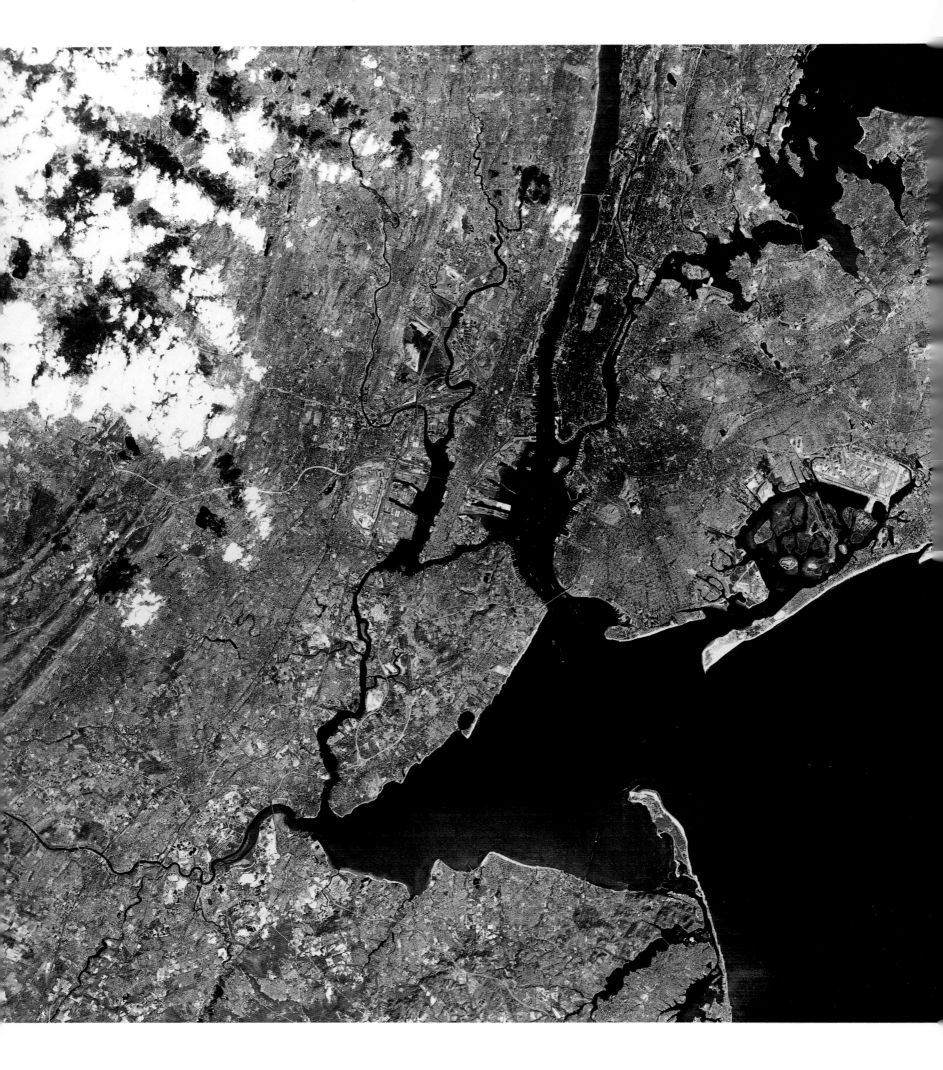

New York City, United States. The large cities of the world are highly noticeable from space, as they are on the ground, because of their concentrations of man-made materials, and the often very linear appearance of streets and city grids. New York City has been growing for over three centuries, starting in 1626, when the small island of Manhattan was reputedly purchased for $24 by the Dutch from the Native Americans. At that time the region was all forested land.

Today, New York City is a densely populated metropolis and one of the cultural and economic magnets of the Western world. The island of Manhattan is visible in the center of this image, surrounded by the Hudson and East rivers. The only significant remaining vegetation on Manhattan, shown in red, lies in the long rectangle of Central Park, in the center of the island. The boroughs of Brooklyn and Queens are to the right of Manhattan, and the Bronx is above it. Jersey City is to the left. Staten Island, one the few areas of the city where there is still some farming, is below the center of the photograph and shows a greater amount of vegetation, also red. Kennedy Airport, in Queens, is the prominent geometric feature above Jamaica Bay, to the right of the center of the image.

Urban Clusters. Cities have always been the jewels of civilizations. Since early history, they have expressed the vital interplay of commerce and culture. These satellite images show four major cities and their unique attributes.

► **Los Angeles, United States.** Founded by the Spanish in the early eighteenth century, Los Angeles is one of the Pacific Rim cities bounding the Pacific Ocean. The many neighborhoods of the sprawling Southern California megapolis, covering 465 square miles, are connected by a vast system of freeways. Extensive use of the automobile in a city of 3-1/2 million has created a serious problem of ever-growing air pollution. Because the region is semiarid, Los Angeles depends on fresh water brought from northern California and Arizona. Blue-green indicates urban areas; dull red, vegetation in parks and playing fields; bright reds, vegetation on hills and predominantly on the San Gabriel Mountains east of the city.

▼ **Mexico City, Mexico.** The capital of Mexico was originally founded by the Aztecs in the fourteenth century. It lies at an altitude of over 7,000 feet in the valley of a dry lake, surrounded by mountains and numerous dormant volcanic peaks, seen at the bottom of the image. It is the second-largest city in the world and growing, with a current population of 20 million and air pollution levels that threaten the health of its inhabitants. The city's urban areas and the connecting roads and streets are in blue-green; vegetation is red.

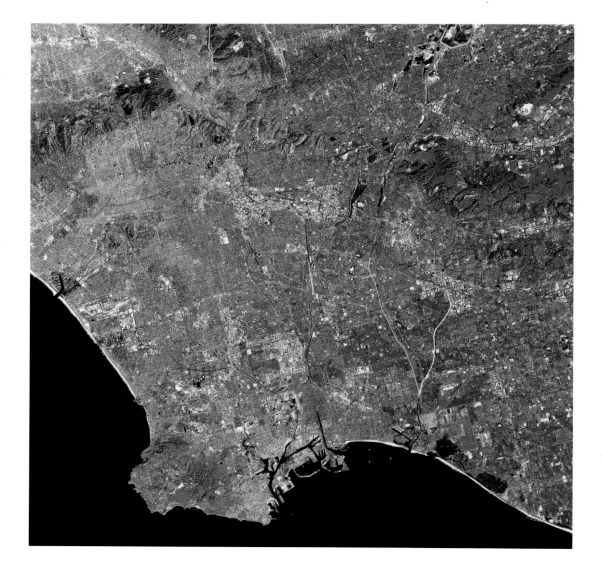

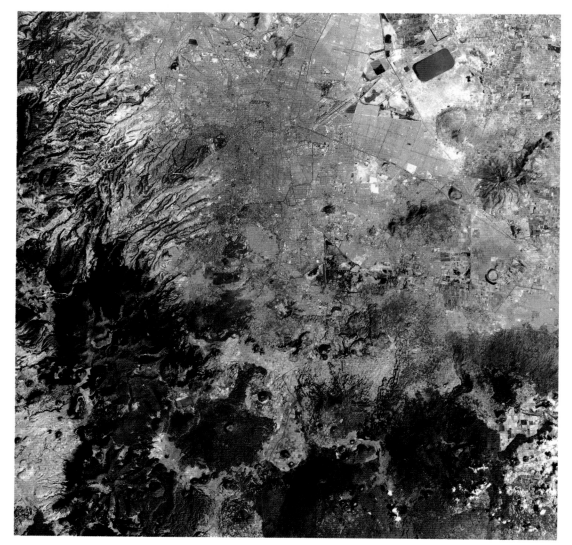

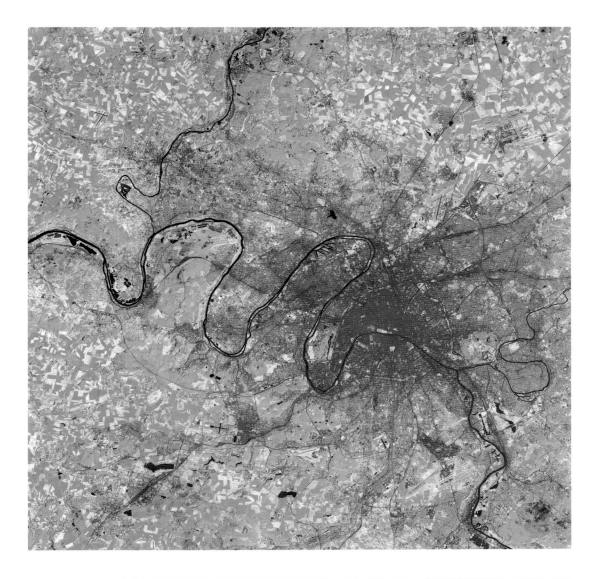

◄ **Paris, France.** The capital of France dates from the Middle Ages. It grew in a radial pattern around the Seine River, which winds through the city and continues for over 100 miles northwest to the English Channel. The population today is 9 million. Urban areas are purple; outlying farmlands are green.

▼ **Cairo, Egypt.** The modern-day capital of Egypt lies adjacent to the Nile River and its fertile delta. The delta and its extensive farmlands are shown in red; the city, at the center, is gray; the surrounding desert is tan. The current population is 10 million.

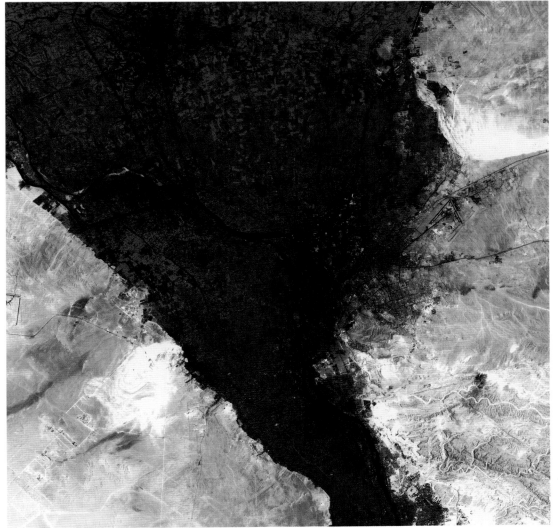

ACID RAIN HAS DAMAGED 600,000 ACRES OF FORESTS IN POLAND AND ALMOST
1 MILLION ACRES IN CZECHOSLOVAKIA.

Acid Rain. Among the serious impacts of burning fossil fuels are atmospheric pollutants known as acid rain. Acid rain is caused by a complex mix of chemical reactions involving sulfur dioxide and nitrous oxides. When these gases interact with water vapor, sunlight, and oxygen, they produce a "soup" of sulfuric and nitric acid compounds. Either by falling to the ground in rain and snow, or by coming in direct contact with clouds, the airborne acids and other pollutants can kill and denude forests and destroy life in lakes and rivers. They can also cause health problems for humans and corrode building exteriors and other metallic and painted surfaces.

Acid rain is carried by winds across national boundaries. Industrial pollution generated in the United States affects forests in Canada; pollution from the United Kingdom blows eastward and impacts Scandinavia. Volcanic eruptions and forest fires are natural processes that also cause acid rain, but in many regions nature's contribution is dwarfed by pollution from human activities.

◄ **Eastern Europe.** This image shows the impact of pollution from toxic gases and acid rain on the forests in the Erzgebirge, a mountain range on the northern border between Czechoslovakia and Germany near Dresden. Germany is at the top left; Czechoslovakia is at the bottom. Healthy forests appear black-red; damaged forests, located in a diagonal at the center of the image, are orange. Two pale smoke plumes from one of the largest coal-fired electric power plants in Czechoslovakia, which contribute to the pollution, can be seen to the right of the center of the image.

▼ **United States.** Air pollution has also affected the forests of central Vermont in the United States. This image shows the Green Mountains in the region southeast of Burlington. The Winooski River is at the top of the image. Camels Hump Mountain, at 4,083 feet in elevation, is below the river. Healthy forests are green. Damaged forests are red and are caused in part by airborne pollutants and acid rain coming from the urban corridors of New York City, Boston, and Washington, DC, as well as traveling from areas hundreds of miles to the west.

Even if I were certain that the world would end tomorrow,
I would plant a tree this very day.

Martin Luther King, Jr., civil rights leader

Deforestation, Brazil. Concern about global deforestation has raised awareness of how important trees are for the health of our planet. They remove from the atmosphere carbon dioxide—a potent gas that contributes to greenhouse warming. When a forest is cleared, fewer trees are left to absorb carbon dioxide for photosynthesis. Furthermore, burning the cut trees adds carbon dioxide to the atmosphere. Many countries besides those in the tropics have histories of intense logging or clearing. The United States was once heavily forested from the Atlantic Ocean to the Mississippi River. Lebanon long ago had abundant cedars. Today rain forests are being cleared at the rate of 50 acres per minute, and the loss of habitat is driving countless species into extinction.

Satellites have monitored much of the deforestation of the rain forest. Year-to-year comparisons of disturbed rain forest such as these images of the state of Rondônia in Brazil in 1975 (below) and 1986 (opposite) record the dramatic expansion of forest clearing. Clear-cutting has followed a systematic pattern: main roads reach into the rain forest, then fan out to create the feather pattern shown in 1986. Healthy forest is in red; deforested regions are in light green and blue. The discovery of gold in the Amazon basin has added to the destruction of the rain forest as new areas are cleared and mercury, a gold refinery by-product, has been allowed to pollute the region.

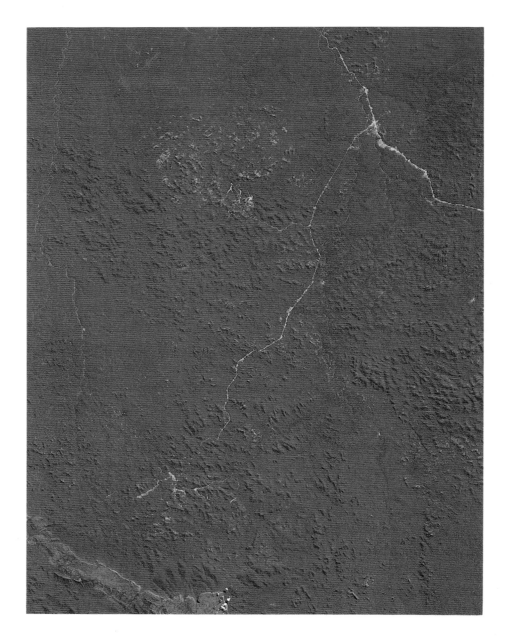

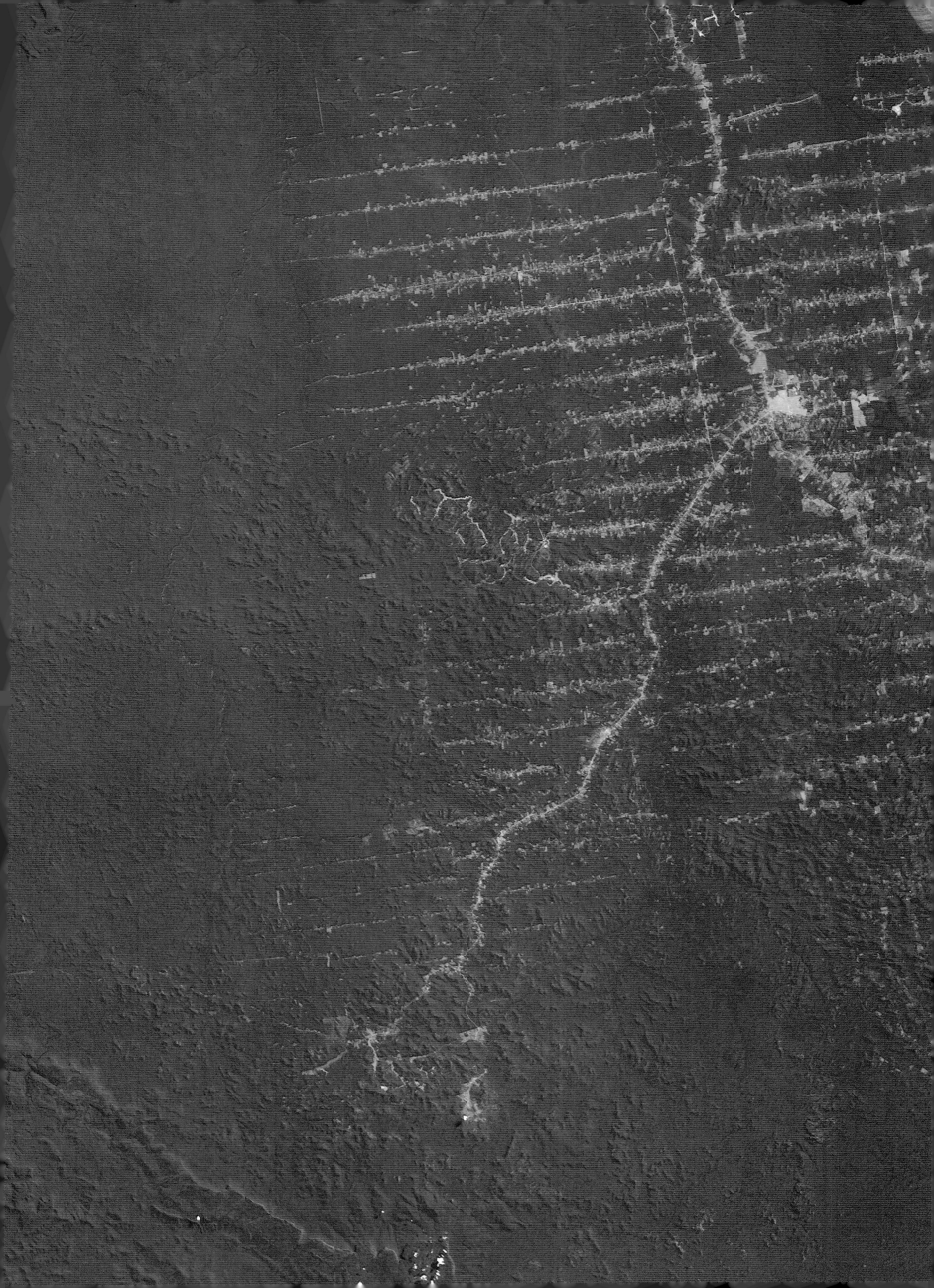

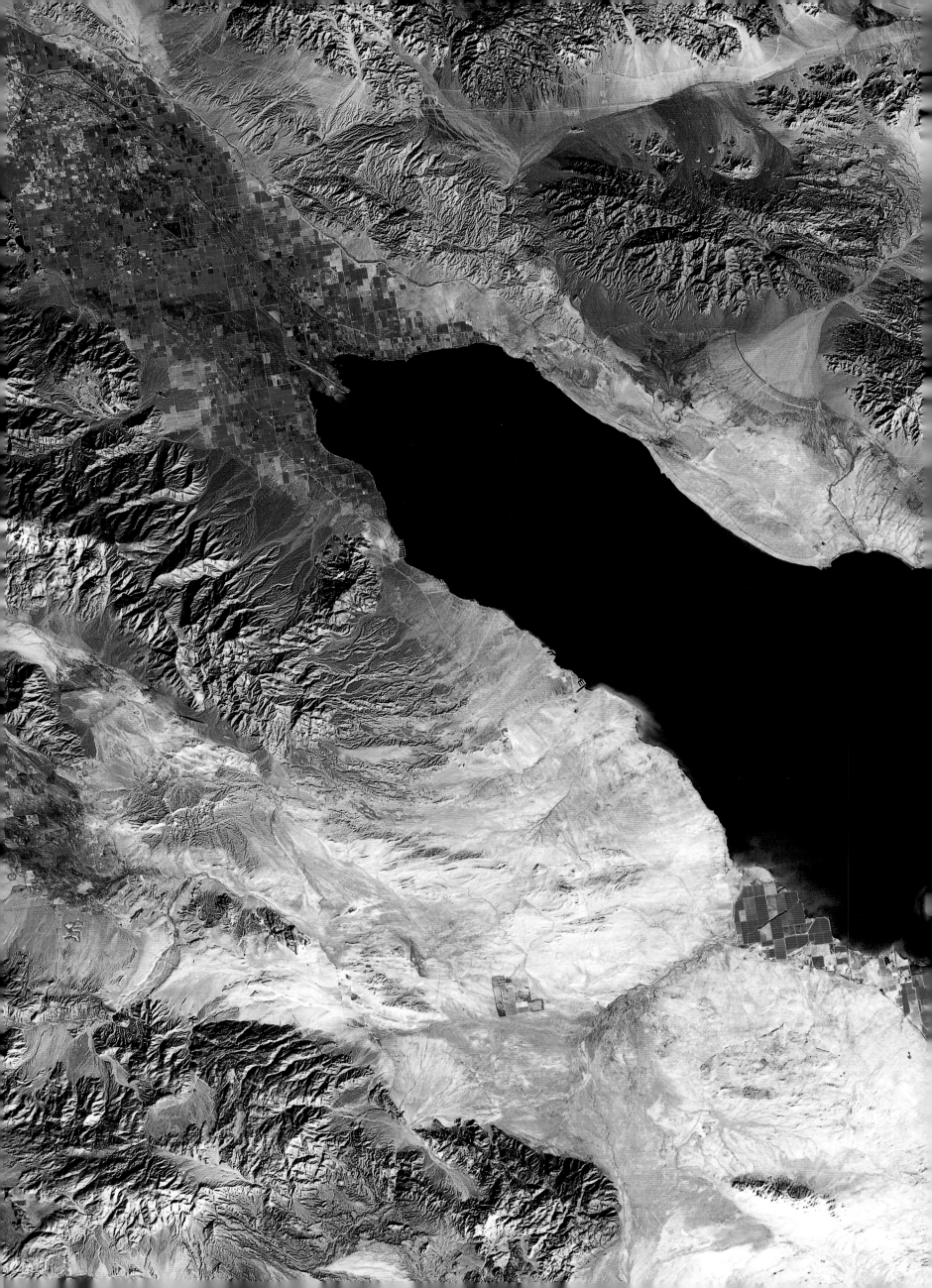

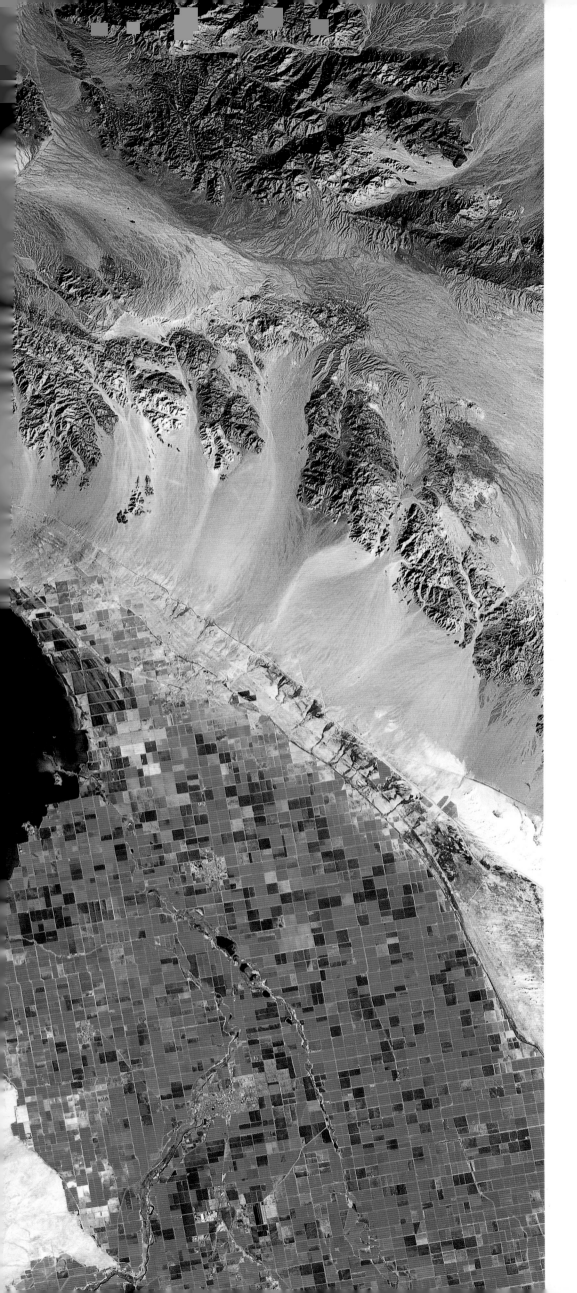

Agriculture in the Desert, United States.
The Salton Sea, in the Imperial Valley of
southern California, was created in the early
twentieth century when the Colorado River
flooded its banks and irrigation channels,
spilling into two deep washes. Like many
semiarid regions of the world, this region has
bloomed with the addition of life-giving
water. Israel, Saudi Arabia, and the American
Southwest have all benefited from irrigation
to develop extensive agriculture.

Vegetation is shown in red, which creates
the checkerboard pattern of farming plots.
The surrounding desert is gray and tan. The
widespread farming is the result of irrigation
made possible by the All American Canal,
which delivers water from the Colorado
River across the desert floor. This intense
agriculture has caused problems for Mexico,
whose water supply from the Colorado River
has diminished and is often polluted by salt
buildup, pesticides, and fertilizers.

Mining Groundwater. The subsurface water stored within soil pores and rock formations is an important, often renewable resource that supports human activities. In many regions, however, groundwater is being depleted at rates faster than it can be replaced. Primarily used for agricultural irrigation and human consumption, groundwater represents an important supplement to the water supply of lakes, rivers, and reservoirs. This important resource not only is facing depletion, but is endangered by pollution. Agrichemicals, hazardous wastes, and harmful salts and minerals are all entering the groundwater, threatening its purity and its potential use.

These two sets of satellite images show changes in center pivot irrigation, which creates circular agricultural plots, in the midwestern United States and central Saudi Arabia from the early 1970s to the mid-1980s. In both cases there is a dramatic increase in the number of irrigation systems being used. Satellite images such as these play an important role in providing an inventory of irrigated crop acreage, which is essential for assessing the response of aquifers, or underground water, to changes in water use.

► **Western Kansas, United States.** This pair of images show farming and irrigation in 1972 (top) and 1988 (bottom). Crops, mainly corn, are red dots or rectangles. Fields not in cultivation are pale white. Irrigation in this area depends on the huge, underground Ogallala Aquifer—the largest source of groundwater in the United States. Extending from South Dakota to the Texas Panhandle, it irrigates over 36,000 square miles of the Great Plains, or one-fifth of all the cropland in the US. Depletion of the Ogallala Aquifer, some areas of which may only pump water for another decade, is a serious threat to crop production and the economy.

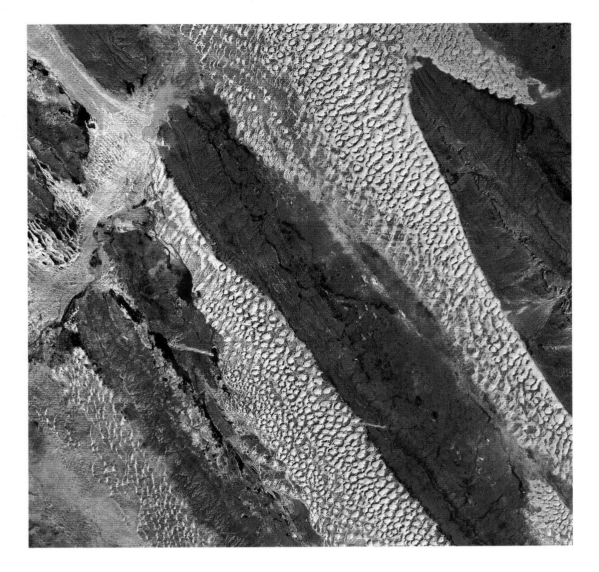

◄ **Saudi Arabia.** Striking development of irrigation has occurred from 1972 (top), when there were no center pivots, to 1986 (bottom), when there were hundreds. Pivots are red dots; dunes are yellow; desert pavement and wadis, or arroyos, are tan and purple. This view includes the city of Buraydah (top center). Oil revenues of the country have been directed toward modernizing agriculture and creating greater self-sufficiency in the production of food. As a result, desert aquifers have been mined for irrigation, predominantly of wheat. These reserves, like oil, are nonrenewable resources and at current rates of use may be depleted by the middle of the twenty-first century.

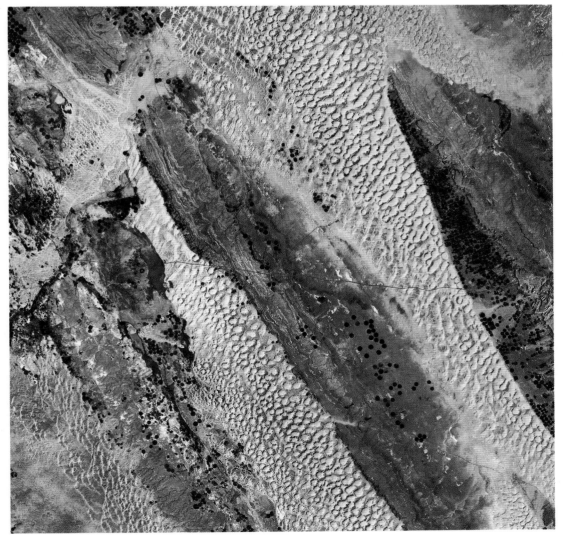

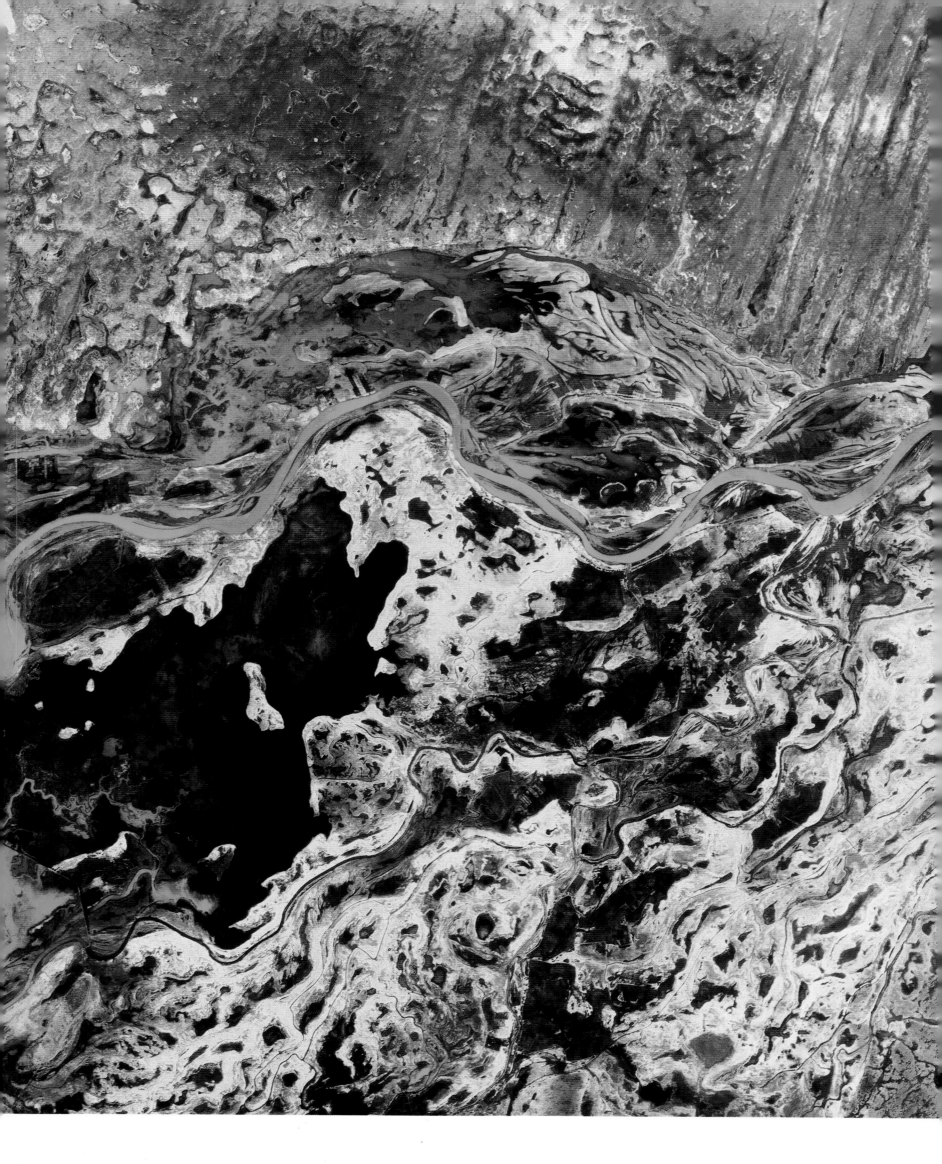

A BABY IS BORN EVERY HALF SECOND.

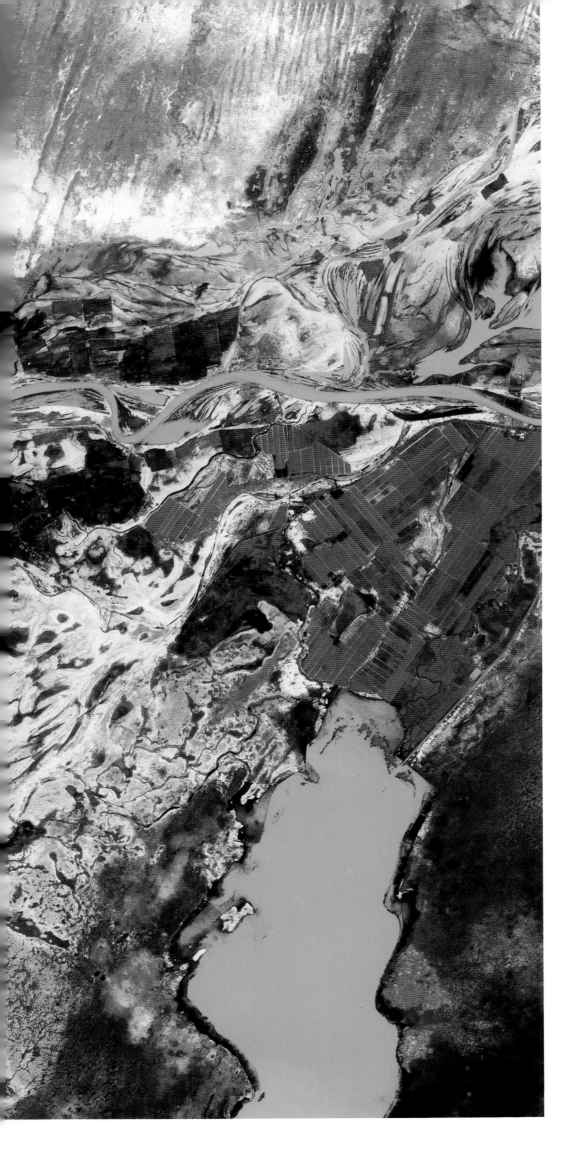

Irrigated Cropland, Senegal. The population of the world is projected to increase by almost 3-1/2 billion people by 2025, and the population of Africa is expected to pass 1 billion by 2010. The plight of drought and human starvation in Africa has been a global concern for over a decade. Increased population, persistent drought, and wars have prevented any long-term solution to these problems for many African countries. In order to meet the food demands of this growing population, agricultural production has been expanded through the use of irrigation technologies. Irrigation of croplands has already provided more than half the increase in global agricultural production over the last twenty years, but it has also meant associated problems for both the farmers and the environment.

This image, made during the rainy season in the Guiers Lake region of Senegal, shows some of the effects of agricultural irrigation. The man-made channel in the lower right diverts water from the Senegal River into the blue lake. The river's salt deposits are seen as white in the lower half of the picture. These salts kill vegetation and are one of the results of irrigation, which brings minerals within the earth to the surface. The red rectangular plots indicate healthy, growing crops, mainly at the confluence of the lake and river in the right center of the image. The constant problem of expanding deserts in Africa is seen in the long, parallel yellow sand dunes at the top of the picture, adjacent to the cropland.

Aral Sea. For ten thousand years, two rivers have fed the Aral Sea—the Amu Darya and the Syr Darya—creating one of the world's largest inland bodies of water. The Aral Sea lies between the republics of Uzbekistan and Kazakhstan, east of the Caspian Sea. In 1954, the 805-mile Kara Kum Canal was built to divert the Aral's inflow. The water was used to make the desert bloom and to irrigate crops, including 90 percent of all the cotton grown in the former Soviet Union. The canal has reduced the flow of water into the Aral virtually to zero and has tragically affected the people and ecology of the region.

The unforeseen and extensive environmental impacts include increased water salinity, pesticide pollution, and loss of an important fishery. Huge storms of salt dust are spawned from the exposed shores of the shrinking lake, and these salts have reportedly been transported by winds to as far away as the Arctic. Climatic changes have made the summer and winter temperatures more extreme. For the area's inhabitants, the environmental degradation has caused such health problems as cancer, respiratory diseases, and high infant mortality.

The environmental focus now is on stabilizing the sea and the river deltas, which will entail a massive redirection of current agricultural practice and a reduction of current irrigated land by half. This solution is not an easy one, considering the economic impact it will have on those people who depend on the water from the Aral Sea for irrigation. It is clear, however, from this example, as from others, that the perceived benefits from one human activity can have long-range deleterious effects on many others.

The two satellite images here compare the northern segment of the Aral Sea in 1973 and 1987. In the intervening fourteen years, the Aral Sea dropped from the fourth to the sixth largest of the world's lakes. In 1973 (below) the Kokaral Peninsula, in the center of the image, was a relatively narrow spit extending into the sea. By 1987 (right) the Kokaral Peninsula had dramatically increased in both width and length, nearly becoming connected to the eastern shoreline of the sea. The white areas along the shoreline are exposed salt flats resulting from evaporation.

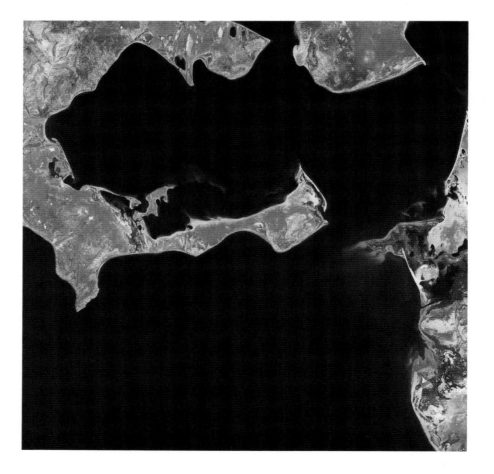

IN 1960, THE ARAL COVERED 26,000 SQUARE MILES. IF THE SEA LEVEL CONTINUES TO DROP, THE ARAL COULD DISAPPEAR BY 2020.

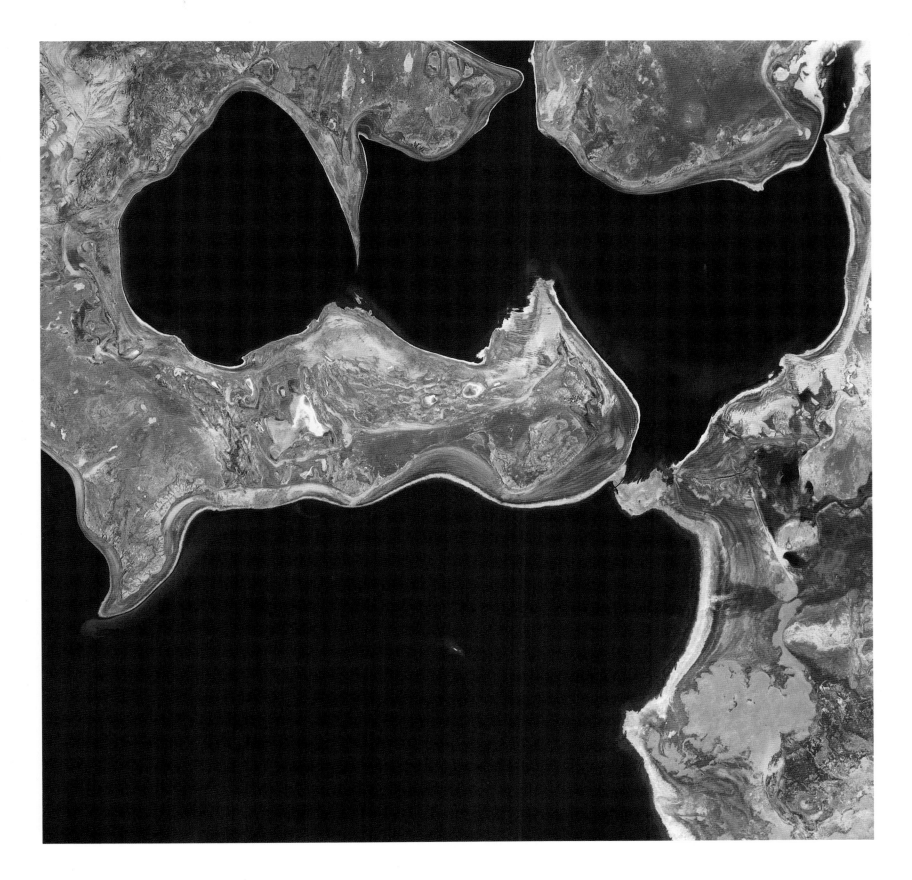

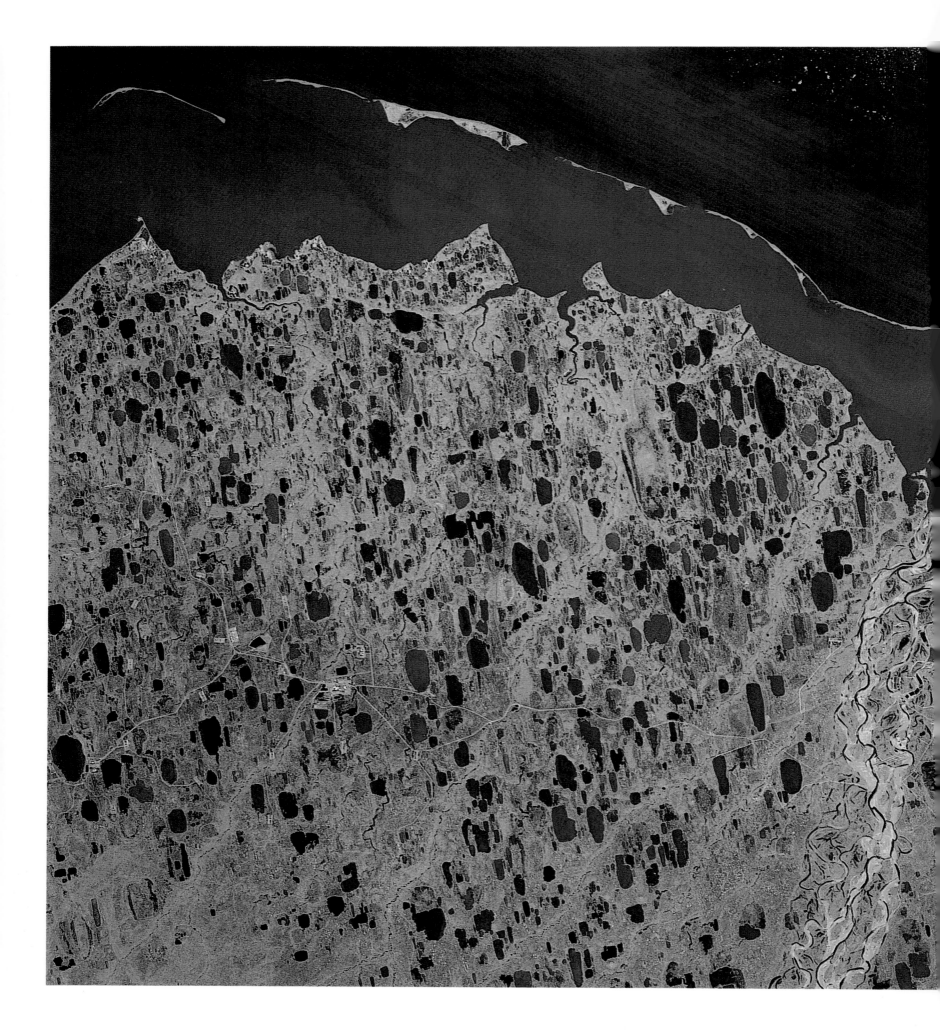

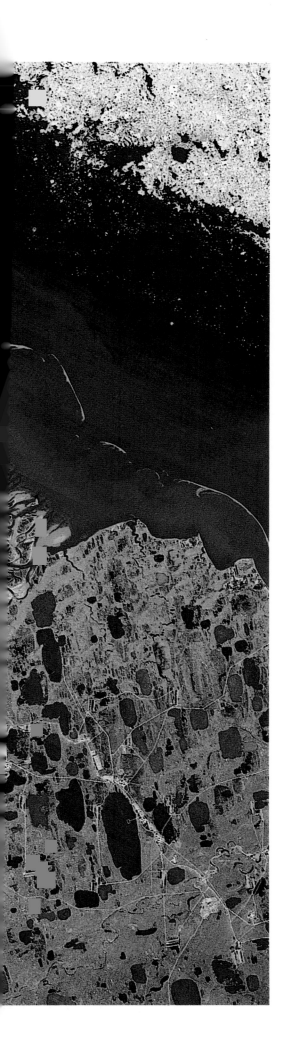

◄ **North Slope Oil Development, United States.** The North Slope of Alaska has been the site of intensive oil exploration and production since the discovery of oil fields there in 1968. This view shows the North Slope where it surrounds the Kuparuk River, on the left, and the Sagavanirktok River, on the right, as they flow northward into the Beaufort Sea. The James Islands are in a line offshore. Numerous elongated lakes are interspersed throughout the permafrost, a terrain composed of permanently frozen subsoil. Oil production sites and the roads joining them are light blue. Sparse vegetation is red-orange. This area is part of the Prudhoe Bay oil development region, where the Trans-Alaska Pipeline transports oil overland to Valdez via Fairbanks and then to Prince William Sound. Oil development in the Arctic has been subject to intense public debate over the potential negative impact on the delicate tundra environment.

▲ **Trans-Alaska Pipeline.** Stretching from Prudhoe Bay to Prince William Sound, the pipeline carries 600,000 barrels of oil a day over 800 miles across three mountain ranges, beneath 350 rivers and streams, and through areas of intense earthquake activity.

Persian Gulf War. War has always taken a toll not only on human life but also on the environment. Cities and countryside have been burned, bombed, and exposed to chemical warfare and atomic radiation. The Persian Gulf War of 1991 represented an alarming advance in the ability of the human species to make war on the environment. As the Iraqi army retreated from Kuwait, it set fire to over 700 oil wells, which burned twenty-four hours a day. The fires consumed 6 million barrels of petroleum a day—the equivalent of one-third of the daily US oil consumption, or 5 percent of the daily world oil consumption. The largest oil spill ever known—6 million barrels of crude released into the Persian Gulf—was also a deliberate act of war by the Iraqis. The spill covered 600 square miles of sea surface, blackened 300 miles of coastline, and killed over 20,000 water birds. The impact on fisheries and other marine life is yet to be determined.

Satellites monitored Kuwait before and after the war. The bottom left image is a view of Kuwait Bay and the area to the south in August 1990, before the war. The bottom right image shows the area on February 15, 1991, and the opposite image was made on February 23, after the oil wells were ignited. Kuwait City is seen at the top left of the image, on the southern side of Kuwait Bay, and the Persian Gulf is the large body of water on the right. Fires and extensive smoke are seen below the city in the Burgan oil field, the second-largest oil field in the world.

Apart from wasting a nonrenewable resource, the Kuwait oil fires are an ecological disaster with regional and potentially global consequences that could take years to reverse. The fires pumped 2 million tons of carbon dioxide into the atmosphere each day, and the smoke plume covered an area equivalent to the distance between New York and Florida. The release of other toxic chemicals has increased vegetation mortality downwind from the fires and has caused respiratory problems for people living southeast of Kuwait. The smoke plume may affect regional weather and temperature patterns by reflecting sunlight and causing unseasonable cooling. The final impacts of the Gulf War may take years to assess. One thing is clear: it was a senseless disaster and a major environmental casualty for the region.

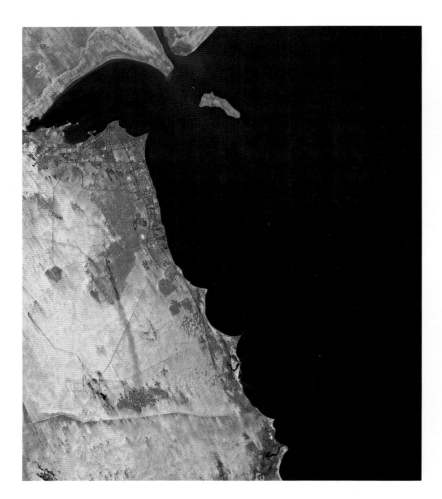

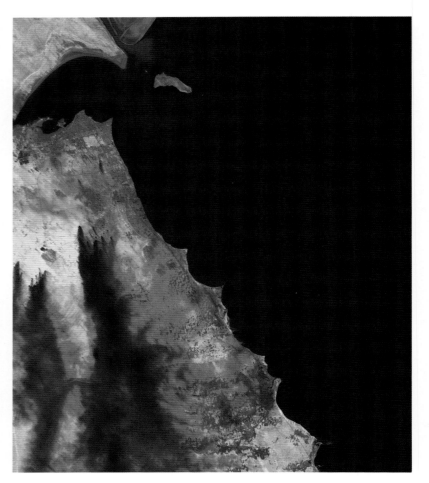

GLOBAL MILITARY EXPENDITURES TOTAL ABOUT ONE TRILLION DOLLARS A YEAR.

EMBRACING EARTH

How we treat our planet is ultimately how we view ourselves. For the first time in our evolution, we are capable of affecting the natural world on a global scale. The beauty of our planet is seen at all levels: from a distance and right before us. Our planet is our only home. We share it with many forms of life. Our own species has wondrous diversity in all its races and cultures. Embracing Earth to ensure its habitability for ourselves and other creatures is to acknowledge our own evolutionary potential and responsibility.

EMBRACING EARTH

Born in fire, our planet continually experiences enormous upheavals. Yet it has the ability to restore itself from many cataclysmic events. Storms, asteroids, volcanoes, glaciers, and earthquakes all leave destruction in their paths. But the land re-forms with new structural features, ready to be carved again by water, wind, and ice. Countless life-forms have disappeared from the tree of life through the long process of evolution. Some, like the dinosaurs, may have died in a blink of evolutionary time from the impact of a giant asteroid that changed the Earth's climate.

Whatever the time frame of change, there is usually a restorative process that allows the Earth to regenerate. Flowers return, then shrubs and trees, and with them the associated animals and ecosystems. Our planet has survived for almost 5 billion years and will continue to do so until the sun evolves into a red giant. Then, 5 billion years from now, in a supernova of blinding light and heat, the Earth's cycle will probably be over, as it becomes a drifting cinder in space.

So the cry of "save the Earth," though noble, is not as realistic for our species and other life-forms as "sustain the Earth." Our planet has endured many cataclysmic events and will continue to do so. Significant Earth cycles and rhythms may change due to our activities, but the planet will not die from our hand. Its continents are in constant motion, drifting to the rhythm of plate tectonics and colliding with enough force to build mountain ranges. An average tropical storm generates a thousand times more electrical power than the United States uses in one day. An earthquake of a 6.0 Richter magnitude equals the energy to launch 2 million Space Shuttles. Human power, though impressive, is still puny in the face of the Earth's forces. Yet our technological impact

may torque the finely tuned relationships of the Earth's components with more force than we realize. Witness the greenhouse warming from industrial activity; notice the growing ozone hole over Antarctica. Watch numerous species becoming extinct each day. Observe the world population double to 10 billion people in the next fifty years. All these changes result from human behavior, from human needs, wants, and fears.

In spite of these ominous changes, we have a choice, and we can restore ecological and environmental balance to those regions affected by our destructive impact. We should take heart in the fact that the Earth regenerates. We have been able to revive countless lakes and rivers polluted by human activities over the last few decades. Some countries have kept their population growth in check, with significant economic and social benefits for their citizens. We can plant trees and shrubs to counterbalance deforestation, and we can help prevent desertification. Eliminating the use of deadly chemicals that destroy the protective veil of our atmosphere may allow it to restore itself before it is too late. We know that there are renewable sources of energy like the sun, which can be developed and applied more widely if we demand it. Not everything we use needs to be thrown away or packaged in excess. Recycling not only enables us to avoid creating more landfills, but also saves materials and energy. The critical issues are the awareness of our impact on the world and the motivation to change our behavior and to think in sustainable terms.

This awareness is not new. It has been observed and recorded in the oral histories of many native peoples, who realized that we are part of nature's web.

Learning to understand and to respect the limits of natural ecosystems, whether on a local, regional, or global scale, requires more than just knowledge. It requires the wisdom to realize that the land we inherit from our parents must be preserved for our children. A philosophy of embracing the Earth is very old. Yet as the third millennium approaches, it is clear that we need to revitalize the tenets of this philosophy to ensure that we can create an enduring future for ourselves and for all other life-forms.

Viewing the Earth from space has revealed that we can study our planet from a perspective like that of the domain of mythic gods. This view has an objective quality; it is like a photograph that doesn't lie. Seeing the planet and the life it holds from a distance opens us up, so we become more objective and less caught up in the immediate roar of energy around us. The emerging view from space can also be regarded as a metaphor for understanding ourselves more objectively, with fewer of the destructive passions that have been too prevalent in our history. We can pause and examine what motivates our behavior, our needs, and our fears.

The power and beauty of nature enable us to reflect on and listen to natural rhythms as well as our own rhythms. The experience can be very calming and expansive. In embracing these rhythms, we go back to deep, native roots that respect and cherish the Earth. Contemplate the awesome grandeur of these images that follow and allow yourself to bond with our planet. We can only hope that these wondrous views will further inspire us to value our unique planet and take heed to safeguard our home.

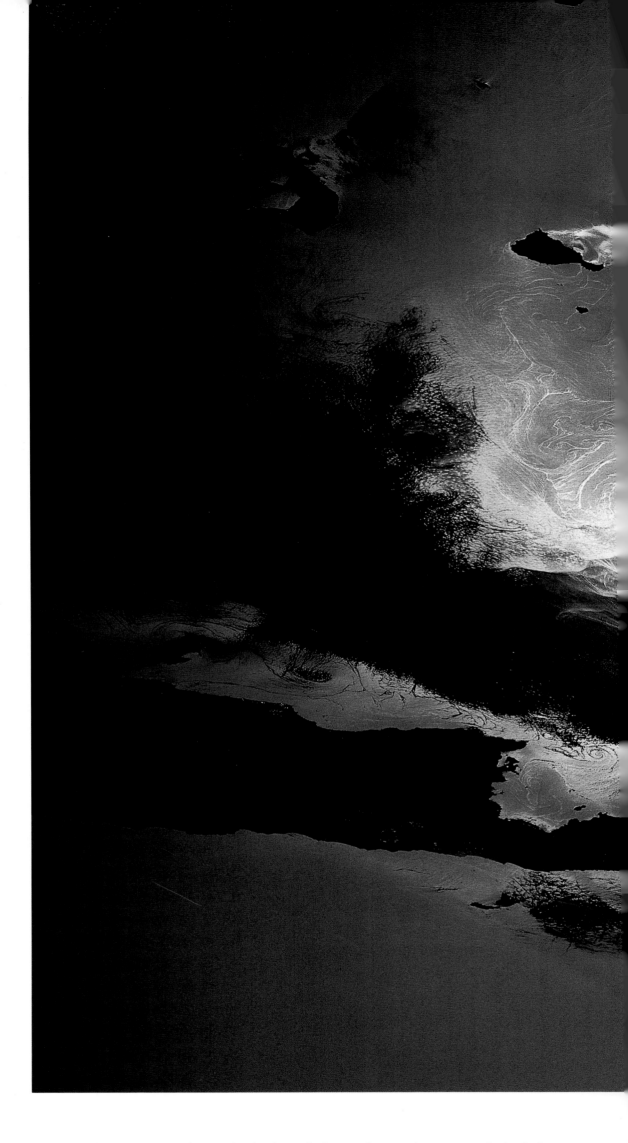

Before land was and sea—
* before air and sky*
Arched over all, all Nature was
* all Chaos,*
The rounded body of all things
* in one,*
the living elements at war with
* lifelessness;*
 ...
Earth, Air, Water heaved and
* turned in darkness,*
No living creatures knew that
* land, that sea*
Where heat fell against cold,
* cold against heat—*
Roughness at war with smooth
* and wet with drought.*

Ovid, poet

Crete and the Aegean Sea. The Greek islands, with their seafaring cultures, were the birthplace of Western civilization. The island of Crete, home of the ancient Minoans, is in the lower left. Above it are the Cyclades, part of the Aegean Islands.

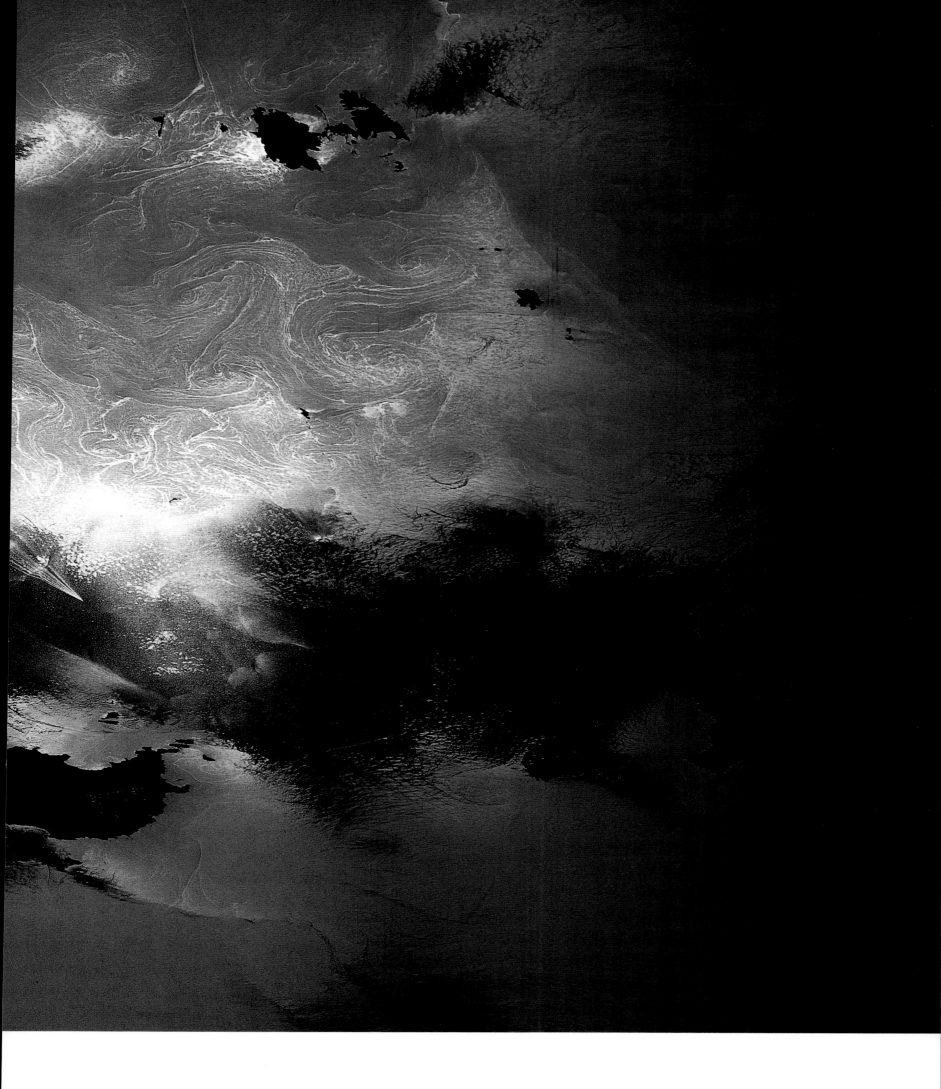

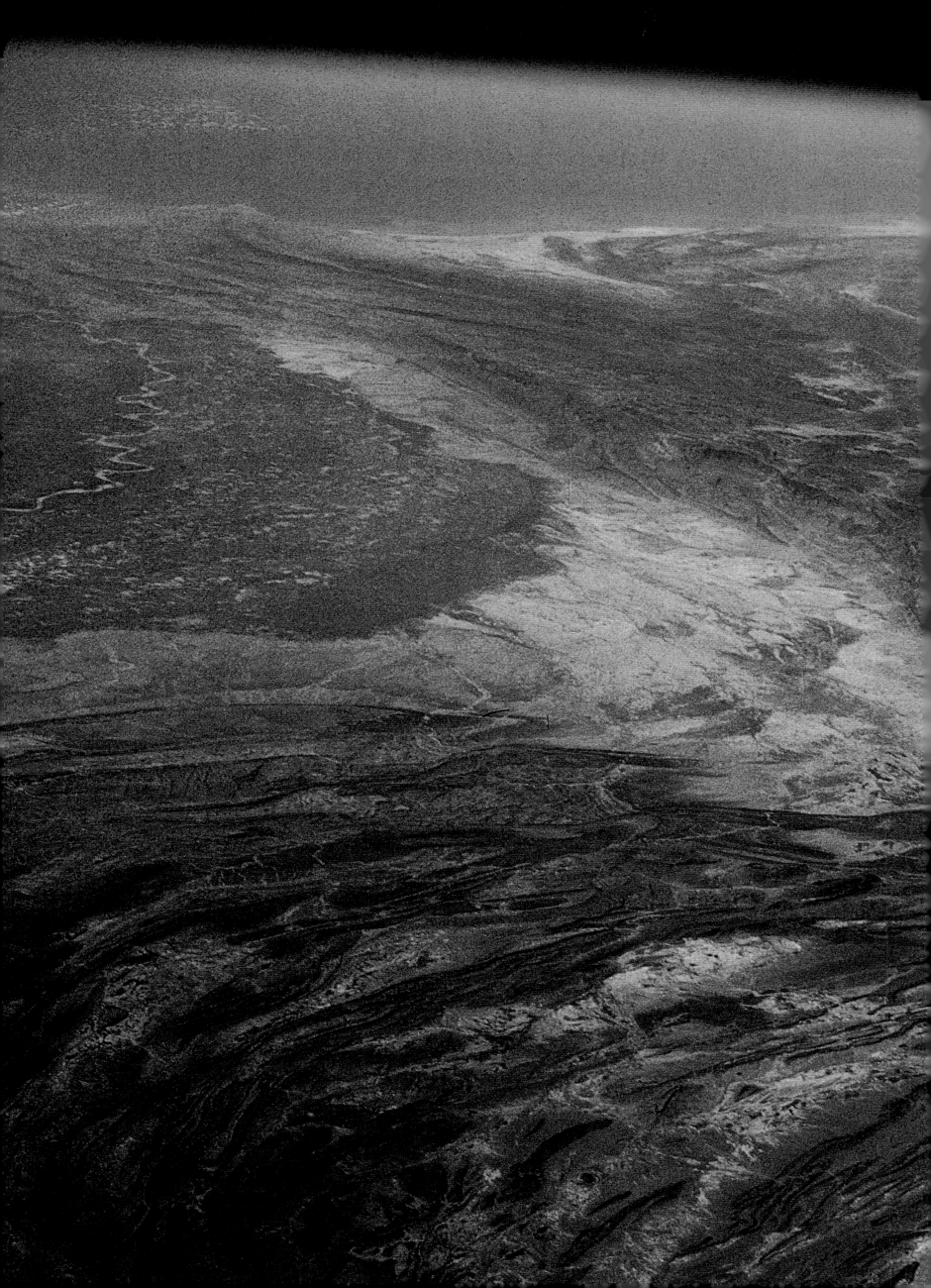

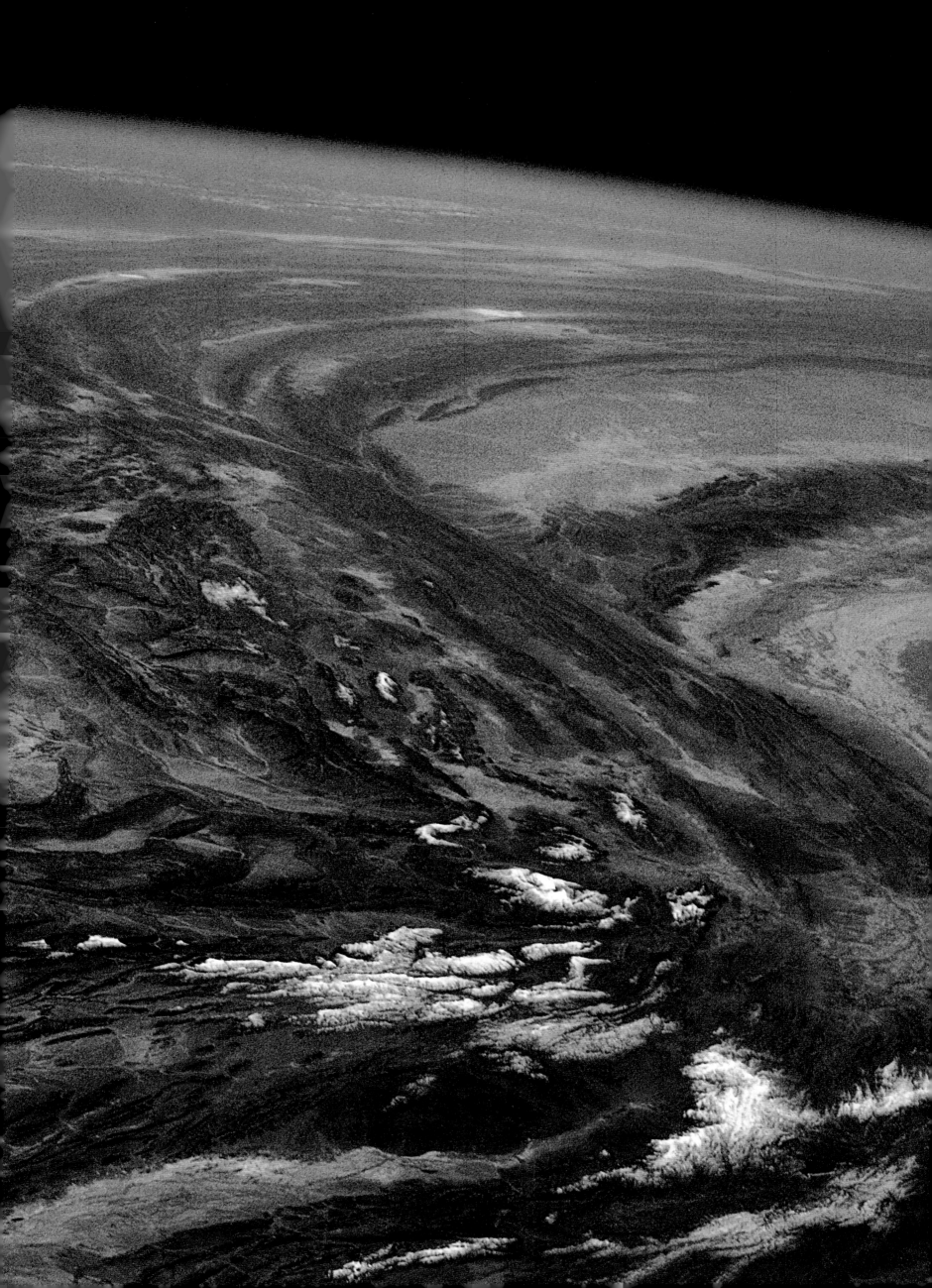

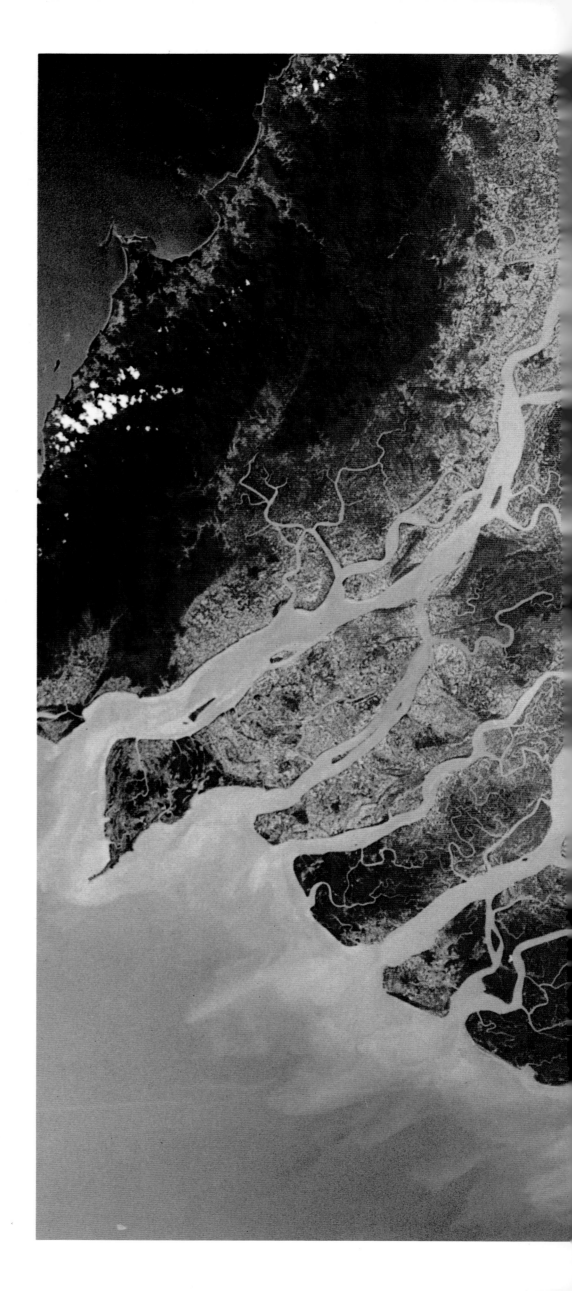

We urge that all people now determine that a wide untrammeled freedom shall remain to testify that this generation has love for the next.

Nancy Newhall, photohistorian

► **Irrawaddy River Delta, Myanmar.** Rivers flow to the sea, bringing their load from the land. In this false-color infrared image of the Irrawaddy River Delta in Myanmar (formerly Burma), healthy vegetation is red, and areas with considerably less vegetation are pink. Numerous plumes of sediment extend into the Andaman Sea, in the center, and into the Gulf of Martaban, at the bottom right. The Bay of Bengal is at the upper left.

◄◄ **Folded Mountains, Pakistan** (previous pages). As the enormous tectonic plates of the Earth move through geologic time, they crash into each other, creating mountains. Here, the view south over Pakistan reveals the fluid past of our seemingly solid Earth. The sinuous mountain ranges of Baluchistan, the dominant features in this image, were formed 40 to 60 million years ago. The Indus River and its valley are on the left, and the Arabian Sea is at the top, beyond the horizon.

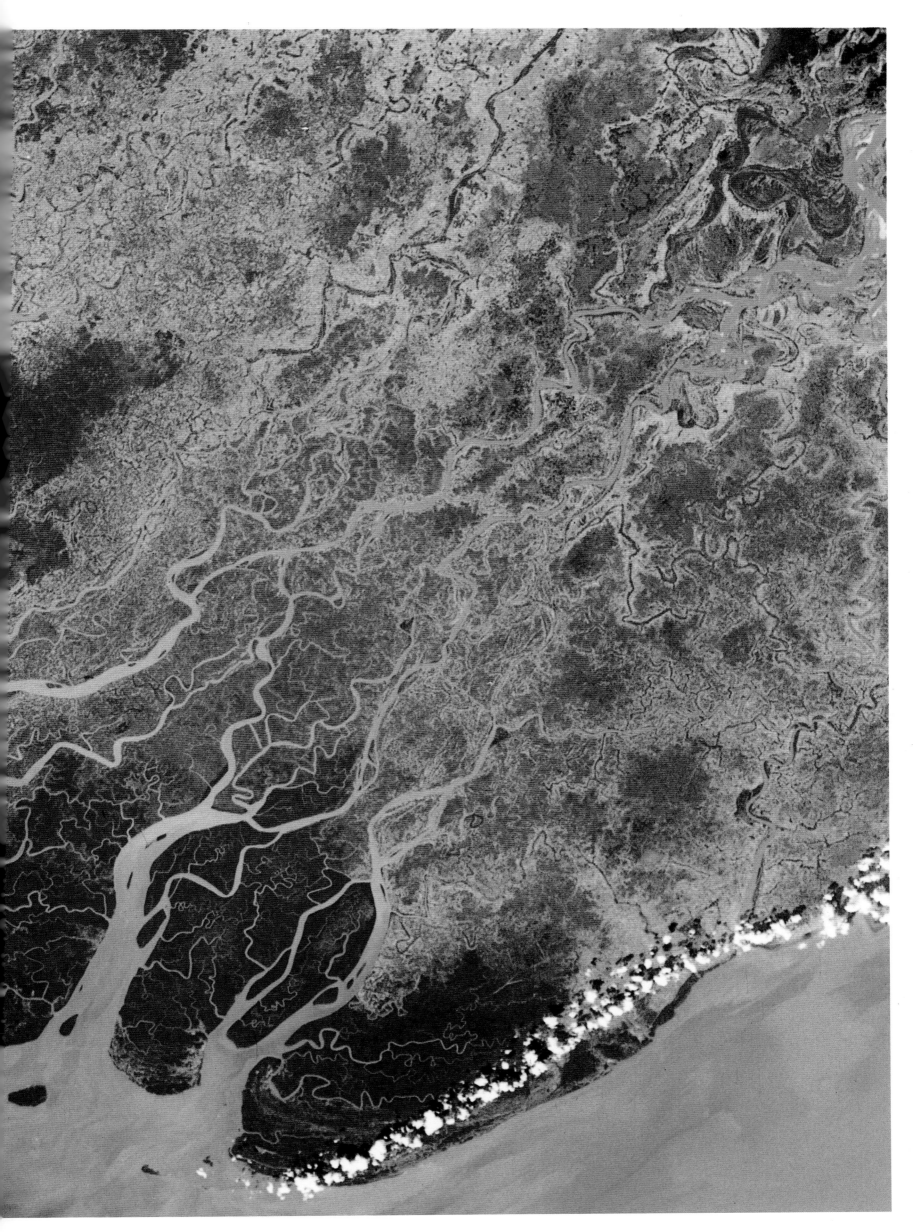

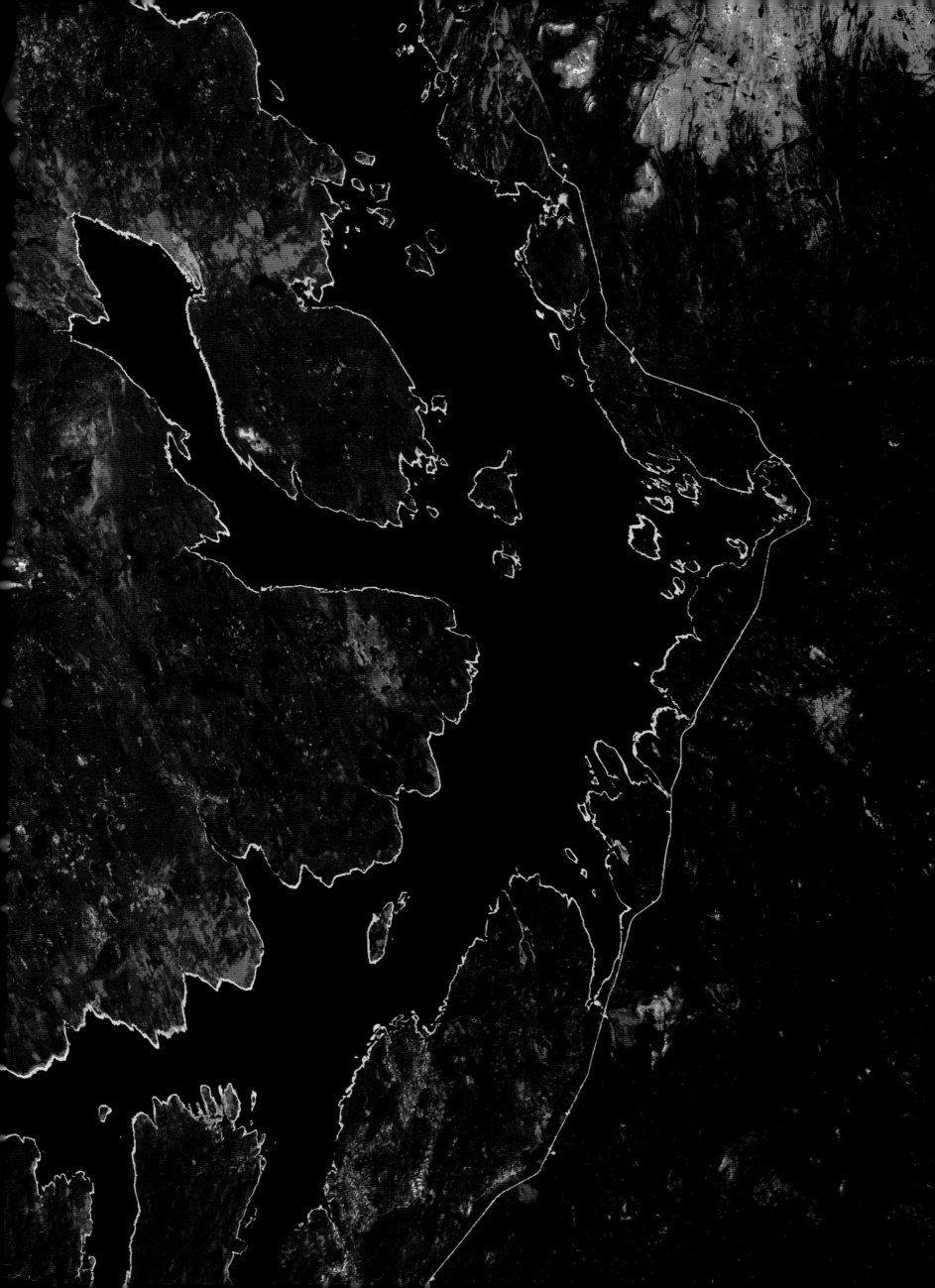

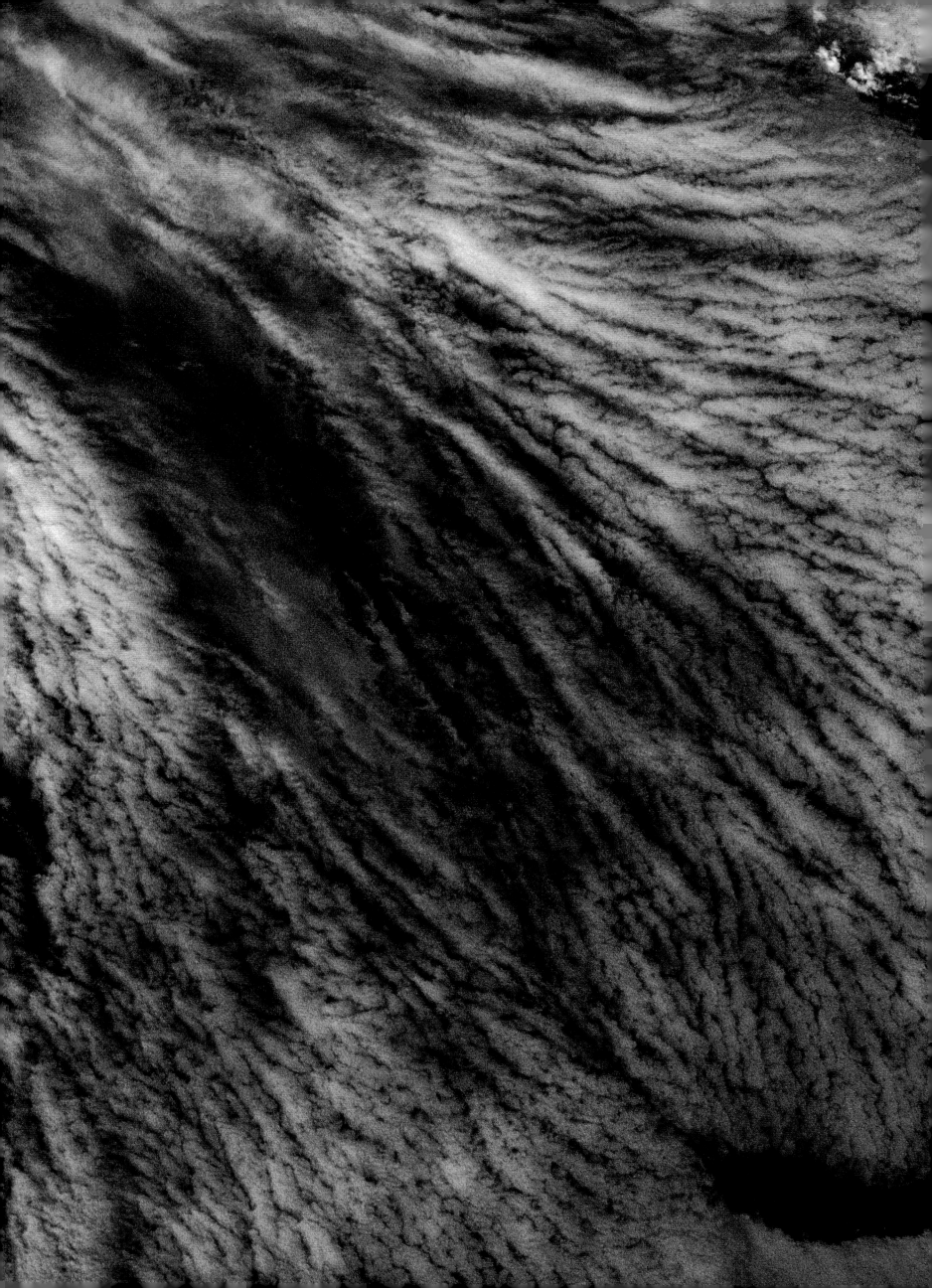

*The softest of stuff in the world
Penetrates quickly the hardest;
Insubstantial, it enters
Where no room is.*

Lao Tsu, philosopher

◄ **Cloud Front, Indian Ocean.** The ocean and atmosphere interact in a dance of energy and moisture. Here a tongue-like cloud front rapidly moves forward to envelop a region of the Indian Ocean.

◄◄ **Manicouagan Reservoir, Canada** (previous pages). Meteors leave scars from their impact on Earth. This lake in northern Quebec, a crater 40 miles in diameter, memorializes the impact of a meteor that struck the Earth 212 million years ago.

153

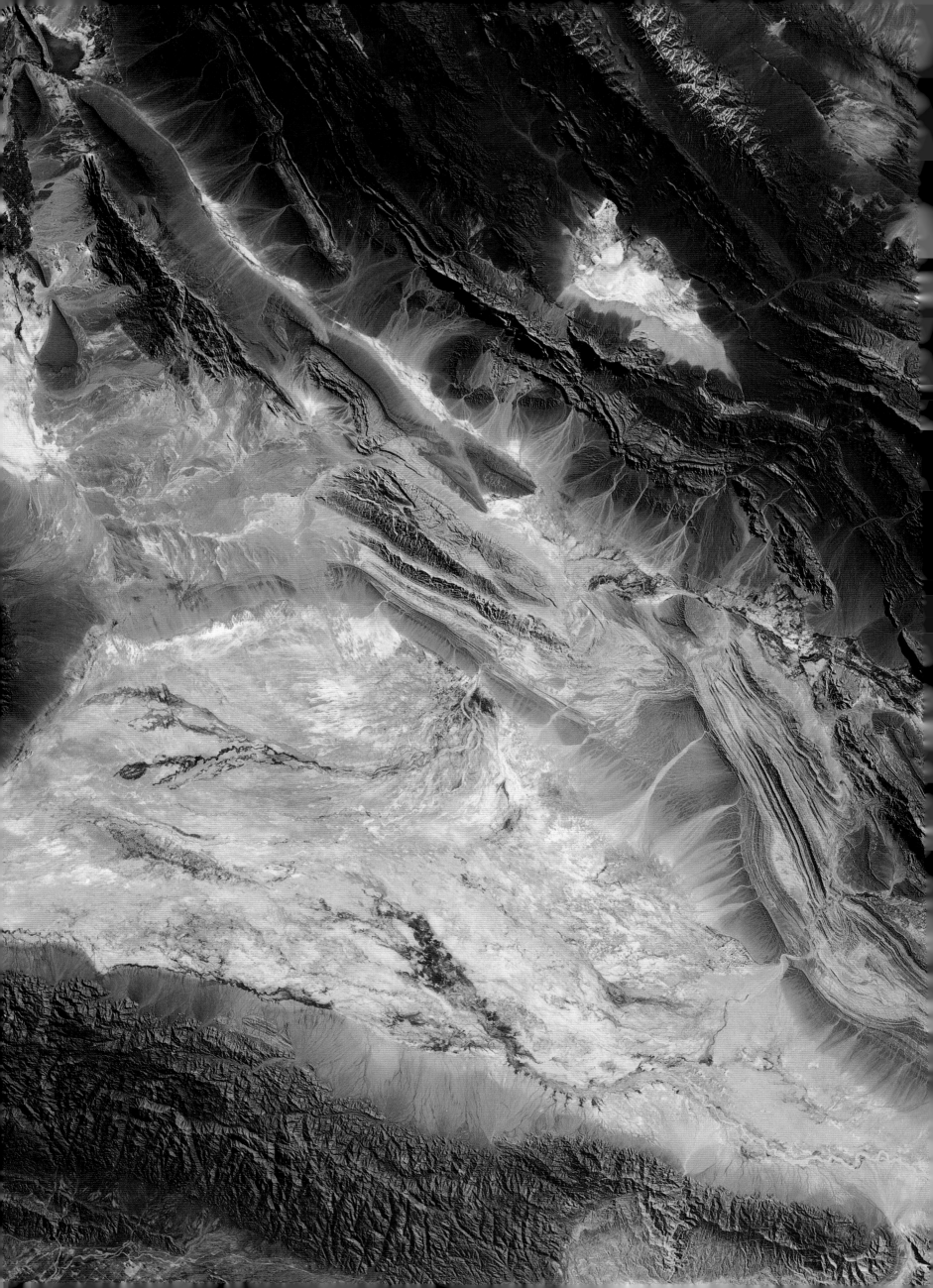

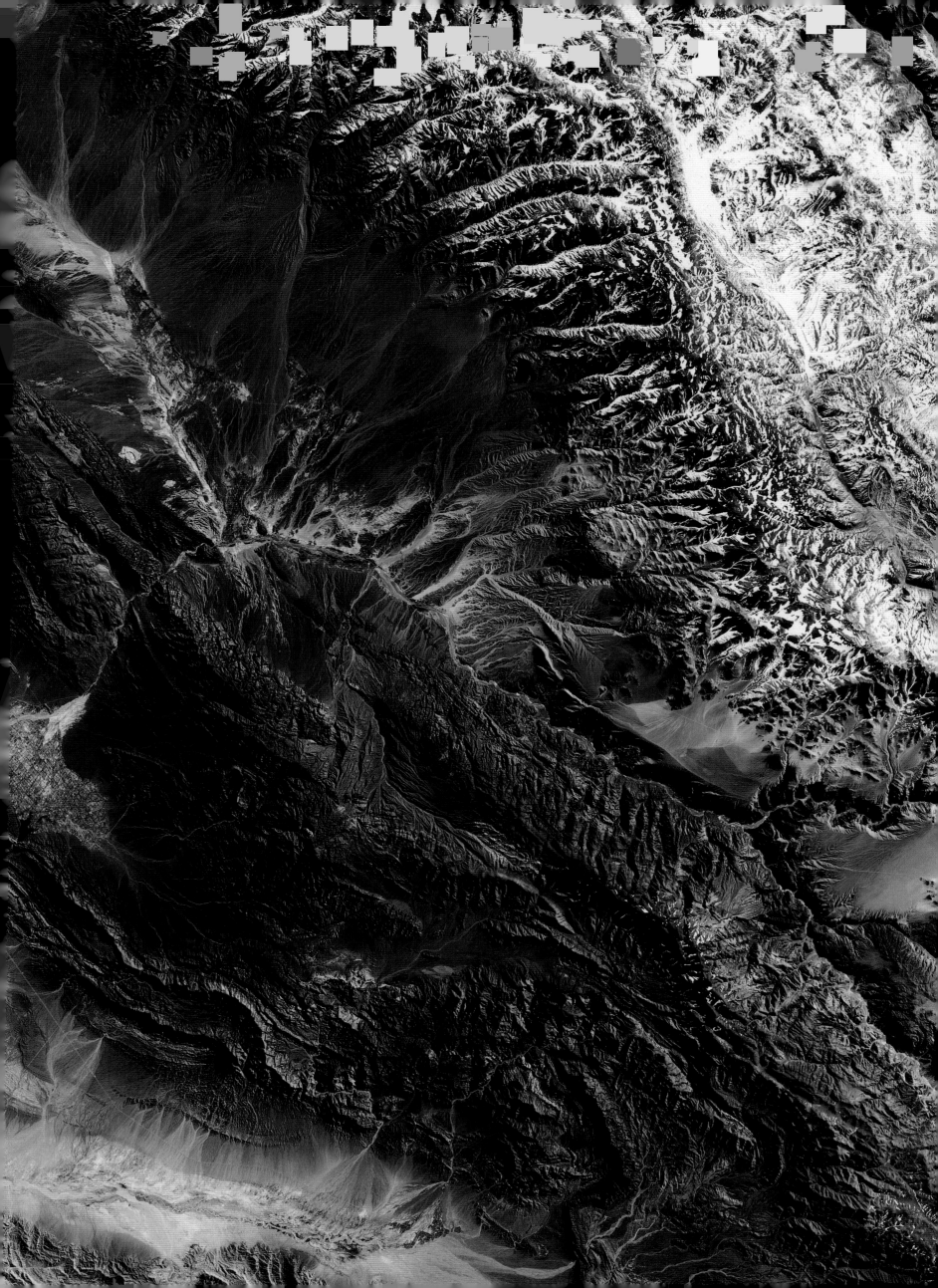

In the cooing of the doves, in the hovering of birds, in the pasturing of cattle, in the excellence of the strong, in the might of the full-grown, in the sleeping of slumberers, in the brightening of morning, in the murmur of the winds.

Sufi prayer

▶ **The Near East.** Ancient civilizations and great religions were spawned in the Near East thousands of years ago. Here Egypt and the Sahara Desert are in the foreground, with Cairo at the far left. The triangular Sinai Peninsula is at the center of the image. The Gulf of Suez, below the peninsula, and the Gulf of Aqaba, above it, flow into the Red Sea, to the right. The Dead Sea, on the boundary of Israel and Jordan, is just beyond the Sinai Peninsula. Spreading out toward the horizon are the deserts of Syria, Jordan, Saudi Arabia, and Iraq. The eastern portion of the Mediterranean Sea is to the far left.

◀◀ **Andes Mountains, Argentina and Chile** (previous pages). The great range of the Andes Mountains dominates South America's western coast. Here the valleys of the snow-covered mountains are at the lower right. The small town of San José de Jáchal, on the eastern side of the mountains in northern Argentina, is near the center of the image.

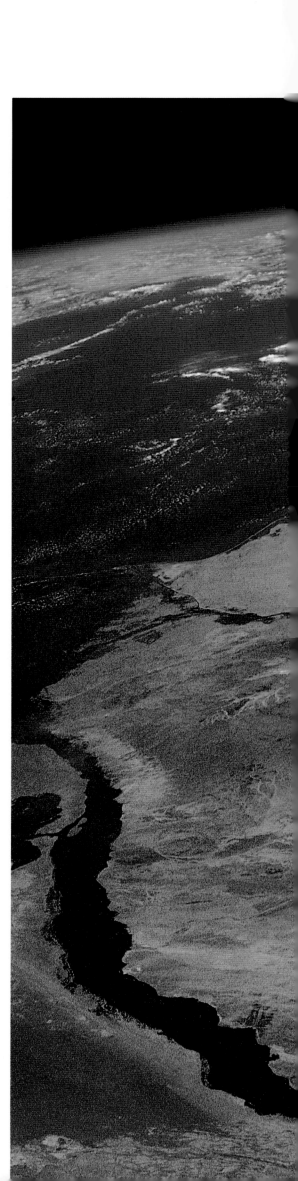

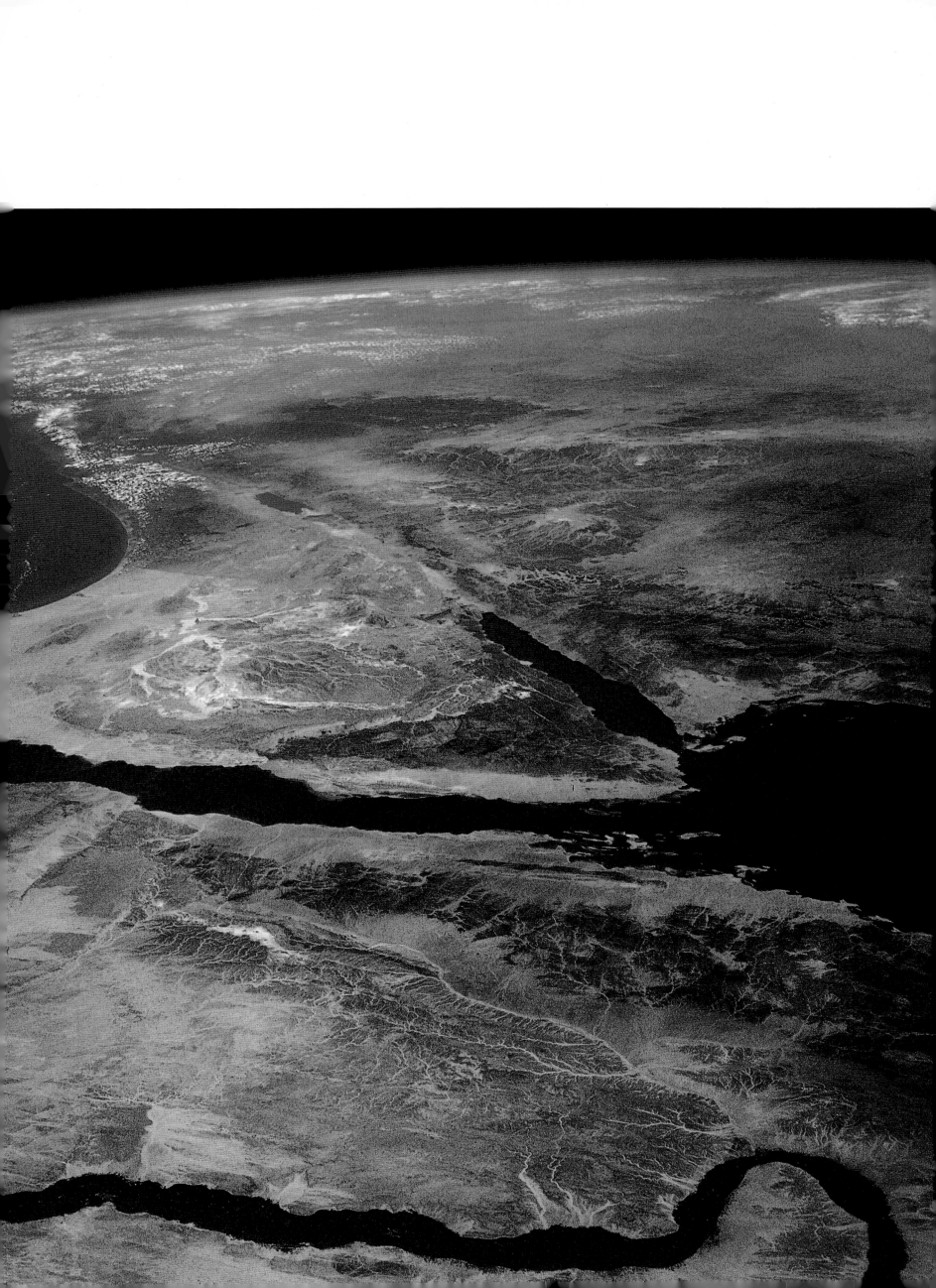

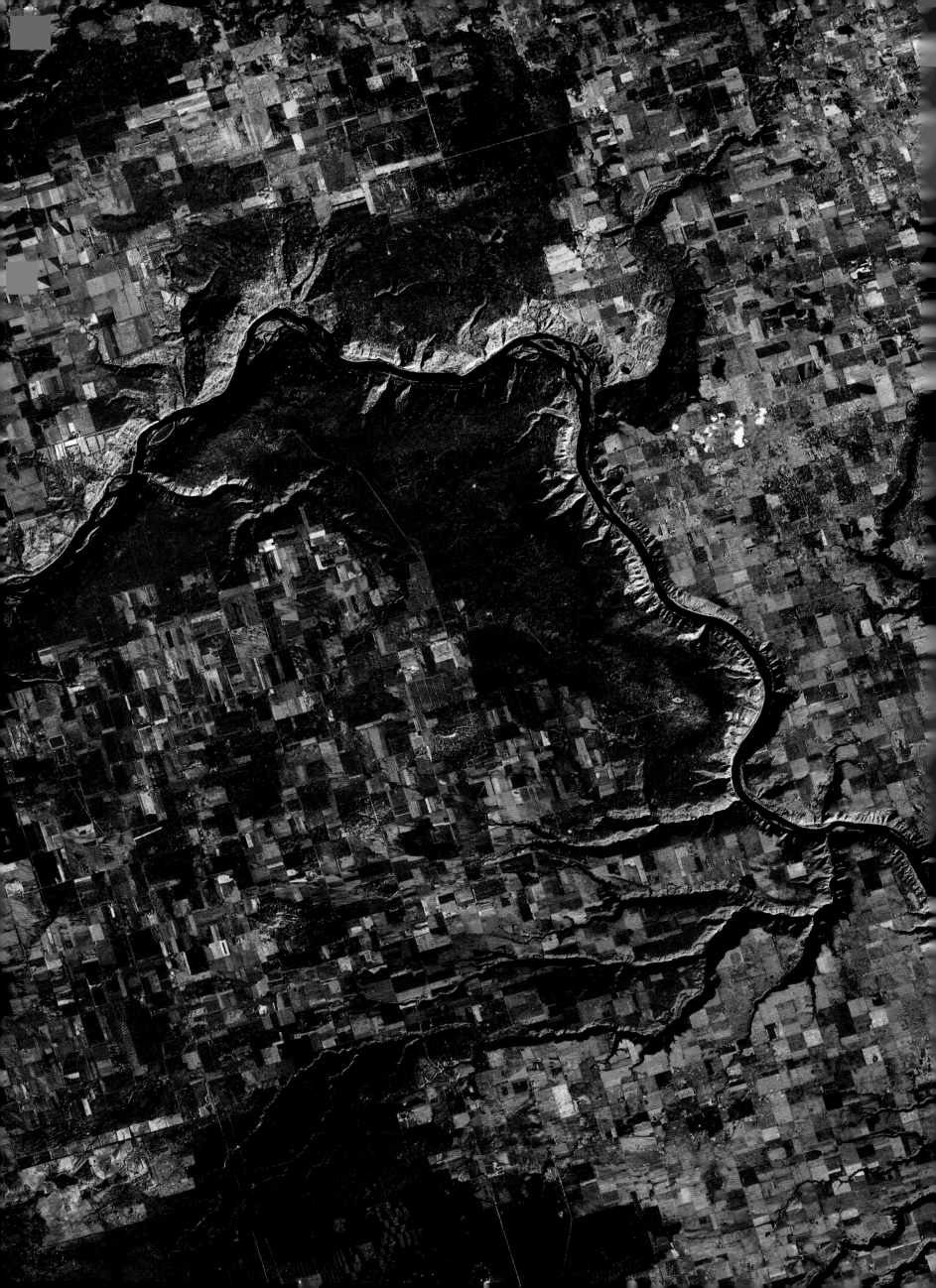

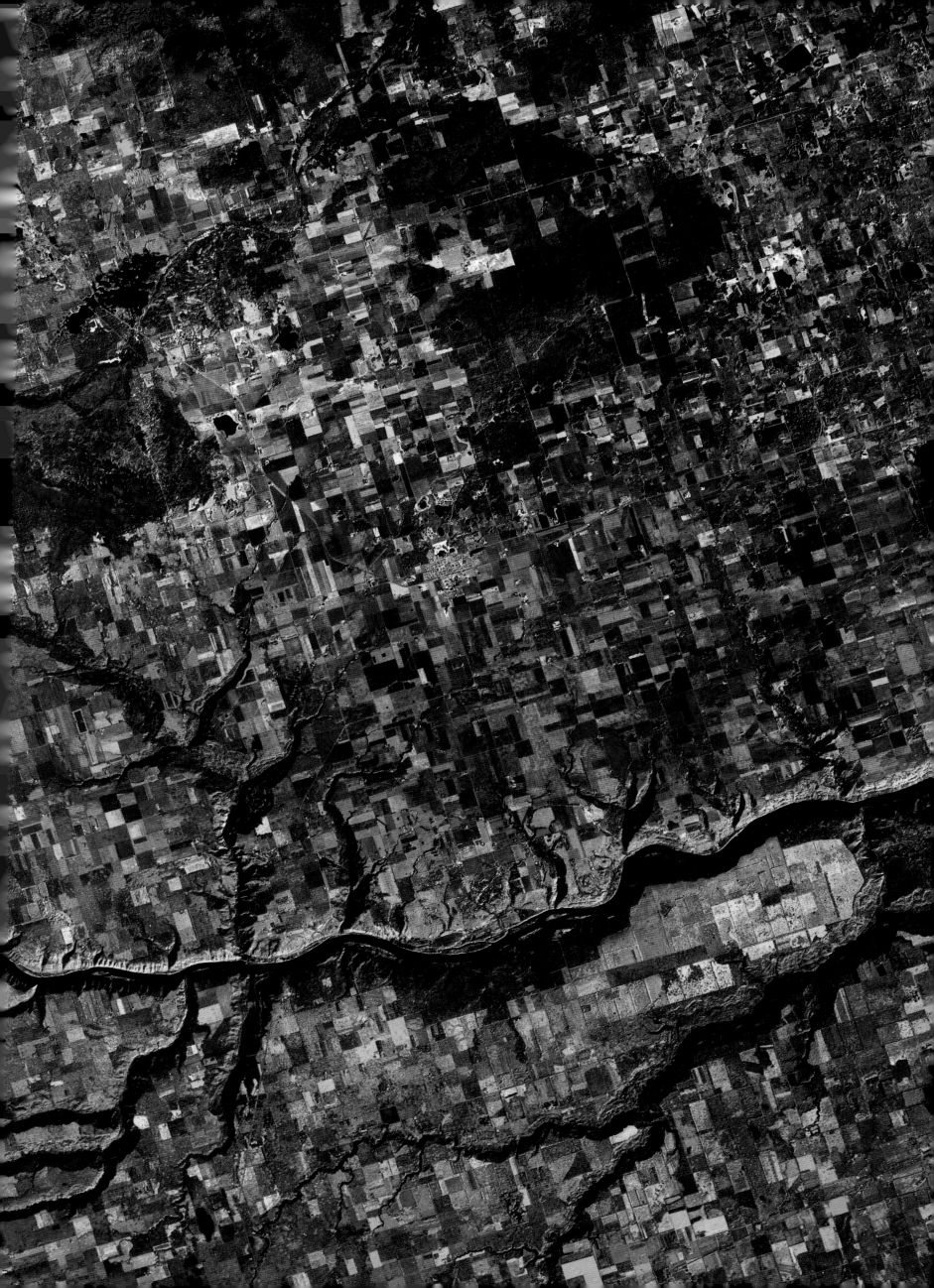

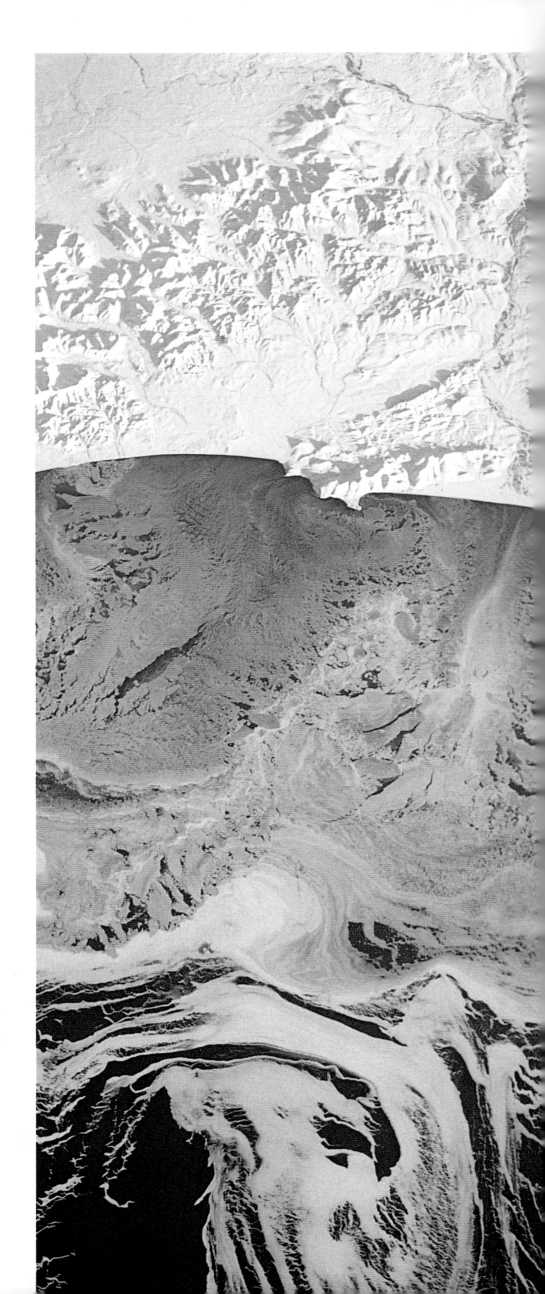

O Hidden Life vibrant in every atom,
O Hidden Light! shining in every creature;
O Hidden Love! embracing all in Oneness;
May each who feels himself as one with Thee,
Know he is also one with every other.

Annie Besant, spiritualist

► **Siberian Winter, Kamchatka Peninsula.**
The polar regions have seasons of protracted
light and darkness and are the great heat sinks
that influence the Earth's climate. Cape
Olyutorskiy in the northeastern portion of the
Kamchatka Peninsula in the former Soviet
Union protrudes into the Bering Sea on the
Arctic Circle. A frozen ice sheet extends
from the point. Swirling ice and water mix
in the bottom half of the image. The sur-
rounding Olyutorskiy Mountains are covered
with snow and ice.

◄◄ **Peace River, Canada** (previous pages). Rivers
are vital conduits bringing fresh water that
enables life to flourish. The Peace River flows
west through northern Alberta, Canada, sur-
rounded by the checkerboard pattern of farms.

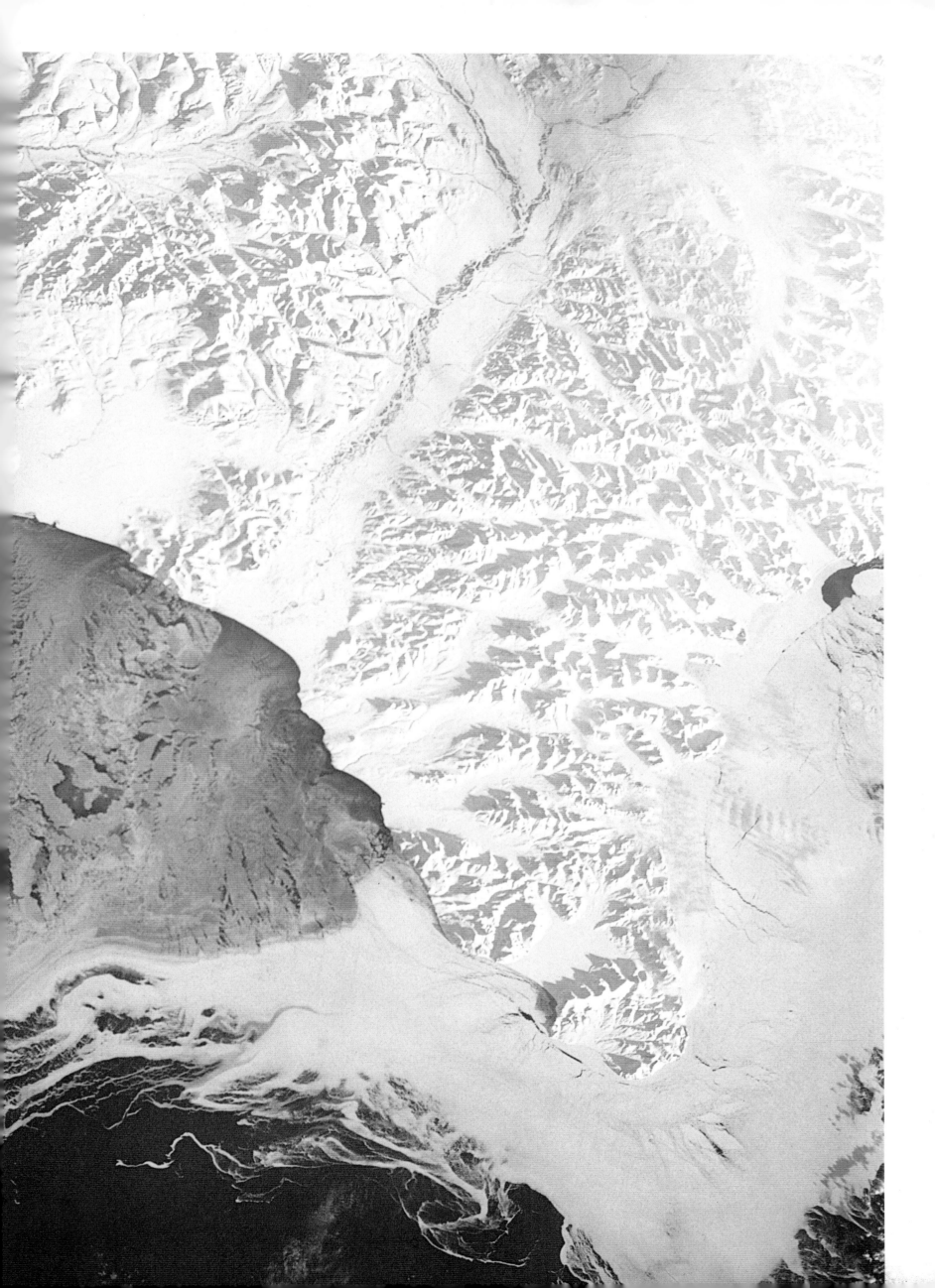

Earth Terminator and Limb. As the sun sets, the Earth sinks into shadow and darkness. The boundary of light and dark, at sunset and at sunrise, is called the terminator. The setting sun along the terminator accentuates the billowy clouds extending to the Earth's horizon, or limb.

We need to rest and allow the earth to rest. We need to reflect and to rediscover the mystery that lives in us, that is the ground of every unique expression of life, the source of the fascination that calls all things to communion.

United Nations Environmental Sabbath Program

REMOTE SENSING: STRIVING FOR A GLOBAL VIEW

by W. Stanley Wilson, PhD
Program Scientist, Earth Observing System, NASA

As the images in this book reveal, the Earth experiences a variety of changes—continental drift, the melting of glaciers during the ice ages, the movement of ocean currents, and the formation of tropical storms. Other changes—the pace of deforestation, the extent of acid rain, the depletion of ozone in the upper atmosphere, and the potential for global warming—

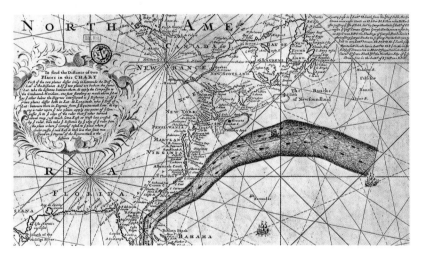

The Gulf Stream as mapped by Benjamin Franklin.

are caused by the presence of mankind on the planet. The task of scientists working today in the field of remote sensing is to observe the process of these changes and distinguish between those that are natural and those that are human-induced; if we can understand them we may be able to predict their effects—and possibly even reduce their adverse future impacts.

Although remote sensing as an observing technology has matured within the last three decades, attempts to map the Earth's highly variable rhythms are not new. The first scientific examination of one of the major ocean currents, the Gulf Stream, was conducted in 1775 by Benjamin Franklin, who gathered information from many sailing ships. This research led Franklin and his collaborator, Timothy Folger, to publish a chart, in 1786, which gives a general indication of the flow of the Gulf Stream but lacks significant details about the current. Two hundred years after Franklin's pioneering work, we are still interested

Nimbus–7

in the circulation of the oceans. One of the many reasons for this interest is that most of the solar energy received by the Earth is stored in and later released by the seas. Ocean currents, in conjunction with the atmosphere, transport the heat from equatorial to polar regions. By studying the movements of the currents, we can understand how they moderate temperature extremes on the continents and anticipate how they may influence our climate.

Each of the changes being experienced by the Earth has its own time scale. Europe and North America are drifting apart, in a process known as continental drift, at a rate of about one inch per year, having separated some tens of millions of years ago. By comparison, the retreat of glaciers from one ice age to the next took place much faster, over a period of ten thousand years. Other natural rhythms have considerably shorter time scales. Ocean currents can shift in a week, and a storm may grow and dissipate over several days. If several modern research ships embarked on a month-long survey within the Gulf Stream region, where Franklin conducted his study two centuries ago, the currents would have changed by the time the survey had been completed. Moreover, trying to map in detail the circulation within an entire ocean basin would require so many ships that the cost would be prohibitive.

The ability to make observations from space not only of the ocean but also of the land and the atmosphere has resulted from advances in technology, such as rockets, satellites, computers, electronics, and communications. Satellites orbit high enough above the Earth to give us a global perspective, a perspective that allows us to observe changes in a manner that cannot be obtained any other way. Remote sensing is particularly valuable in collecting what are called synoptic views—series of observations of the atmosphere, ocean, or land surface, each of which is made over a broad region within a rela-

tively short period of time. Many of us see synoptic views of the atmosphere every day when we watch the rapidly moving satellite images of clouds and storm fronts on televised weather reports, which are made by the satellites of the National Oceanic and Atmospheric Administration (NOAA). With the availability of repeated views of a natural or human-induced change, it is

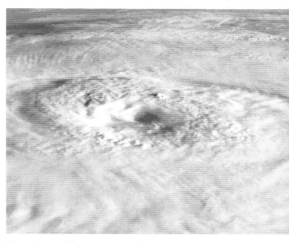

Hurricane Elena, Space Shuttle.

possible to observe how a pattern moves and distorts. This information provides a basis for understanding and predicting how the pattern can be expected to evolve in the future.

To understand remote sensing of the Earth, it is helpful to know what happens to the radiation emitted by the sun. When solar radiation enters the atmosphere, some of it is absorbed by molecules within the atmosphere. A good example is how harmful ultraviolet rays are absorbed by the ozone layer of the upper atmosphere. Some of the solar radiation passes through the atmosphere and reaches the Earth's

Mount Ararat, Landsat.

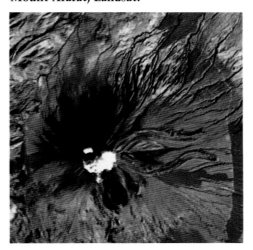

surface. Of the radiation striking the surface, some is absorbed and some is reflected. Some of the radiation that is absorbed is reradiated at longer wavelengths, much of it in the form of heat, or infrared radiation.

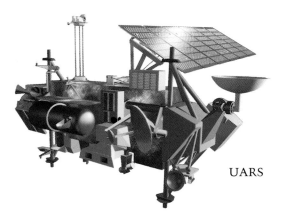

UARS

The characteristics of both reflected and reradiated energy depend on the material—rocks, soil, snow, ice, or clouds—and its properties, such as chemical composition, temperature, and moisture content. A continuing challenge in remote sensing is how to unscramble the relative contributions made by the different materials and their varying properties within a particular sensor's field of view.

Baja California, CZCS.

In orbiting the planet high enough to see a vast ocean basin or an entire continent, satellites are faced with an inherent obstacle: the presence of the atmosphere lying between the satellite, with its remote sensing instrument, and the target on Earth. Another of the key challenges in gathering observations of the Earth from space is how to identify and correct for such atmospheric effects as clouds, water vapor, and aerosols.

The simplest means of remote sensing is to take pictures using a camera with film sensitive to the ordinary light that we can see with the naked eye. This, the visible portion of the electromagnetic spectrum, experiences little absorption by the atmosphere and is known as an atmospheric window because our view through it is relatively unimpeded. The photograph of the clouds associated with Hurricane Elena in the Gulf of Mexico was taken by an astronaut aboard the Space Shuttle. Images such as this and those taken by NOAA weather satellites provide an excellent early-warning system ensuring that no hurricane goes undetected.

Specific wavelength bands or colors within the visible portion of the spectrum were used by the Thematic Mapper Sensor on a NASA Landsat satellite

to record the scene of Mount Ararat in Turkey. This false-color image was generated by mixing three Landsat bands, each identified with a different color. Images such as this can reveal the presence of certain minerals, which crops are under cultivation, and other subtle features on land that are not apparent in a simple photograph taken from space using the visible region of the spectrum.

Similarly, the oceans can be viewed to estimate the distribution of phytoplankton, the small, freely drifting plants that serve as the basis for the marine food chain. The Coastal Zone Color Scanner (CZCS) aboard Nimbus-7, a NASA research satellite, looks at the ocean in a number of bands in the visible portion of the spectrum such as blue, green, and red. Typically, green waters have high concentrations of phytoplankton chlorophyll, while blue waters have very low levels. Most of what the satellite sees in these bands, however, comes from light scattered by small particulates in the atmosphere. But in the red wavelength, the ocean does not give off any light and appears black. Because this band only contains light coming from the atmosphere, it can be used to correct the other bands to determine the contribution made by the ocean alone. Since phytoplankton are the fundamental source of food in the ocean, concentrations of other organisms—including commercially important fish—are frequently found in phytoplankton-rich regions. Because phytoplankton use carbon dioxide in the process of photosynthesis, they represent a potential sink for some of the carbon dioxide that is accumulating in the atmosphere and can contribute to greenhouse warming.

The infrared region of the spectrum can be used to show the pattern of ocean currents. The view of the Gulf Stream, taken by an Advanced Very High Resolution Radiometer (AVHRR) aboard one of the NOAA meteorological satellites, is much more detailed than the Franklin-Folger chart of 1786. Because

the Gulf Stream is relatively warm compared with the surrounding ocean, an infrared sensor can measure the surface temperatures of the current and track its position. Another advantage of the infrared band over the visible portions of the spectrum is that images can be collected at night, when there is little or no visible light.

Both visible and infrared radiation is obscured by the moisture present in clouds. In order to "see through" clouds, scientists turn to the microwave band, the portion of the electromagnetic spectrum that includes radar. Satellites can look at the surface of the Earth and view natural microwave emissions, which come from solar radiation that has reached the surface, been absorbed, and is reradiated in the microwave. A good example of the capability of microwave sensors is the detection of both ice at sea and snow on land by the Special Sensor Microwave Imager on the satellites of the Defense Meteorological Satellite Program. Polar regions are monitored regularly because they are believed to be the first areas where global warming may occur. If it is raining, microwave emissions from the rain predominate, and consequently can be used to estimate rainfall.

Satellites can carry an altimeter, an instrument that points a microwave radar straight down on the Earth and bounces it off the surface. Measurements of the time it takes for a pulse to leave the satellite, bounce off the ocean, for example, and return to the

Loess Plateau, SAR.

satellite are used to determine the height of the sea surface. As the satellite orbits the Earth, measurements taken over a broad area are used to create a map of the topography of the sea surface. The surface of the Gulf Stream, for instance, increases by 3 feet from the inshore to the offshore side, over a distance of about 50 miles. Knowledge of such changes in surface elevation is critical for understanding the circulation of the oceans.

Another microwave instrument, the synthetic aperture radar (SAR), continuously sends out radar pulses over a broad region and receives the resulting echoes. By sorting out which echo comes from which point on the surface of the Earth, it is possible to distinguish objects as small as 50 feet across. Because SAR is sensitive to characteristics on the Earth's surface such as moisture content and reflective properties,

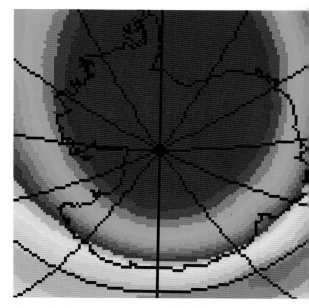

Ozone hole over Antarctica, TOMS.

it can be used for geologic mapping in conjunction with Landsat imagery. In the future, SAR and Landsat will be employed to better characterize vegetation, such as forests; while Landsat can detect the colors associated with leaves, SAR is able to penetrate the foliage and provide information on the structure of the branches and trunks.

Finally, the atmosphere can be analyzed by comparing the varying amounts of solar radiation absorbed at specific wavelengths by different chemical constituents in the atmosphere. The results show the quantities of the particular constituents present in

TOPEX/Poseidon

the atmosphere. The Total Ozone Mapping Spectrometer (TOMS) aboard Nimbus-7, an excellent example of this technique, has been determining ozone concentrations in the atmosphere since 1978. TOMS observations have demonstrated that the Antarctic ozone hole has doubled in size over the past decade. During the same time, there has been a 3 to 5 percent reduction in ozone at the middle latitudes. The TOMS on Nimbus-7 has a limited lifespan, so scientists have scheduled a series of replacement TOMS, the first of which was launched in mid-1991 on a Soviet Meteor-3 satellite.

While TOMS specializes in observing ozone, the Upper Atmosphere Research Satellite (UARS), launched by the US in 1991, will provide a more comprehensive understanding of the stratosphere, including the particular mechanisms of ozone depletion. Other research satellites include the European Remote Sensing Satellite (ERS-1), the Japanese Earth Resources Satellite (JERS-1), the Canadian Radarsat, and TOPEX/Poseidon, a joint venture between the

Atlantic Gulf Stream, AVHRR.

US and French space agencies. These satellites join the existing US, Soviet, European, Japanese, and Indian meteorological satellites, as well as the US, French, and Soviet commercial land satellites, in gathering information on the Earth's natural and human-induced changes.

With so many space-faring nations participating in these satellite programs, remote sensing is a truly international endeavor. The field also entails collaboration: sensors from one country are included in the payload of the satellite of another country. Ground-based research by still other countries benefits from the exchange of data with those countries supplying the satellite systems. Satellite observations are continuous, from one country to the next, through forests and over grasslands, from ice-covered ocean to snow-covered land. Just as remote sensing transcends national boundaries, it also transcends discipline boundaries by involving many scientists with different areas of expertise. Such efforts lay the basis for unifying the various disciplines of the earth sciences into what is becoming known as earth system science.

By addressing the earth system, international efforts in remote sensing, sometimes popularly referred to as Mission to Planet Earth, can help us comprehend the most important problems facing the planet and the well-being of its inhabitants. Given the stresses that the rapidly increasing world population is putting on the environment, this global perspective will help us assess what steps we can take to reach a balance between human presence on the planet and preservation of the planet. Crucial to this process is the need to approach impending environmental crises by collaborative rather than confrontational means. Through an understanding of the global view, we can strive for global solutions.

We travel together, passengers on a little space ship, dependent on its vulnerable reserves of air and soil; all committed for our safety to its security and peace; preserved from annihilation only by the care, the work, and, I will say, the love we give our fragile craft. We cannot maintain it half fortunate, half miserable, half confident, half despairing, half slave—to the ancient enemies of man—half free in a liberation of resources undreamed of until this day. No craft, no crew can travel safely with such vast contradictions. On their resolution depends the survival of us all.

Adlai E. Stevenson, former US ambassador to the United Nations

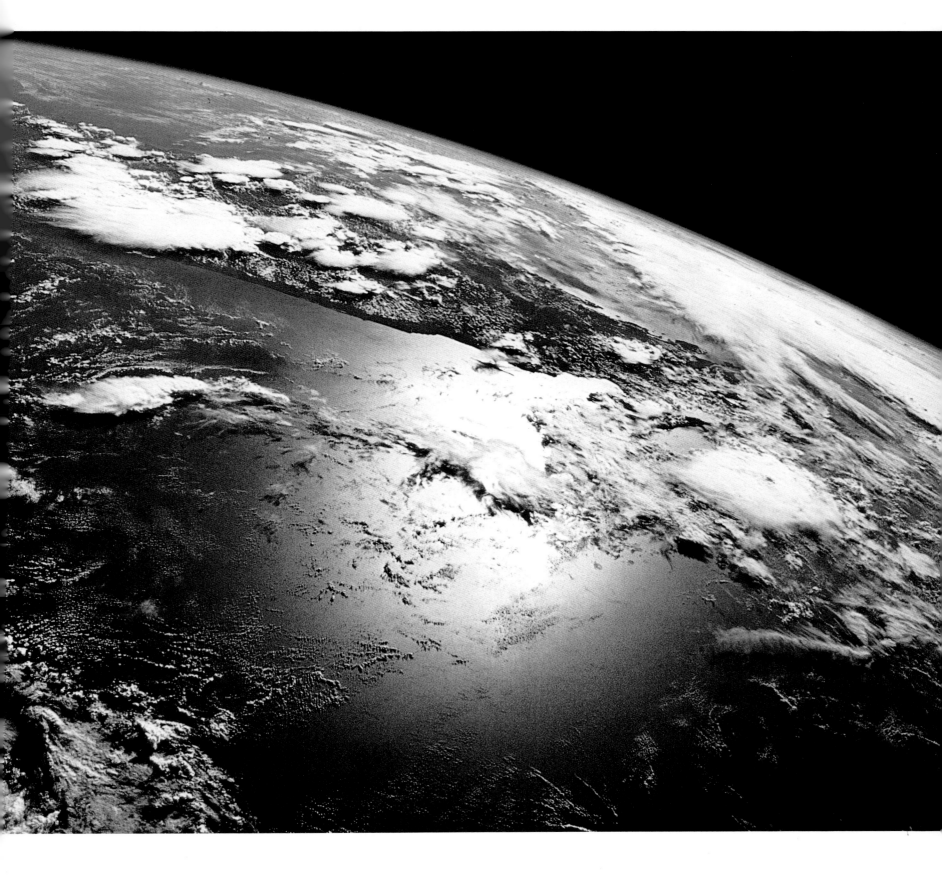

CREDITS

Image Credits

Endpaper: NASA Space Shuttle.
Page 2: NASA Space Shuttle.
4–5: METEOSAT-2, © SSC, Published with permission of the Swedish Space Corporation. **6**: NASA Space Shuttle. **8**: NASA Space Shuttle. **12–13**: © Payson R. Stevens. **16–17**: Courtesy James Marsh, NASA Goddard Space Flight Center. **18**: NASA Landsat. **19**: US Geological Survey. **20**: NASA Landsat, courtesy US Geological Survey/ EROS Data Center. **21**: © CNES, Provided by SPOT Image Corporation, Reston, Virginia. **22**: NASA Landsat. **23**: © Payson R. Stevens. **24–25**: NASA Space Shuttle. **26–27**: NASA, SIR-A Radar, courtesy John Ford, Jet Propulsion Laboratory, and Nicholas Short. **28**: © CNES, Provided by SPOT Image Corporation, Reston, Virginia. **29**: © Payson R. Stevens. **31**: NASA Landsat. **32**: NASA Space Shuttle. **33**: © Payson R. Stevens. **34–35**: © CNES, Provided by SPOT Image Corporation, Reston, Virginia. **36**: NASA Landsat. **38–39**: Courtesy Moustafa T. Chahine, Jet Propulsion Laboratory, and Joel Susskind, NASA/Goddard Space Flight Center. **40–41**: NASA Space Shuttle. **42**: Peter Woiceshyn, Jet Propulsion Laboratory; Morton Wuertle, University of California Los Angeles; Steven Peteherych, Atmospheric Environment Service of Canada. **43**: NOAA GOES-4. **44–45**: NOAA AVHRR, courtesy Gray Tappan, US Geological Survey/EROS Data Center. **46**: NOAA AVHRR. **47**: NASA Space Shuttle. **49**: NASA Space Shuttle. **50–51**: NASA Space Shuttle. **52**: NASA Space Shuttle. **53**: NASA Space Shuttle. **54**: NASA Apollo Mission. **55**: NOAA GOES-4. **56**: US Geological Survey/EROS Data Center. **57**: NOAA Satellite Research Laboratory, courtesy Larry Stowe and Robert Carey. **58–59**: Chet Koblinsky and Gene Carl Feldman, NASA Goddard Space Flight Center. **60**: NOAA AVHRR, courtesy Otis Brown, Robert Evans, and Mark Carle, University of Miami Rosentiel School of Marine and Atmospheric Science. **62**: NASA Space Shuttle, courtesy Larry Armi, Scripps Institution of Oceanography. **63**: NASA Space Shuttle. **64**: NASA Space Shuttle. **65**: NASA Space Shuttle. **66**: © CNES, Provided by SPOT Image Corporation, Reston, Virginia. **67**: © CNES, Provided by SPOT Image Corporation, Reston, Virginia. **68**: © Payson R. Stevens. **69**: Courtesy Lee Fu and Benjamin Holt, NASA/Jet Propulsion Laboratory. **70–71**: NASA Space Shuttle. **72–73**: © CNES, Provided by SPOT Image Corporation, Reston, Virginia; and US Geological Survey/EROS Data Center. **75**: © CNES, Provided by SPOT Image Corporation, Reston, Virginia. **76–77**: NASA Landsat, courtesy Goddard Space Flight Center. **78–79**: Dorothy Hall, Donald Cavalieri, and Gene Carl Feldman, NASA/Goddard Space Flight Center. **80–81**: Jay H. Zwally/ NASA Goddard Space Flight Center. **82**: © Claire Parkinson/NASA Goddard Space Flight Center. **83**: © CNES, Provided by SPOT Image Corporation, Reston, Virginia. **84**: © Payson R. Stevens. **85**: Landsat, courtesy B. Lucchitta, US Geological Survey. **86–87**: NASA Space Shuttle. **88**: NASA, Jet Propulsion Laboratory, and University of Alaska, Fairbanks. **89**: © Bruce F. Molnia, US Geological Survey. **90–91**: © Radarsat International Inc. **92**: Alaska High-Altitude Aerial Photography Program, courtesy Paul D. Brooks, US Geological Survey. **93**: © Bruce F. Molnia, US Geological Survey. **94**: NASA Landsat, courtesy US Geological Survey/EROS Data Center. **96–97**: Gene Carl Feldman and Compton J. Tucker, NASA/ Goddard Space Flight Center. **98–99**: Gene Carl Feldman, NASA/ Goddard Space Flight Center. **100–101**: © CNES, Provided by SPOT Image Corporation, Reston, Virginia. **102–103**: NOAA, courtesy Dennis Clark. **104–105**: Image courtesy of Earth Satellite Corporation. **106–107**: Gregg Vane and Howard Zebker, NASA/Jet Propulsion Laboratory. **108**: Landsat, courtesy Donald Ohlen, US Geological Survey/EROS Data Center. **109**: Landsat, courtesy Donald Ohlen, US Geological Survey/EROS Data Center. **111**: Courtesy Kevin P. Gallo, NOAA/NESDIS, EROS Data Center, and Jesslyn F. Brown, TGS Technology, Inc., EROS Data Center. **112–113**: Kevin P. Gallo and Jesslyn F. Brown, produced at US Geological Survey/EROS Data Center from data provided by the National Snow and Ice Data Center. **114–115**: © Payson R. Stevens. **118–119**: NASA/Goddard Space Flight Center, courtesy Mark Schoeberl and Gene Carl Feldman. **120**: NASA Landsat. **121**: © Payson R. Stevens. **122**: Los Angeles, © CNES, Provided by SPOT Image Corporation, Reston, Virginia; Mexico City, NASA Landsat. **123**: Paris, NASA Landsat; Cairo, NASA Landsat. **124**: NASA and NOAA Landsat, courtesy Barrett N. Rock and James Vogelmann, University of New Hampshire; David Zlotek, Cirrus Technology; and Hanan Kadro, University of Freiburg/FRG. **125**: NASA and NOAA Landsat, courtesy Barrett N. Rock and James Vogelmann, University of New Hampshire. **126**: NASA Landsat, courtesy Gray Tappan, US Geological Survey/EROS Data Center. **127**: NASA Landsat, courtesy Gray Tappan, US Geological Survey/EROS Data Center. **128–129**: NASA Landsat. **130**: NASA Landsat, courtesy Gray Tappan US Geological Survey/EROS Data Center. **131**: NASA Landsat, courtesy Gray Tappan, US Geological Survey/EROS Data Center. **132–133**: © CNES, Provided by SPOT Image Corporation, Reston, Virginia. **134**: NASA Landsat, courtesy Gray Tappan, US Geological Survey/EROS Data Center. **135**: NASA Landsat, courtesy Gray Tappan, US Geological Survey/EROS Data Center. **136**: NASA Landsat, courtesy US Geological Survey/EROS Data Center. **137**: © Payson R. Stevens. **138**: US Geological Survey/Eros Data Center. **139**: US Geological Survey/ Eros Data Center. **140–141**: © Payson R. Stevens. **144–145**: NASA Space Shuttle. **146–147**: NASA Space Shuttle. **148–149**: NASA Space Shuttle. **150–151**: © Radarsat International Inc. **152–153**: NASA Space Shuttle. **154–155**: NASA Space Shuttle. **157**: NASA Space Shuttle. **158–159**: © Radarsat International Inc. **160–161**: NASA Space Shuttle. **162–163**: NASA Space Shuttle. **164**: Courtesy Woods Hole Oceanographic Institute. **165–168**: NASA. **169**: NASA Space Shuttle. **169**: NASA Space Shuttle. **171**: NASA Space Shuttle. **176**: NASA/Jet Propulsion Laboratory.

For information on how to obtain single images in this book contact:
World Perspectives, PO Box 709, Bolinas, California, 94924, 415-868-0670 Tel, 415-868-1944 Fax

Quote Attributions
Page 24: The Dalai Lama and Galen Rowell, *My Tibet.* **33**: William Blake, *The Marriage of Heaven and Hell.* **40**: Krishnamurti, *Think on These Things.* **61**: Rachel L. Carson, *The Sea Around Us.* **74**: Loren Eiseley, *The Immense Journey.* **91**: Samuel Taylor Coleridge, "Hymn before Sun-rise, in the Vale of Chamouni." **110**: "Love Poem" by Leslie Marmon Silko. From *Sisters of the Earth,* edited by Lorraine Anderson. © 1991 by Lorraine Anderson. **144**: Ovid, *The Metamorphoses, Book I.* **148**: © 1991 by Beaumont Newhall. Reprinted with permission of the Estate of Nancy Newhall, Courtesy of Beaumont Newhall. **153**: Lao Tsu, *The Way of Life.* **160**: Annie Besant, "O Hidden Life." **169**: Adlai E. Stevenson, speech, July 9, 1965.

Captions for images in introductory and concluding pages:
2: Clouds over South America.
4–5: Planet Earth. The yellow areas highlight northern Africa and the Middle East. The Mediterranean and Europe lie north of the African continent.
6: Atlantic Ocean sunglint.
8: Saudi Arabia coast with clouds and sunglint.
169: Indian Ocean sunglint.
171: Peruvian coast and Andes Mountains looking south.
173: Aurora over the Arctic.

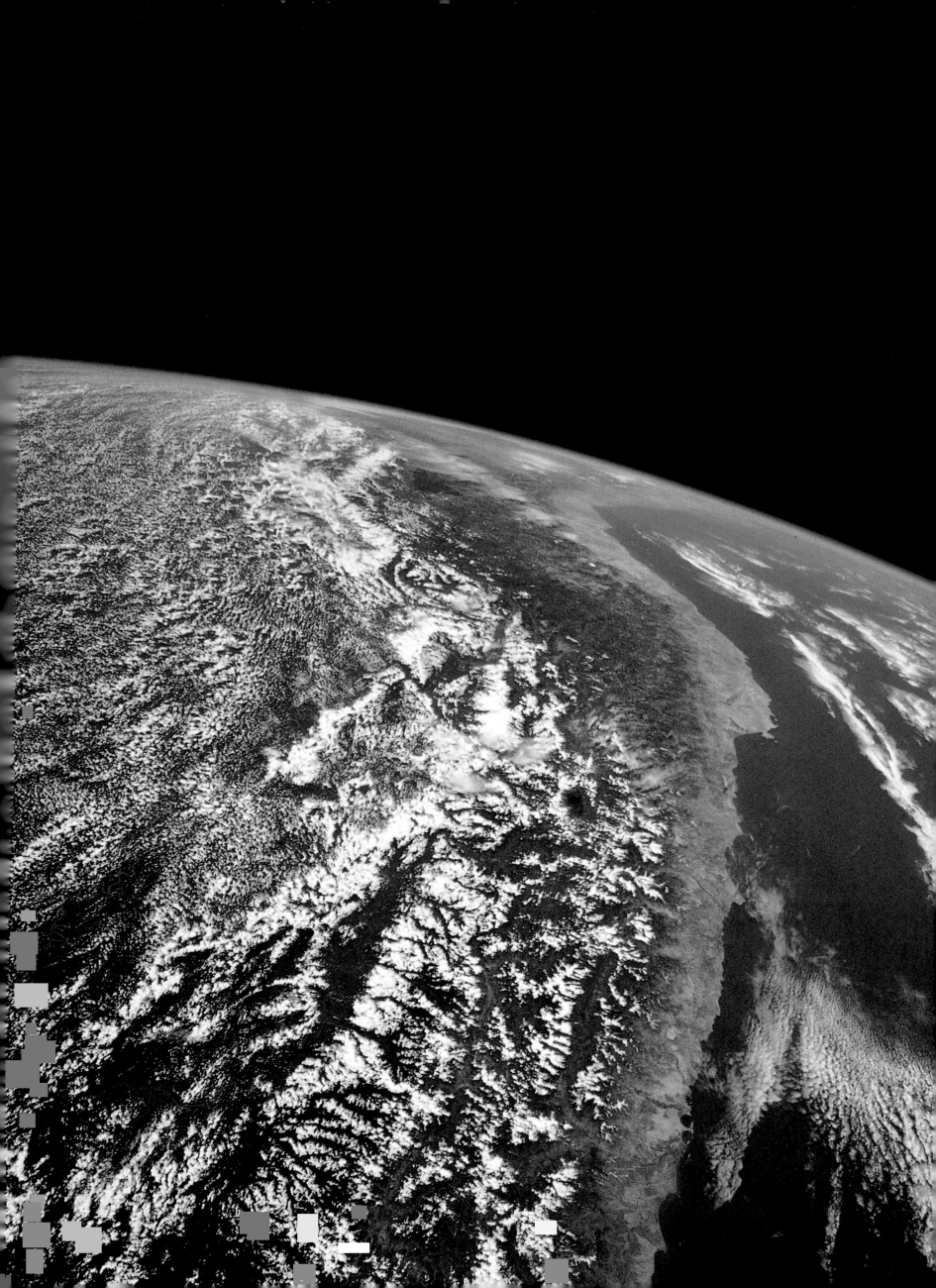

ACKNOWLEDGMENTS

Embracing Earth: New Views of Our Changing Planet was a labor of love that could not have happened without the support of many people. We appreciate the encouragement we received from the people at Chronicle Books. Our senior editor, Jay Schaefer, pushed us beyond our limits. He helped to stimulate the conceptual framework of the book and to draw out the best in our design. Judith Dunham, our text editor, brought to the book a knowledge of geography and natural science, as well as an attention to detail, which added to the refinement of the text. Karen Silver made sure everything moved forward in a timely fashion and kept the book on schedule.

Special thanks to Brad Bunnin, our lawyer, for his unflagging support, creative ideas, and enthusiasm. Additional legal thanks go to Roberta Cairney and Walt Hansell for their counsel and to Anne Hiaring for her last-minute advice and help.

The designers at InterNetwork, Inc., worked under intense time pressures. Leonard Sirota was a constant resource for design ideas and buoyant enthusiasm. Patrick Howell gave elegance to the design. Eric Altson demonstrated powerful organizational skills and contributed to refining the design concepts. Monica Cruz organized all the editing, word processing, and research.

We also acknowledge Colleen Hicks for her astute advice, her unwavering cheerfulness, and the broad range of her support, including quote research and office administration.

The major science agencies in the United States that develop and work with satellite technologies—NASA, NOAA, the United States Geological Survey's Earth Resources Observation Systems Data Center (EDC)—provided important imagery for the book. These agencies are ultimately supported by the people of the United States, who have an opportunity to see the results of such vast research in an accessible form, as the wonderful images in this book. Images were also kindly provided by the SPOT Image Corporation of France, Radarsat International Inc. of Canada, Swedish Space Corporation, and Earth Satellite Corporation in the United States.

Many organizations and individuals were responsive to and supportive of our efforts to assemble this book in a relatively short time. First, we thank Stan Wilson at NASA Headquarters, who has written the essay "Remote Sensing: Striving for a Global View," which adds an important overview to the technical aspects of remote sensing. Other individuals at NASA who were especially helpful or provided technical review include Shelby Tilford, Dixon Butler, Ming-Ying Wei, David Adamec, Ghassem Asrar, Bob Brakenridge, Joe Engeln, Jack Kaye, Mike Kurylo, Tony Janetos, Joe McNeal, Greg Mitchell, Bob Murphy, Bill Patzert, Bob Thomas, Lou Walter, and Diane Wickland.

The United States Geological Survey's EDC also provided essential image support, for which we thank Al Watkins, Chief of the National Mapping Division. We also thank Dave Carneggie, for working with EDC contributors on image research; Gray Tappan, for enthusiastically suggesting a variety of imagery; and Rose Tyrell, for responding efficiently to our image requests. Other EDC personnel who were helpful in recommending or providing imagery include Norman Bliss, Mathew Cross, Kevin Gallo (NOAA), Tom Loveland, Rich McKinney, Don Ohlen, Russ Pohl, Wayne Rohde, Frank Sadowski, Mark Shasby, and K. C. Wehde. In addition, we acknowledge the valuable contributions of Richie Williams, Doug Posson, Denise Wiltshire, and Bruce Molnia, USGS personnel from the National Center in Reston, Virginia, who offered suggestions and encouragement, as well as images.

At NASA's Goddard Space Flight Center thanks go to Gene Carl Feldman, for the ocean color images as

well as the beautiful images that introduce the sections on water, ice, and life; Compton J. Tucker, for images of vegetation; and Arlin Krueger, Courtney Scott, and Scott Doiron, for images of the Mount Pinatubo eruption. Lisa Rexrode was extremely helpful in organizing and providing Landsat imagery. NASA's Johnson Space Center also gave us support, and we thank Kamlesh Llula and Dave Pitts for their suggestions on environmental Space Shuttle imagery.

Individuals at NOAA who provided image support include Mike Hall, Eileen Shea, and Frank Lepore, and Laura K. Metcalf and Laurence W. Arnold (NOAA/NESDIS). Larry Stowe and Robert Carey of NOAA's Satellite Research Laboratory assisted us with imagery of the Mount Pinatubo eruption.

Other scientists who were extremely helpful in sharing imagery from their research include Moustafa Chahine, Kevin Hussey, Peter Woiceshyn, Ben Holt, John Ford, Howard Zebker, and Gregg Vane at the Jet Propulsion Laboratory; Barrett Rock at the University of New Hampshire; Yann Kerr at Laboratoire d'Études et de Recherches en Télédétection Spatiale; Otis Brown and Robert Evans at the University of Miami; and Nicholas Short at Bloomdale College.

We thank the following individuals in the private sector who suggested and provided beautiful images: Clark Nelson at SPOT Image Corporation, Susan Ross at Radarsat International Inc., Max Miller at Earth Satellite Corporation.

We also appreciate the help of Richard Underwood, who supplied photography suggestions and identified many of the Space Shuttle images, and Paul Grabhorn, Amy Budge, and Ben Shedd, who researched Space Shuttle imagery. Leonard Frank generously shared quotations from his book in progress, and Sayre Van Young and Kelly Zinkowski helped with quotation research.

Each of the authors individually also extend special appreciations.

Kevin Kelley is deeply grateful to Payson Stevens, who had the frontline responsibility for writing and designing the book. Payson drafted the text with great discipline and focus, and artfully, gracefully, and forcefully carried the book to its conclusion. Payson is a man of extraordinary energy and talent, and it has been a privilege to collaborate with him and with his team at InterNetwork. I am also pleased to acknowledge Barry Fishman, Bill Arthur, Robert Johnston, Joseph Miller, and Alia Johnson for their advice and guidance. I also thank my daughter, Vanessa, and my son, Aaron, for their enthusiasm and perceptive comments. Special thanks to my wife, Susan, for her advice, encouragement, and love.

Payson Stevens expresses his sincere gratitude to Kevin Kelley, whose book *The Home Planet* was an inspiration for this book and for our collective efforts to expand awareness and appreciation of the Earth. I also thank Roger Revelle, my mentor, who died while this book was being written. Roger devoted much of his professional career to science in the service of people and taught me that the most important thing is to learn how to ask the right questions. The images in this book are visual questions about process and patterns. He would have enjoyed them being made available to the public. Thanks, too, to my friends Richard Carter, Carmela Corallo, Barry Fishman, Cornelia von Mengershausen, Jon Phetteplace, Richard Rosow, and Larry Siegel, who provided spiritual and practical advice, and to my family, Naomi Coval-Apel, Eric Stevens, Larry Stevens, and Bob Apel, for their encouragement. Renée Hobi deserves the deepest appreciation and love for her understanding of what it takes to create an endeavor such as this book.

INDEX

ONE EARTH, ONE WORLD

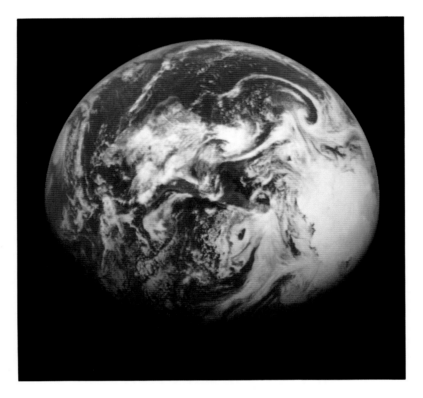

Home Planet. A view of our planet from 1.3 million miles away, as taken by the Galileo spacecraft on its course to Jupiter in December 1990.

Designed and Produced by InterNetwork, Inc.

Book Team:
Art Director: Payson R. Stevens
Senior Designers: Patrick Howell, Leonard Sirota
Associate Designer & Electronic Manager: Eric Altson
Research & Word Processing: Monica Cruz
Copyeditor: Judith Dunham

*To replace the trees needed to manufacture the paper
for this book, the authors and publisher will arrange to plant trees
in endangered rainforests.*